Austerity to Affluence

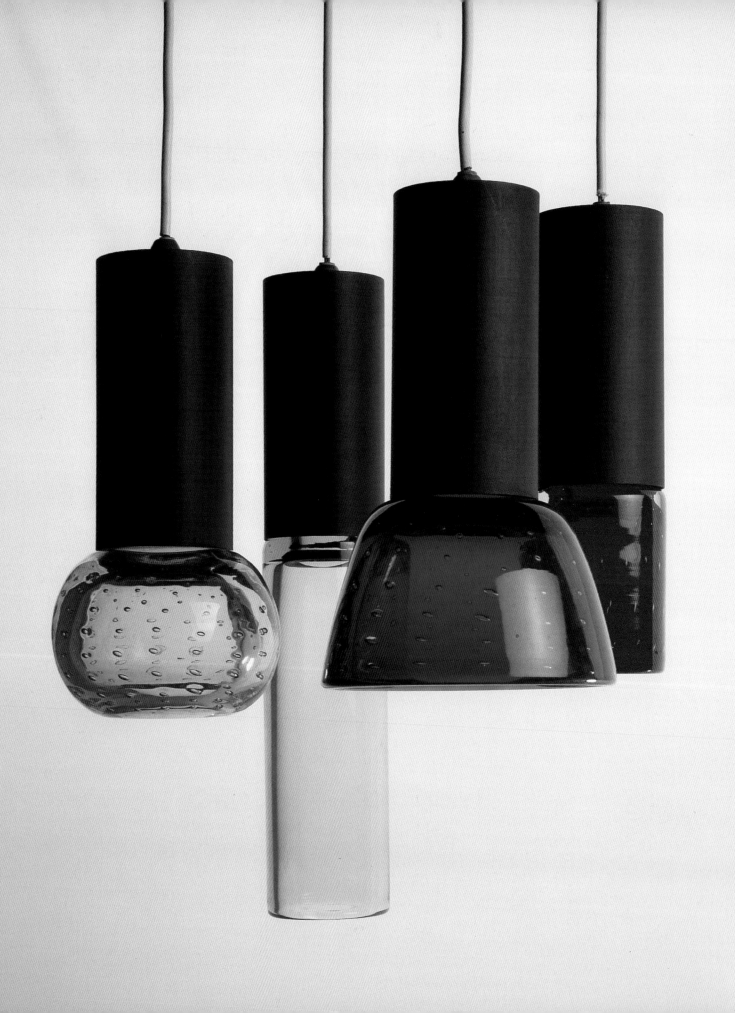

A Phoenix from the Ashes

Post-war British Design

ALAN PEAT

Lynton Lamb, F.S.I.A.

Peter Ray, F.S.I.A.

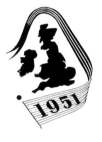

Robin Day, A.R.C.A., F.S.I.A.

Peter Ray, F.S.I.A.

Thomas Eckersley, O.B.E., F.S.I.A.

Milner Gray, R.D.I., F.S.I.A.

Alternative designs for the 'Festival of Britain' symbol competition, 1948.

After World War II a new style emerged in Britain which was fresh and invigorating. Its development was conditioned by the impact of the War, which, through shortages and restrictions of materials, had effectively interrupted both art and design. In the immediate aftermath young artists and designers were excited by the opportunity to start afresh. In fine art a number of different schools emerged, but the main debate was between the realists and the abstract artists. In design, too, a battle was fought between the traditionalists and the champions of the Contemporary style. The age of utility was replaced by a youthful new look which arose at varying speeds in different fields before unifying. It is this unified look, unmistakeably 1950s, which we know as Contemporary.

It was typical of post-war Britain that art and design were perceived as part of the national effort, and this was a significant factor in the momentum necessary for Contemporary design to establish itself. It was indebted to several influences, most notably from America and Sweden. Yet British design of this period was not intransigently derivative, it developed a distinct style and the new British Contemporary look had a real cohesion.

Deprived of choice for a long period, dictated to by the rigours of the Utility scheme, depressed by rationing and bomb damage, the British people were ready for change. Their mood was reflected initially in the political situation – the election of the first majority Labour government in British history. Immediately after the War the welfare state was put in place with the express aim of producing an egalitarian society.

Change was also afoot in the worlds of art and design. Although the Council of Industrial Design (CoID) had been founded in 1944, the first major step *en route* to the Contemporary style was the 'Britain Can Make It' exhibition, held at the

Victoria and Albert Museum in 1946. Many pre-war stalwarts such as R.D. Russell, A.B. Read and the Edinburgh Weavers came back in force, but the exhibition also marked the first public appearance of Ernest Race's BA chair, a truly contemporary design which recycled left-over wartime materials, particularly aluminium alloy. Also included was Robert Goodden's elegant display of sports equipment. Although there were complaints that Britain could make it but it could not have it (due to prevailing restrictions), the importance of this exhibition was neatly summarized by Sir Hugh Casson who described it as, "… a nursery for new design ideas, a lift to public morale".[1] The public flocked to it in their thousands, patiently queuing around the block for the duration of the exhibition.

The success of 'Britain Can Make It' inspired a series of exhibitions which began to establish the Contemporary style, leading up to the 'Festival of Britain' in 1951. At the British Industry Fair in 1949 firms such as Hille exhibited furniture by young designers such as Robin Day and Clive Latimer. In the same year Abram Games won the design competition for the symbol of the planned 'Festival of Britain' and the successful 'Enterprise Scotland' exhibition took place, which included Sir Basil Spence's elegant Allegro dining suite shown on Morris of Glasgow's stand, also designed by Spence with a mural by Victor Pasmore. *Design* magazine was launched by the CoID to 'spread the message'; initially a propaganda magazine, it undoubtedly helped to disseminate the Contemporary style. Although a multitude of factors intertwined to give Contemporary design its momentum, it is possible to unpick several strands critical to the rise of the style.

One, often overlooked, was the rôle of British educators and intellectuals in

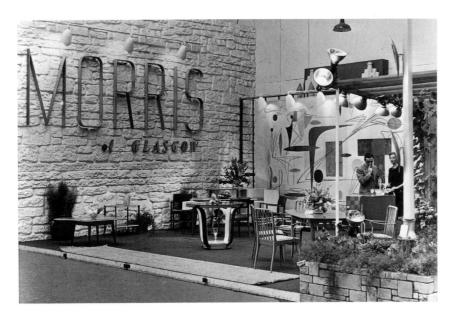

Sir Basil Spence's stand for Morris of Glasgow at the 'Enterprise Scotland' exhibition, 1949. Neil Morris's Cloud table and Spence's Allegro dining suite are displayed against a mural by Victor Pasmore.

spreading the word. Foremost in the field were men such as the forward-thinking Robin Darwin, appointed Principal of the Royal College of Art in 1948; sculptor Eduardo Paolozzi, who also taught textiles at the Central School of Arts and Crafts (1950–55); Robin Welch at the Central School of Art and Design (1957–63); and Herbert Read, whose influential book *Education through Art* had been published in 1942. Read went on to be President of the Society for Education through Art, founded in 1945, which introduced Nan Youngman's Pictures for Schools scheme, bringing established and new artists to the attention of schoolchildren and teachers.

Intellectuals such as Nikolaus Pevsner, the Slade Professor of Fine Art at the University of Cambridge, recognized the need for travelling exhibitions which could tour smaller towns to show off the "best in strictly modern textiles or pottery or furniture".[2] His vision came to fruition with the setting up of local authority teaching collections, the best of which represented (and therefore patronized) the artists and designers of the day. Of prime importance was the Camberwell Collection, originally called the Schools Circulating Design Collection, which was put together by London County Council's Education Department between 1951 and 1976. (Between 1951 and 1957 the selection of objects was made by Sydney Foott of the CoID.)

Magazines such as *ARK*, founded 1950, an independent student production published for the Royal College of Art, acted as useful vehicles for young designers anxious to embrace the Contemporary style. On a wider scale, magazines such as *House & Garden* certainly helped to popularize modern British design. They regularly published photographs provided by the CoID and by firms such as Heal & Son. Manufacturers such as Midwinter Ceramics and David Whitehead Ltd, who both played a rôle in defining the new style, often placed full page colour advertisements in magazines such as *Design* and *The Ambassador*. Finally, outlets for Contemporary design such as Henry Rothchild's Primavera in Sloane Street, London, promoted their shops through placements in popular magazines. Important annuals included *The Studio Yearbook of Decorative Art* and *The Daily Mail Ideal Home Book*. The rôle of television as a promoter of Contemporary

design received a boost in 1953 when the set for *Joan Gilbert's Diary* became a showcase of modern design with all items (including chairs by Race) selected from the CoID's *Design Review*.[3]

The media were not, however, always positive and indeed reactions to the 'Festival of Britain' were varied, but the importance of the exhibition as a promotional vehicle should not be diminished. Misha Black, who before the War was already well established as a designer working for EKCO as well as the Modern Architecture Research Group, discussed the enormous sales potential of exhibitions in the book *Exhibition Design* (Architectural Press, 1951).

An important point to consider is the CoID's rôle as a selector for the 'Festival of Britain': it selected all objects for the Festival, some 10,000 in total. To do this the Council compiled its now famous 1951 stock list, which later became the *Design Index*. This 'control' feature which the CoID exerted helped to unify the Contemporary style and was continued to some extent with the establishment of the Design Centre and its annual awards for good design.

The 'Festival of Britain' was a powerful patron of new designers and artists: Ernest Race was commissioned to produce his famous Springbok and Antelope chairs; Robin Day received a commission to design seating for the Festival Hall and numerous artists, including Victor Pasmore, Graham Sutherland, Leonard Rosoman and Edward Bawden, designed murals for the various pavilions. New and established artists also had the opportunity to produce large paintings for the Festival's '60 for '51' exhibition of paintings. The Festival Pattern Group invited twenty-six leading manufacturers to develop designs in ceramics, cutlery, floor-covering, furniture, wallpaper, glass and textiles based on crystallography structures.

The specific source of this initiative was a paper read by Kathleen Lonsdale in 1949, but the overall desire was to create a different style, to produce something that was not derivative. Crystallography was certainly something new, and indeed crystal-like motifs were used in John Tunnard's mural for the Regatta restaurant. Space-age imagery was central to the Festival style, occurring in anything from a Sputnik-shaped cigarette holder to the flying-saucer body of Ralph Tubbs's 'Dome of Discovery'. Textile designs were named after atomic power stations, and molecular motifs (the famed 'cocktail-cherry-on-a-stick') were all pervasive. The success of the 'Festival of Britain' was not the success of specific individuals but rather the success of a collective look. Although it was destined to be pulled down within a year the impact of what was seen in the show lasted for more than a decade.

Further exhibitions such as the Institute of Contemporary Art's exhibition of experimental furniture in 1951 continued to showcase contemporary designs such as work by the retailer–designer Geoffrey Dunn. The Festival Pleasure Gardens at Battersea, designed by Britain's foremost exhibition designer of the post-war years, James Gardner, in 1951, are forgotten now, but were important then in that, while modern, they continued the British tradition of ironic whimsy and eccentricity – best exemplified in Rowland Emmett's Oyster Creek railway. Such fantastic whimsy certainly formed an element of the Contemporary style and was quintessentially British.

The sense of renewal, of rising above the rationing and the bomb damage, which the 'Festival of Britain' symbolized, was furthered in 1953 with the dawning of the 'New Elizabethan Age'. Queen Elizabeth II's Coronation was the occasion for new patronage – the Tea Centre, for example, commissioned a Contemporary

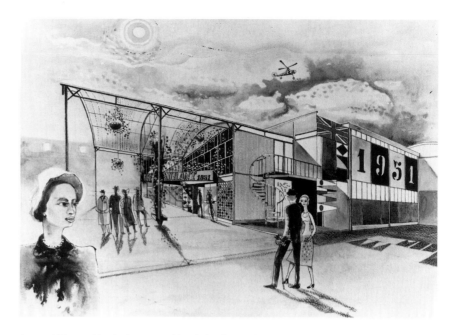

Leonard Manasseh's winning competition design for the '51' bar at the 'Festival of Britain'. Taken from an unpublished book *The Development of the South Bank Exhibition* by Leslie Gooday 1950.

teaset from the silverware designer Eric Clements. Still exhibitions rather than the Coronation had the greater impact in the field of design. They set out the new look on a large, architectural scale but also showcased modern design on a smaller scale, above all in the designing and redesigning of a great number of shops and showrooms across the country in a modern style. These moves created opportunities for design teams such as the Design Research Unit (DRU), founded by Misha Black and Milner Gray; this team received substantial commissions both at 'Britain Can Make It' and the 'Festival of Britain'. The new style was also being fostered by companies such as Ogle Design, founded 1954, Conran Design, founded 1955, and Leslie Gooday & Associates, amongst others. DRU were also involved in the interior decoration of the Time Life Building on New Bond Street, London. This was designed by Michael Rosenauer and was very much a tribute to Britain's designers by the American company. It was one of the first post-war buildings to be built without wartime restrictions, and is an outstanding example of the collaborations between

leading artists and designers of the 1950s, a trend which culminated in the rebuilding of Coventry Cathedral by Sir Basil Spence.

As a symbol of regeneration little could have been more fitting than the consecration of Coventry Cathedral in 1962. The competition was won and the design largely set by the early 1950s after Spence had worked on the 'Festival of Britain'. Coventry stands as a monument to the Festival-look; Bevis Hillier has suggested that Coventry is perhaps the best remaining example of the 'Festival of Britain' style. As Basil Spence noted, "I like to think that Coventry is a modern cathedral in the sense that it sets out to express the spirit of the age in which we live." Spence clearly stipulates the modernist agenda which was prevalent in England and emphasizes "... how closely the artists in various media have combined and co-operated with me in the creation of the Cathedral". Spence seized the opportunity to patronize living artists: John Piper produced the enormous Baptistery window; Jacob Epstein created the figure of *St Michael and the Devil*; Hans Coper the monumental ceramic candleholders; John

Hutton's masterpiece was the Great West Screen, and Graham Sutherland's tapestry *Christ in Glory* reigned in splendour.

An urgent need for new housing owing to the effects of bombing led to the growth of new towns such as Basildon, Harlow, Hatfield, Hemel Hempstead and Stevenage. At Hatfield the architects Lionel Brett and Kenneth Boyd designed thirty-six modern houses. The Hatfield Development Corporation then invited the CoID to assist with the furnishing and decorating of the show-house. In ways such as this, and through the involvement of architects' departments such as that of London County Council (instrumental in the Roehampton Estate), the Contemporary style was further disseminated.

The post-war baby boom compelled local authorities to commission new school buildings. The sheer number of these being erected in post-war Britain assisted in the public's acceptance of Contemporary designs: nearly fifty schools were completed in Hertfordshire alone by the County Council's Architect's Department under C.H. Aslin.

Individual architects also helped to forge a new style, notably Denys Lasdun, who designed living spaces ideal for Contemporary furnishings such as the fifteen-storey block in Claredale Street, Bethnal Green, London (1954) and the block of flats at no. 26, St James's Place, London (1958).

The international force of British design in the 1950s was significant and individual designers and artists received international acclaim. In 1948 Robin Day and Clive Latimer produced the winning entry in the international competition for low-cost furniture design organized by the Museum of Modern Art in New York (MoMA); in 1951 Day designed a room for the Milan Triennale which included designs that have since become interna-

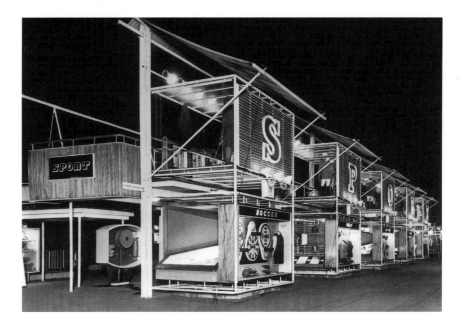

Gordon and Ursula Bowyer's Sport Pavilion at the 'Festival of Britain', 1951.

tional classics – among them Lucienne Day's fabric Calyx for Heal's. Her design won a gold medal in Milan and went on to win the American Institute of Decorators' International Award as the best textile in the United States in 1952. Ernest Race also won a gold medal at Milan for his BA chair and a silver for his Antelope chair. Other British people active in the field of art and design included Herbert Read, who had an international standing, as did Gordon Russell, who sat on the panel at MoMA with Edgar Kaufmann and Mies van der Rohe for the low-cost furniture competition.

By the early 1960s the Contemporary style was becoming debased and another change influenced by Op Art, Pop culture and a whole range of new factors were beginning to affect the design world. Thus the Contemporary style is chronologically circumscribed, yet in its sixteen or so years a body of work of great significance was produced in Britain. The exhibition which this book accompanies has been designed as a testament to the excitement of the period and the talents of its foremost British designers and artists.

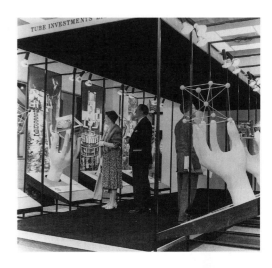

Leslie Gooday's prize-winning stand for Tube Investment Ltd at the 'British Exhibition', New York, 1960.

1 Hugh Casson, '1946: Knockout for Tired Eyes', *Design*, no. 253, January 1970, p. 52

2 Nikolaus Pevsner, as quoted in 'The Royal Society of Arts and Design Today', *Design*, no. 65, May 1954, p. 37

3 Anonymous, 'Points and Pointers', *Design*, no. 58, October 1953, p. 6

4 Ifor B. Evans and Mary Glasgow, *The Arts in England*, Falcon Press Ltd, 1949

Furniture Design

GEOFFREY RAYNER

In the aftermath of the Second World War it was felt in government circles, particularly those of the Board of Trade, that design would play a significant part in generating a successful social and economic recovery for Britain. It was thought, for instance, that furniture design would take a leading rôle in projecting a vital, modern, go-ahead image for Britain at the numerous prestigious and highly competitive national and international exhibitions which became a major feature of the post-war period. Well designed modern furniture was also seen as an essential ingredient for successfully obtaining export orders, so necessary for Britain's economic recovery.

Of more immediate importance was the urgent need to rebuild Britain's bomb-damaged towns and cities and to develop new towns and housing estates in healthy rural and suburban surroundings. It was equally necessary to produce new and modern types of furnishings which would further serve to enhance the lifestyle it was hoped British people would lead in the somewhat utopian world expected to result from the radical social reforms of the recently introduced welfare state. Young designers, along with town planners, architects and the recently formed Council of Industrial Design (CoID), enthusiastically threw themselves into the task of building the 'New Jerusalem'. Robin Day, the furniture designer, writes concerning the attitudes of British designers in the 1940s and 1950s that design was then "more a religion" and designers were "filled with evangelical zeal".[1]

The zeal which Day refers to was principally fanned and kept alight by the missionary fervour of the CoID. The Council's formation in 1944 grew out of the experiences of the various wartime advisory committees of the Board of Trade, particularly their growing awareness of the need to expand exports once the War was over, and of the dependence of this on improved standards of industrial design. Amongst the principal movers for the creation of the CoID was the design panel of the wartime Utility Furniture Advisory Committee and its chairman, Gordon Russell. The Utility Furniture Scheme had grown out of the government's requirement to make a fair provision of furniture within the limitations of wartime resources, to those in greatest need, at centrally controlled prices. In 1942 the government imposed a severely restrictive scheme on what remained of the furniture industry, allowing manufacturers only to produce furniture from an extremely limited range of Board of Trade selected designs by Edwin Clinch and H.J. Cutler.

Under Gordon Russell's chairmanship the Utility Scheme's design panel favoured and commissioned furniture which met the requirements both of the functionalist principles and pared-down style of the British Arts and Crafts movement, and of the Modernist movement for rational design suited to mass-production. These principles were essentially those of Gordon Russell and, subsequently, the CoID, and remained so, becoming a primary influence on the development of attitudes and approaches to furniture design throughout the 1950s.

The exemption from purchase tax of furniture made under the scheme was a major incentive for manufacturers to continue conforming to the Utility standard, which ended as late as January 1953, long after the easing of restrictions in 1948. Consequently a large proportion of furniture then produced in Britain fulfilled the criteria of Gordon Russell and the CoID for 'good' design. For example, between April and June 1951, furniture conforming to the Utility standard still represented 90 per cent of all production in Britain.[2]

It is somewhat surprising to realise that

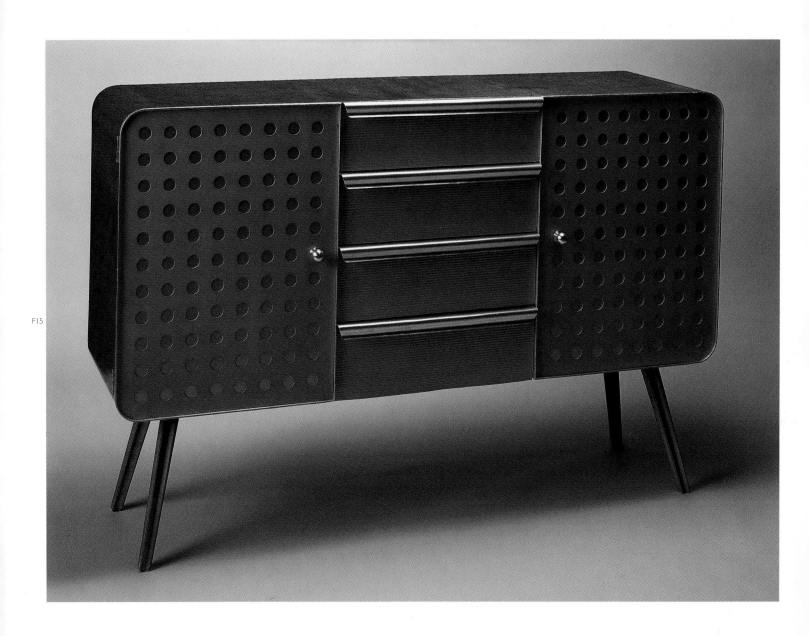

some of the most important, original and influential British furniture design of this century was produced in the austerity period of the immediate post-war years. Outstanding amongst these are Ernest Race's BA and DA furniture of 1945 and 1946 and Robin Day's Hillestack and Hilleplan ranges for Hille of 1950 and 1951. Race's furniture designs were first shown publicly in 1946 at the vast 'Britain Can Make It' exhibition, organized by the recently formed CoID in the galleries of the Victoria and Albert Museum which had been emptied for the duration of the War.

The BA range of 1945, distinguished by the intelligence, restraint and elegance of its designs, was almost certainly the first example of furniture in the new Contemporary style to be produced in Britain. It was also remarkable for employing new technologies and materials developed in the forcing house of wartime needs. A light aluminium alloy was used for the furniture's structure, with tabletops and cabinet panels made of Holoplast, a lightweight honeycomb-sectioned plastic laminated with a thin mahogany veneer that had been given a heat- and stain-resistant finish. In the absence of traditional materials such as wood, Race made his 1946 DA range of furniture from welded lightweight steel rod, which was then upholstered with a thin layer of hair and latex foam. In the first production both the BA and DA ranges were covered, for lack of anything else, with ex-RAF lightweight cotton duck which was dyed blue, terracotta or green.[3]

Unfortunately the BA range met with limited success in the domestic market, to a large degree precisely because of the unconventional materials used and the furniture's advanced design. Expense also played its part, an advertisement of 1947 quoted a price of £32. 7s. 6d. for the sideboard cabinet, then nearly the equivalent of a month's take-home pay for skilled manual and office workers.[4] As a result, according to Alexander Gardner-Medwin, then design officer of the CoID and subsequently a director of Race Furniture, the cabinet was not put into full production, only a very limited number being produced.[5] Race and the co-founder of Race Furniture, Noel Jordan, subsequently decided the company's future lay in the contract market, although domestic sales were retained. This decision, Gardner-Medwin feels, was responsible for the company's future success.[6] The BA3 and 3[A] chairs and the BC tables continued in production as part of Race's range of contract furniture until well into the 1960s, the BA3 chair having been awarded a prestigious gold medal at the Milan Triennale in 1954.

Advanced design and use of unfamiliar materials were also reasons why Clive Latimer's Plymet range of furniture was not taken beyond the prototype stage of development. The range, commissioned by Heal's, was, although controversial, a major attraction of the 'Britain Can Make It' exhibition. In commissioning it, Heal's were very much carrying out the wishes of the President of the Board of Trade, Sir Stafford Cripps. He wanted the exhibition, in order to change the *status quo* in design, to "display prototypes" and that firms should be persuaded "to make some [prototypes] so that, even if they didn't end up being manufactured, public excitement would be engendered".[7]

The majority of people did not, however, endorse 'futuristic designs' and the Plymet cabinet was criticized by one excited member of the public as "looking too much like a fridge".[8] At that time Latimer was working as an assistant to Robin Day at the Beckenham School of Art, and Day remembers his disappointment over the failure to put the Plymet range into production.[9] James Gardner succinctly summed up the situation when he said, "These things were really more concepts of what might be produced than actual products."[10] The designer Frank Guille, a former pupil of Robin Day's at Beckenham, also remembers Latimer's disappointment and recalls that publicity brochures, and even price lists, were frequently produced for ranges of furniture that were not put into production for lack of any positive public or commercial interest.[11]

However, a few years later, in 1948, Robin Day and Clive Latimer were jointly to experience enormous success when their designs for modular storage units took first prize in the competition for low-cost furniture held by the Museum of Modern Art (MoMA), New York. The prototypes entered in the competition had been made in Heal's workshops in return for the European rights to manufacture them. Ironically, despite the worldwide publicity and prestige accorded to Day and Latimer's prize-winning designs, they were never produced commercially either in the United States or in Britain.[12]

Shortly following his success in the MoMA competition, Day entered into what became a highly creative and, in professional terms, lifelong partnership with the furniture manufacturers Hille. Having initially to design, at Hille's request and against his own grain,[13] a luxurious lacquered suite of dining-room furniture, Day was then able to produce what he considers to be his first serious furniture for Hille, the Hillestack and Hilleplan ranges of 1950 and 1951 respectively. Both ranges were made to the Utility standard and are classic examples of Day's essentially modernist and democratic agenda for developing well designed but unpretentious and reasonably priced furniture, which lends itself to the maximum flexibility of use in as wide a variety of situations as possible.

Another furniture company which gained a reputation for good modern design in the 1940s was the Scottish firm Morris of Glasgow. Neil Morris was not only a director of the company, but also responsible for designing and commissioning much of the furniture which gained the firm its high reputation. Morris designed the Cloud table in 1946 and the later Bambi and Toby chairs. He also collaborated with the architects Maxwell Fry and Jane Drew in designing furniture for the Institute of Contemporary Arts.[14] All this furniture was produced in a distinctive and luxurious plywood laminate of betula wood and Honduras mahogany.

Between 1947 and 1948 Morris commissioned Sir Basil Spence to design a suite of dining-room furniture. The suite, the Allegro, was made in a refined organic style from a special lightweight plywood originally developed during the War for use in aircraft construction. The elegant Allegro armchair was in the permanent collection of the Museum of Modern Art as early as 1949.[15] However, Anthony Blee, Sir Basil Spence's son-in-law, says that the Allegro furniture, like so much other high-profile British design of the period, had an extremely limited production.

Traditional Windsor furniture was given a new lease of life in the 1940s and 1950s by Lucian Ercolani. Under his direction Ercol furniture produced a series of light, simple and subtle modern 'Windsor' designs that fitted easily into the Contemporary interiors of the small modern houses and flats then being built in the new towns and housing estates arising around the country from the aftermath of the War. The first examples of Ercol's 'new look' 'Windsor' furniture were shown in 1946 at the 'Britain Can Make It' exhibition. They clearly had an influence on subsequent Scandinavian design. Distinguished designers such as

Hans Wegner and Borge Mogensen from Denmark, the Swede Alf Svenson and Finland's Ilmari Tapiovaara, amongst others, produced Contemporary style furniture derived from the Windsor chair and its structure.

Many other lively and imaginative ranges of furniture were produced in the 1940s such as J.W. Leonard's Esavian chairs, desks and tables of aluminium and plywood. Eric Lyons, architect of the classic 1950s' Span housing, also produced his Tecta range of ply- and bentwood furniture for the Packet Furniture Company which later amalgamated with E.A. Khan & Co. Ltd.

The surge of creative activity, released by the ending of the War, reached its crescendo in the planning, designing and building of the 'Festival of Britain' between 1948 and 1951. The Festival was organized by the CoID and was, in part, a vast showcase for the talents of British designers. Ernest Race was commissioned to design a number of pieces of exposed, steel-rod furniture for use at the Festival – the most well known of which, the Antelope chair, now synonymous with 1950s' design in general, went on to win a silver medal at the Milan Triennale in 1954.

A group of sophisticated modern furniture was also commissioned from Robin Day for use in various venues at the Festival site. His armchair for the Royal Festival Hall and the dining chair used in the Festival Hall restaurant are amongst his most important designs from the 1950s. Other designers such as A.J. Milne also produced furniture for the Festival. Milne, who was probably the only British designer to work in a fully realised three-dimensional and sculptural organic style, received many commissions for furniture designs from Heal's. Christopher Heal both designed Contemporary furniture himself and commissioned much more

from designers and architects of the standing of Nigel Walters.

While some designers had work specially commissioned for the Festival many others were represented by companies' exhibits. The prestigious firm of Gordon Russell displayed an influential sideboard by David Booth and Judith Ledeboer, the front of which had a routed decoration in the form of a double helix. This type of routed decoration was subsequently used by many other designers, notably Peter Hayward for W.G. Evans and H.E. Long for Heal's, a company which played a prominent role in publicizing and disseminating the Contemporary style.

Another company which consistently held to a strong modernist agenda throughout the post-war period was the firm of Kandya. Set up in the late 1920s, Kandya specialized in high-quality modular furniture, mainly constructed from beechwood. In the small and open-plan houses and flats of the post-war era, the divisions between kitchen, dining and living areas were lost and there was a need to define the resulting open space. To meet this demand Kandya added to their range of modular units a number of designs for stools, chairs, tables and room dividers in which the previously well defined demarcations between, for instance, kitchen and dining furniture no longer strictly applied. Some items such as room dividers were wholly new concepts which avoided traditional definition and were ambiguous in their flexibility of function and purpose.

Kandya are best known for the remarkable Jason chair, designed for them in 1950 by the Dane Karl Jacobs. Apart from its legs, the chair was formed from a single square of plywood. In 1953 Frank Guille was commissioned to design a version of the Jason chair with steel-rod legs replacing the originals of beech. From then on the chair was available in both versions.[16] Following his remodelling of

the Jason chair Guille was employed as consultant designer to Kandya until the 1970s.[17] During his time with Kandya he developed an important range of modular units and associated furniture in a functionalist manner of a harmonious refinement and subtle elegance.

From the middle of the 1950s the individuality and liveliness of the earlier post-war period gives way to an increasingly restrained, sober and rectilinear style, one which is often dependent solely on the use of richly grained woods to replace the earlier expressiveness of designers such as Ernest Race. In about 1956 Robert Heritage, later Professor of Furniture at the RCA, designed a well known sideboard for Archie Shine which is transitional in style. Although new in its long, low-slung, rectilinear form, it still retained in other aspects of its design something of the sparky panache of the style associated with the 'Festival of Britain'. This sideboard was given a Design Centre Award in 1958.

The Design Centre had been set up in 1956 by the CoID to make 'good' design accessible to both public and professionals through the Centre's displays and exhibitions, and also through the Design Index, which housed details of designs approved by the Council. The Design Centre Award could be considered as a replacement of the old Utility standard mark.[18] The award was also an expression of the attempt by the CoID to guide people back into the paths of good design in the face of what they saw as a growing state of visual anarchy. The anarchy stemmed from the influence of popular versions of Contemporary designs which were then beginning to fill high-street shops and from the assertion of popular taste, due largely to the increasing financial ability of people to indulge in styles more often related to Hollywood movies than to the Council's concepts of good taste.

In the atmosphere of self-conscious restraint pervading the design establishment at the close of the Contemporary era, it took the talents of designers of the calibre of John and Sylvia Reid to produce successfully the elegant minimalist furniture they designed for Stag.

The subtle, dignified and harmonious proportions of Dick Russell's seating for the newly rebuilt Coventry Cathedral, consecrated in 1962, remains an eloquent swansong for an important period in the history of British furniture design – a period which began with the imagination, inventiveness and energy so necessary in the austerity of the early post-war years, and which closed amidst the contented affluence of the early 1960s.

1 Robin Day, from the foreword to this book.

2 Hazel Conway, *Ernest Race*, London (The Design Council) 1982, p. 19.

3 *Ibid.* p. 16.

4 *Ideal Home* magazine, August 1947, p. 10.

5 Alexander Gardner-Medwin, interview with the author, 17.2.97.

6 *Ibid.*

7 Giles Velarde interview with James Gardner, *Did Britain Make It? British Design in Context 1946–86*, ed. Penny Sparke, London (The Design Council) 1986, p. 11.

8 Lucy Bullivant, 'Design for Better Living and the Public Response to Britain Can Make It', *Did Britain Make It? British Design in Context, 1946–86*, ed. Penny Sparke, London (The Design Council) 1986, p. 149.

9 Robin Day, interview with the author 12.11.96.

10 Velarde 1986, p. 10.

11 Frank Guille, interview with the author 4.10.96.

12 Robin Day, interview with the author 12.11.96.

13 *Ibid.*

14 Roberto Aloi, *Esempi di arredamento moderno di tutto il mondo, sedie poltrone divani*, second series, Milan (Ulrico Hoepli) 1953, illus. no. 152.

15 'Decorative Art', *The Studio Year Book*, 1949. Illus. Advertisement, p. viii. London and New York (The Studio Publications) 1949.

16 Frank Guille, interview with the author 4.10.96.

17 *Ibid.*

18 Hazel Conway, 1982, writes that as early as 1942 Russell was already proposing that the "utility specification be used as the basis of a quality mark for furniture in the post-war period", p.16.

F1

Ernest Race (1913–1964: see Biography page 124) for Race Furniture Ltd, London
BA3 armchair, 1945
Stove-enamelled cast aluminium with cotton velour-covered upholstery, 73 cm x 44.5 cm x 41.5 cm (28³/₄″ x 17¹/₂″ x 16¹/₄″)
Model and part numbers to legs
An example exhibited 'Britain Can Make It' (exhib. cat. p. 46, group P, no. 110); The 10th Milan Triennale, 1954, awarded a gold medal
PUBLISHED *Designers in Britain*, 1947, vol. 1, p. 225

F2

Ernest Race for Race Furniture Ltd, London
BA3ᴬ armchair, 1945
Stove-enamelled cast aluminium with vinyl-covered upholstery, 75.5 cm x 59.5 cm x 41.5 cm (29³/₄″ x 23¹/₂″ x 16¹/₄″)
Stamped model and part numbers to legs
PUBLISHED *Designers in Britain*, 1949, vol. 2, p. 19

F3

Ernest Race for Race Furniture Ltd, London
BD1 cabinet, 1945–46
Cast and sheet aluminium, Holoplast panels with mahogany veneer, turned beech

handles, sprayed flock interior, 85 cm x 119.5 cm x 40.5 cm (33¹/₂″ x 47³/₄″ x 16″)
Stamped model and part numbers to legs
PUBLISHED *Designers in Britain*, 1947, vol. 1, p. 230
Price for sideboard when retailed by Arding & Hobbs in 1947, £32. 7s. 6d.

F4

Ernest Race for Race Furniture Ltd, London
BB21 occasional table, 1945–46
Stove-enamelled cast and sheet aluminium, plywood and plastic laminate, 40.5 cm x 61 cm (16″ x 24″)
An example exhibited 'Britain Can Make It' (exhib. cat. p. 46, group P, no. 111)
PUBLISHED *Designers in Britain*, 1947, vol. 1, p. 230; *Design*, no. 72, December 1954, illus. p. 10
Plastic laminate, Cocktail, for Formica Ltd, attributed to Jacqueline Groag

F5

Ernest Race for Race Furniture Ltd, London
DA1 armchair, 1946
Welded lightweight steel-rod frame with coil-sprung seat, hair and latex foam upholstery covered in a woven fabric, stove-enamelled cast aluminium legs, 92 cm x 71 cm x 54.5 cm (36¹/₄″ x 28″ x 21¹/₂″)

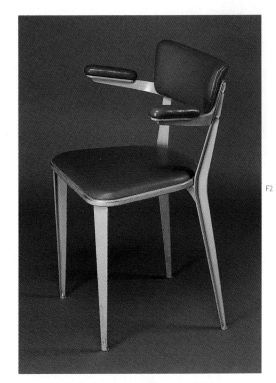

F2

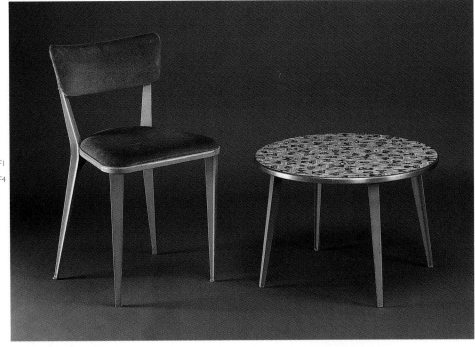

F1
F4

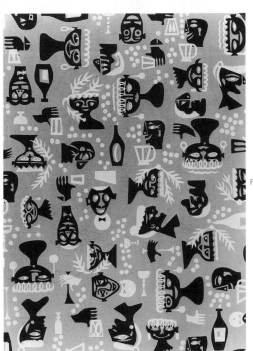

F4

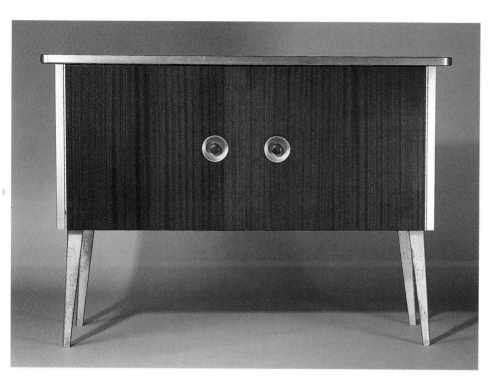

3

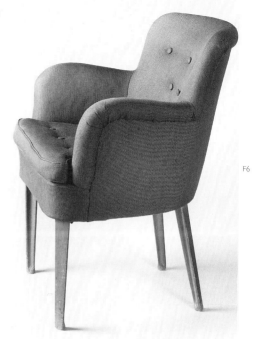

F6

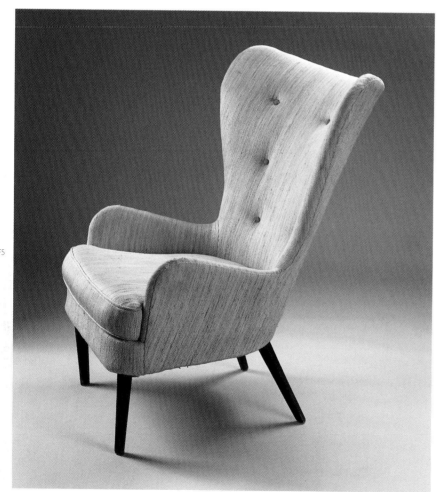

F5

Race logo transfer to inner frame
PROVENANCE Laurence Rowley, only son
of the founder of The Rowley Gallery,
Kensington Church Street
PUBLISHED *The Studio Yearbook of
Decorative Art*, 1949, p. 21
This armchair, with its legs uniquely painted
black, was upholstered to a particular speci-
fication as part of an interior design scheme
for Laurence A.J. Rowley. The chair was dis-
persed, along with other furniture from the
scheme and personal possessions of
Laurence Rowley, in 1994

F6
Ernest Race for Race Furniture Ltd,
London
DA armchair, 1946
Welded lightweight steel-rod frame, with
coil-sprung seat, hair and latex foam uphol-
stery, covered in ex-RAF cotton duck; stove-
enamelled cast aluminium legs, 82.5 cm ×
66.5 cm × 58.5 cm (32½″ × 26¼″ × 23″)
Race logo transfer to inner frame
PUBLISHED *Designers in Britain*, 1949, vol.
2, p. 26
This armchair is part of the original 1946
production, the covering of its upholstery
being from necessity improvised from RAF
cotton duck

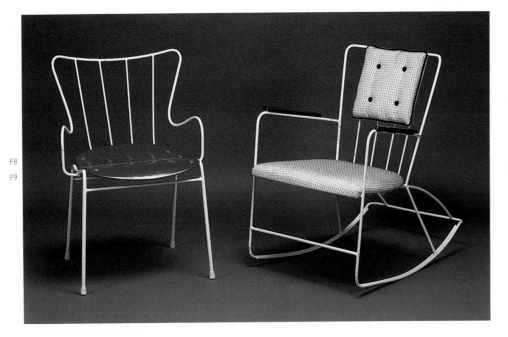
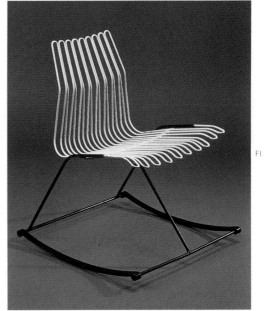

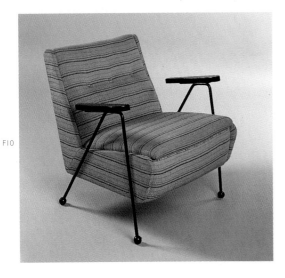

F7
(Attrib.) **Ernest Race** for Race Furniture Ltd, London
Steel-rod armchair with loose upholstery, *ca.* 1947
Painted steel-rod frame, plywood, hair and latex foam upholstery covered in Rexine leathercloth; rubber ferrules, 82.5 cm × 57 cm × 62.5 cm (32½" × 22" × 24½")
This previously unrecorded design appears to pre-date other exposed-rod furniture by Race. Its identification was confirmed by a former senior member of Race's management at the opening of the exhibition 'Fifties in the Home' held by Liberty's in 1992

F8
Ernest Race for Race Furniture Ltd, London
Rocking chair, 1948
Painted steel-rod frame, wooden armrests, upholstered seat and back cushion covered in woven rayon material, 77 cm × 61 cm × 76 cm (30¼" × 24" × 30")
An example exhibited 'Festival of Britain' (exhib. cat. p. 122, section no. K753)
PUBLISHED *Designers in Britain*, 1949, vol. 2, p. 17

F9
Ernest Race for Race Furniture Ltd, London
Antelope stacking armchair, 1949–50
Painted steel-rod frame, painted plywood seat, plastic ferrules, 75 cm × 52.5 cm × 53.5 cm (29½" × 20¾" × 21")
Race logo transfer to underside of seat
An example exhibited 'Festival of Britain' (exhib. cat. p. 139, no. D901). The 11th Milan Triennale, 1954, awarded a silver medal
PUBLISHED *Designers in Britain*, 1951, vol. 3, p. 202

F10
Ernest Race for Race Furniture Ltd, London
Prototype Woodpecker armchair, *ca.* 1952
Painted steel-rod frame, wooden armrests,

coil-sprung upholstered seat, covered in woven textile, 66 cm × 66.5 × 57 cm (26" × 26¼" × 22½")
Specification label to underside
PUBLISHED *The Studio Yearbook of Decorative Art*, 1953–54
According to Alexander Gardner-Medwin, the Woodpecker chair was developed as modular seating. The armchair version is extremely rare – a variation of the modular form which, despite being included in a 1953 advertisement, was not put into full production

F11
Ernest Race for Race Furniture Ltd, London
Kangaroo rocking chair, 1952
Painted steel-rod and steel strips, 72.5 cm × 56 cm × 60.5 cm (28½" × 22" × 23¾")
PUBLISHED *The Studio Yearbook of Decorative Art*, 1953–54, p. 130
The Kangaroo was commissioned for use on the roof terrace of the newly built Time Life Building in New Bond Street. It had a very limited commercial production

F12
Ernest Race for Race Furniture Ltd, London
Prototype Neptune deck chair, 1953
Beech laminate frame, plywood, webbing,

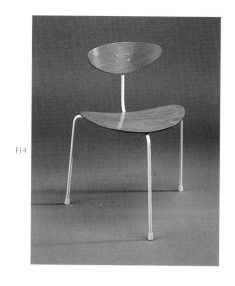

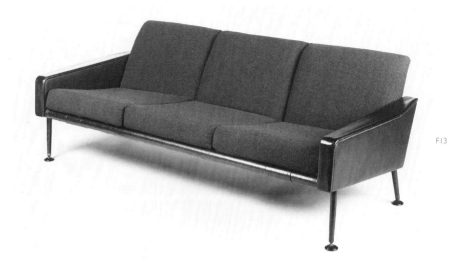

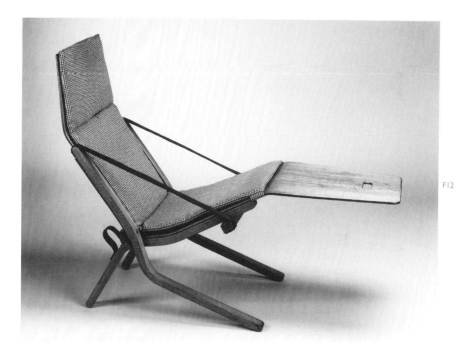

removeable Seatex rubber upholstery covered in Tygan, 95.5 cm × 56 cm × 127.5 cm (37½″ × 22″ × 51″)
PUBLISHED *Design*, no. 162, February 1954, pp. 22–23
PROVENANCE Peter Kidman and by descent
This prototype chair was a gift from Ernest Race to Peter Kidman of Aylesbury Bros, who was responsible for developing the laminates for the Neptune chair. Aylesbury Bros also produced the plywood seats of the Antelope and Roebuck chairs for Race

F13
Ernest Race for Race Furniture Ltd
R57 settee, 1956
Tubular steel subframe, plywood covered in leather and vinyl, removeable cushions covered in woollen material, beech legs, Armstrong Glide feet, 61 cm × 189 cm × 73.5 cm (24″ × 74½″ × 29″)
PUBLISHED *Design*, no. 100, April 1957, p. 52
The R57 range of chairs and settees was developed for use on board liners of P&O's Orient Line. See Hazel Conway, *Ernest Race*, London (The Design Council) 1982, p. 64

F14
Ernest Race for Race Furniture Ltd
Unicorn stacking side chair, 1957
Painted steel-rod, plywood, plastic ferrules,

67.5 cm × 46.5 cm × 40 cm (26½″ × 18¼″ × 15¾″)
Race logo transfer to underside
PUBLISHED *Design*, no. 112, April 1958, p. 74
This chair was commissioned for use in the British Pavilion at the 1958 Brussels World Fair. It had a limited commercial production in 1958

F15
Clive Latimer for Heal & Son Ltd
Plymet prototype cabinet, 1945–46
Cast and sheet aluminium, sheet steel, birch veneer, 86 cm × 135 cm × 40 cm (33¾″ × 54″ × 15¾″)
EXHIBITED 'Britain Can Make It' (exhib. cat. p. 44, group P, no. 74)
PUBLISHED *The Studio Yearbook of Decorative Art*, 1943–48, p. 75
For a full description see p. 13

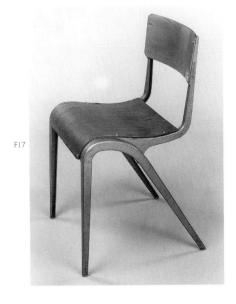

F17

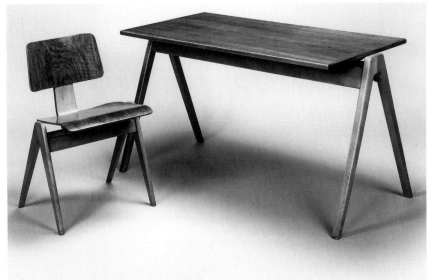

F18
F19

F16
Edwin L. Clinch for Goodearl Brothers
Ltd, High Wycombe
Side chair, 1945
Painted aluminium, upholstery covered in
leathercloth
Utility stamp to underside
An example exhibited 'Britain Can Make It'
(exhib. cat. p. 43, group P, no. 45)
PUBLISHED *Designers in Britain*, 1947, vol.
I, p. 6
Edwin Clinch designed a considerable part
of the official government range of utility
furniture. In the post-war period he worked
frequently with Geoffrey Dunn of Dunn's of
Bromley

F17
James W. Leonard for Esavian Ltd,
Education Supply Association, Stevenage
Stacking side chair, 1948
Painted cast aluminium, plywood, polythene
ferrules, 74.5 cm x 40.5 cm x 47 cm (29¹/₄″
x 16″ x 18¹/₂″)
Printed stamps to underside of seat, *ESA
Esavian* and serial number
An example exhibited 'Festival of Britain'
(exhib. cat. p. 154, section no. 1504)
PUBLISHED *Designers in Britain*, 1949, vol.
2, p. 27, plate 6

F18
Robin Day (1915– : see Biography page
124) for S. Hille & Co., Chigwell
Hillestack side chair, 1950
Beech, plywood with walnut veneer, 72 cm
x 49 cm x 43 cm (28¹/₄″ x 19¹/₄″ x 17″)
An example exhibited 'Hille – 75 Years of
British Furniture', Victoria and Albert
Museum, 1981
PUBLISHED *House & Garden*, July 1952, p.
63. The retail price from Liberty's was then
66s. each

F19
Robin Day for S. Hille & Co., Chigwell
Hillestack table, 1950
Beech, plywood top with veneer, 71 cm x
127.5 cm x 61 cm (28″ x 51″ x 24″)
Ivorine plaque to underside of top stamped
Hille, London and impressed utility mark
An example exhibited 'Hille – 75 Years of
British Furniture', Victoria and Albert
Museum, 1981
PUBLISHED *House & Garden*, July 1952,
p. 63. The retail price from Liberty's was
then £8. 10s. 7d.

F20
Robin Day for S. Hille & Co., Chigwell
Armchair, 1950
Plywood with rosewood veneer, copper-
plated steel-rod frame, upholstery covered
in woven wool material, 66 cm x 89.5 cm x
63.5 cm (26″ x 35¹/₄″ x 25″)
EXHIBITED The 9th Milan Triennale, 1951,
awarded a gold medal; 'Hille – 75 Years of
British Furniture', Victoria and Albert
Museum, 1981
PUBLISHED *Designers in Britain*, vol. 4,
1954, p. 14
Designed for use in the Royal Festival Hall
during the 'Festival of Britain', this seems to
be the only surviving armchair from the ori-
ginal furnishings of the Festival Hall. It was
removed when the Hall was refitted in
1962. In 1981 the upholstery was recovered
to an original specification by Hille, when it
was loaned for inclusion in the exhibition
held at the Victoria and Albert Museum

F21
Robin Day for S. Hille & Co., Chigwell
661 dining chair, 1950
Plywood with veneer, painted steel-rod,
upholstered seat covered in a tweed fabric,
77 cm x 53.5 cm x 45.5 cm (30¹/₄″ x 21³/₄″
x 18″)
Ivorine plaque to underside of seat stamped
Hille, London

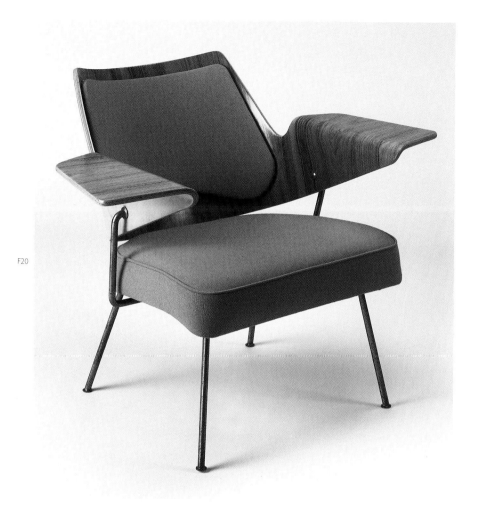

F20

An example exhibited 'Festival of Britain' (Homes & Gardens Pavilion); the 9th Milan Triennale Exhibition, 1951, awarded a gold medal

PUBLISHED *Designers in Britain*, 1951, vol. 3, p. 190

The 661 was commissioned for use in the restaurant of the Royal Festival Hall

F22

Robin Day for S. Hille & Co., Chigwell Hilleplan bookcase composed of modular units, 1951
Beech and plywood with walnut and birch veneers, glass doors, 153 cm × 135 cm × 45.5 cm (61½″ × 54″ × 18″)
Ivorine plaque to interior of units, stamped *Hille, London*
PUBLISHED *The Studio Year Book of Decorative Art*, 1952–53, p. xii

F23

Robin Day for S. Hille & Co., Chigwell Hilleplan bureau, 1951
Beech and plywood with veneers, 114 cm × 91.5 cm × 45.5 cm (45½″ × 36″ × 18″)
Ivorine plaque to interior of unit, stamped *Hille, London*
PUBLISHED Philippe Garner, *Twentieth Century Furniture*, 1980, p. 153

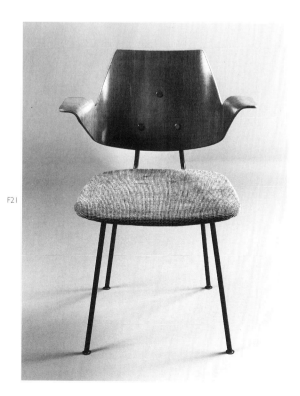

F21

F23

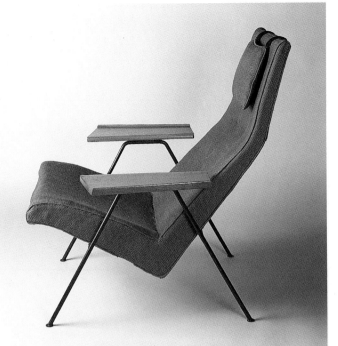

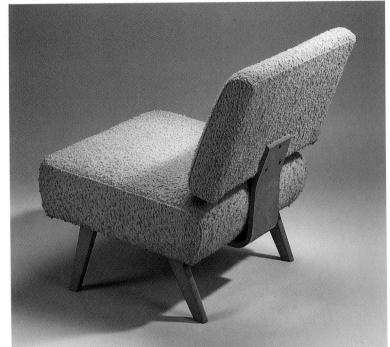

F2[

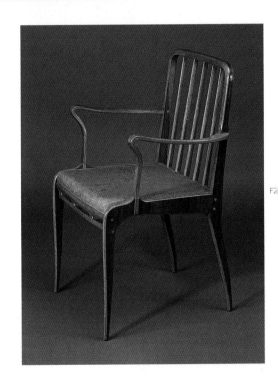

F2[

F24
Robin Day for S. Hille & Co., Chigwell
Lounger armchair, 1952
Painted steel-rod, mahogany, upholstery
covered in tweed, 90 cm × 90 cm × 86.5
cm (35¹/₂″ × 35¹/₂″ × 34″)
PUBLISHED *Esempi di Arredamento*, 1953,
plate 223
This lounger chair has become an iconic
image of British Contemporary design from
the 1950s perpetuated by its use as decora-
tion on the celebrated Homemaker range
of china by Enid Seeney and Tom Arnold

F25
Robin Day for S. Hille & Co., Chigwell
TV Lounge chair, 1952
Solid beech and beech laminate, with coil-
sprung seat and upholstery covered in
bouclé wool, 72 cm × 62.5 cm × 63.5 cm
(28¹/₄″ × 24¹/₂″ × 25″)
PUBLISHED *The Studio Yearbook of Decorative
Art*, 1953–54, p. 9

F26
Robin Day for S. Hille & Co., Chigwell
Polyprop, stacking side chair. Designed and
developed 1960–62
Painted steel tube, injection-moulded
polypropylene, 74 cm (29″)
EXHIBITED 'Hille – 75 Years of British Fur-
niture', Victoria and Albert Museum, 1981
PUBLISHED *Design*, October 1963, p. 13
LENT BY Robin Day
This chair is probably the most successful
British chair design of this century in terms
of the longevity of its sales. It is also one of
the first injection-moulded one-piece plastic
chairs to be successfully produced

F27
Sir Basil Spence (1907–1976) for
H. Morris & Co Ltd, Glasgow
Allegro armchair, 1947
Honduras mahogany and Canadian betula
laminate. Foam-upholstered seat covered in
leather, 85 cm × 52.5 cm (33¹/₂″ × 20³/₄″)
Inset metal label *Morris of Glasgow* and
impressed number to frame
An example exhibited 'Enterprise Scotland',
Glasgow, 1949
PUBLISHED *The Studio Yearbook of
Decorative Art*, 1949, p. viii
COLLECTION The Museum of Modern
Art, New York, since 1948

F28
Neil Morris for H. Morris & Co. Ltd
Cloud table, 1947
Honduras mahogany and Canadian betula
laminate, 46.5 cm × 114.5 cm (18¹/₄″ ×
45³/₄″)

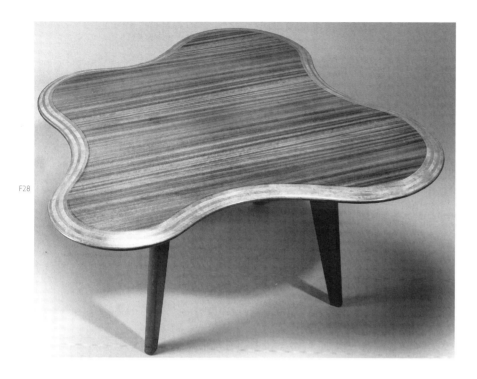

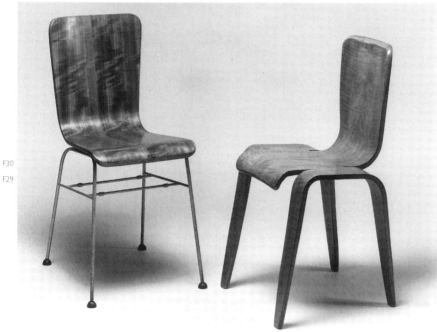

F28

F30
F29

Printed marks to underside of tabletop; *Cumbrae*, *Morris of Glasgow* and serial number. Traces of paper label
An example exhibited 'Enterprise Scotland', Glasgow, 1949
PUBLISHED *Designers in Britain*, 1949, vol. 2, p. 21
Included as part of Morris's Cumbrae range.

F29
Neil Morris for H. Morris & Co. Ltd, Glasgow
Bambi stacking side chair, *ca.* 1950
Honduras mahogany and Canadian betula laminate, 77.5 cm × 41.5 cm × 43 cm (30½″ × 16¼″ × 17″)
Printed stamp to underside *Bambi*, *Morris of Glasgow, registration of design applied for*
PUBLISHED *The Book of Good Housekeeping Institute*, *ca.* 1954, plate 20

F30
Neil Morris for H. Morris & Co. Ltd, Glasgow
Toby stacking side chair, early 1950s
Laminated wood, painted steel-rod, Armstrong Glide feet, 80.5 cm × 32.5 cm × 46.5 cm (31¾″ × 12¾″ × 18¼″)
Impressed marks to underside, *Toby*, *Morris of Glasgow*
PUBLISHED *Design*, no. 108, December 1957, p. 8

F31
Eric Lyons for the Packet Furniture Ltd, Great Yarmouth
Linden armchair, *ca.* 1948
Beech laminate with coil-sprung upholstered seat covered in a woven fabric, 72.5 cm × 56.5 cm × 58.5 cm (28½″ × 22¼″ × 23″)
Impressed utility mark to underside of seat. Printed stamp to underside of arm, *Tecta Range* and *Registered Design* with obscured number
PUBLISHED *House & Garden*, July 1952, illus. p. 13. Retail price £5. 5s. 0d.

F32
Eric Lyons for the Packet Furniture Ltd, Great Yarmouth
Armchair, *ca.* 1950
Beech laminate, upholstery covered in

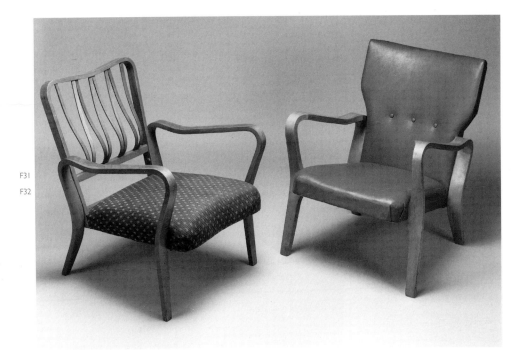

F31
F32

PUBLISHED Kandya sales catalogue, September 1957, p. 9. Price £3. 15s. 0d.

F33a
Carl Jacobs and **Frank Guille** for Kandya Ltd, Hayes
Jason stacking chair, C3, 1953
Part-painted, single beech laminate, painted steel-rod, plastic ferrules, 72 cm × 52 cm × 40.5 cm (28¹/₂″ × 20¹/₂″ × 16″)
Transfers to underside; *Kandya* and registered design numbers
PUBLISHED Kandya sales catalogue, September 1957, p. 2. Price with teak veneer £4. 7s. 0d.
Frank Guille's first commission for Kandya was this restyling of the Jason chair

F34
Paul K. Bridson for Kandya Ltd, Hayes
374 table, *ca.* 1951
Painted steel-rod, plywood with plastic laminate and edging, 71 cm × 105 cm × 68.5 cm (28″ × 42″ × 27″)
Transfer to underside *Kandya*
PUBLISHED Kandya sales catalogue, September 1957, p. 2. Price £11. 19s. 6d.
Paul Bridson was employed by Kandya as house designer. He worked alongside Frank Guille who was design consultant for the company

F35
Frank Guille (1928– : see Biography page 124) for Kandya Ltd, Hayes
611 room divider, *ca.* 1955
Painted metal frame, agba wood, painted and veneered plywood, mahogany, glass and plastic laminate, 150 cm × 145 cm × 40.5 cm (60″ × 58″ × 16″)
PUBLISHED *Design*, no. 100, April 1957, p. 40. Retail price, including purchase tax, £37. 19s. 0d.

F36
Frank Guille for Kandya Ltd, Hayes
Trimma cabinet, 642, 1956
Solid beech, painted and veneered plywood, glass, 172.5 cm × 102.5 cm × 38 cm (69″ × 41″ × 15″)
Transfer to back *Kandya*

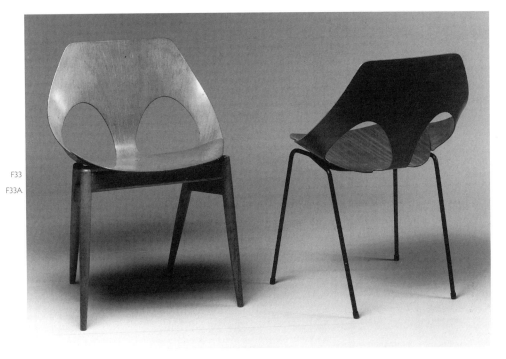

F33
F33A

Rexine leathercloth, 72.5 cm × 52 cm × 66 cm (28¹/₂″ × 20¹/₂″ × 26″)
This chair is related to the Linden chair and the Cromerwood range. All are part of the Tecta range developed by Lyons between 1946 and the mid 1950s for Packet Furniture which subsequently amalgamated with E.A. Khan Ltd. See *Design*, December 1954, no. 72, p. 42.

F33
Carl Jacobs (1925–) for Kandya Ltd, Hayes
Jason stacking side chair, C2, 1950
Beech and single-sheet beech laminate, 72.5 cm × 52 cm × 40.5 cm (28¹/₂″ × 20¹/₂″ × 16″)
Transfers to underside; *Kandya* and registered design numbers

PUBLISHED Kandya sales catalogue, 1961.
Price £33. 10s. 0d.

F37
Frank Guille for Kandya Ltd, Hayes
Lamina table, 313, *ca.* 1955
Laminated beech and plastic laminate, 71 cm
× 135 cm × 68.5 cm (28" × 54" × 27")
Transfer to underframe *Kandya*
An example exhibited 'Design of the Times
– 100 Years of the Royal College of Art',
Royal College of Art, London, 1996
PUBLISHED Kandya sales catalogue, 1961.
Price £14. 19s. 6d.; *Design in the Festival, an
Illustrated Review of British Goods*, 1951,
p. 27
The plastic laminate used for the tabletop,
Blue-Grey Check by Warerite Ltd, appears
to have originally been a wallpaper design,
Crossley, by Harry Skeen for John Line &
Sons Ltd, 1951

F38
Frank Guille for Kandya Ltd, Hayes
C40 stacking side chair, *ca.* 1958
Laminated beech with veneer, 77.5 cm × 47
cm × 56 cm (30½" × 18½" × 22")
Transfer to underframe *Kandya*
PUBLISHED Kandya sales catalogue, June
1963

F39
Frank Guille for Kandya Ltd, Hayes
C32 breakfast stool, *ca.* 1958
Plastic coated metal frame, plywood, lami-
nated beech, foam upholstery covered in
Velbex plastic, 89 cm × 45.5 cm × 39.5 cm
(35" × 18" × 15½")
PUBLISHED Kandya sales catalogue, 1966

F40
Lucien R. Ercolani (1888–1976: see
Biography page 124) for Ercol Furniture Ltd,
High Wycombe
376 side chair, early 1950s
Beech, elm, 79 cm × 45.5 cm × 40.5 cm
(31" × 18" × 16")
Impressed British Standard kite mark to
underside and printed stamp *75*
PUBLISHED Ercol sales catalogue, August
1958

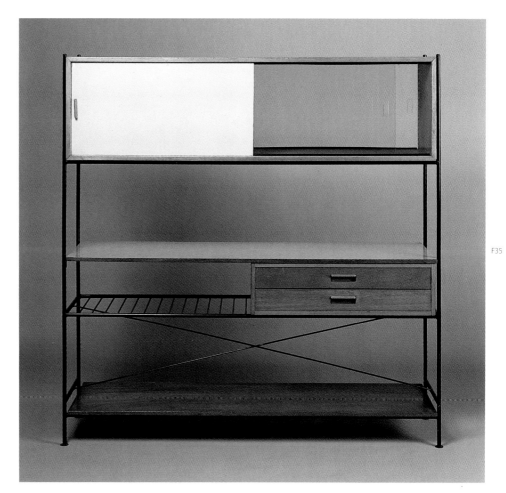

F35

F41
Lucien R. Ercolani for Ercol Furniture
Ltd, High Wycombe
401 side chair, *ca.* 1957
Beech, plywood with elm veneer, 75 cm ×
44 cm × 42 cm (29½" × 17¼" × 16½")
Foil label to underframe, *Ercol, made in
England* with logo, printed stamp *Beds C.C.*
and *County Library*
PUBLISHED Ercol sales catalogue, August
1958

F42
Lucien R. Ercolani for Ercol Furniture
Ltd, High Wycombe
355 studio couch, 1957
Beech, elm, painted metal, Pirelli rubber
webbing straps, foam cushion covered in a
woven material, 73.5 cm × 202.5 cm × 76
cm (29" × 81" × 30")
PUBLISHED Ercol sales catalogue, August
1958

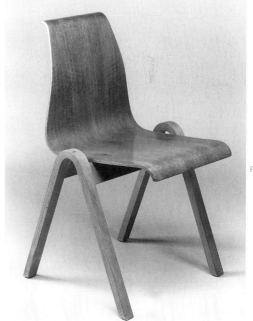

F38

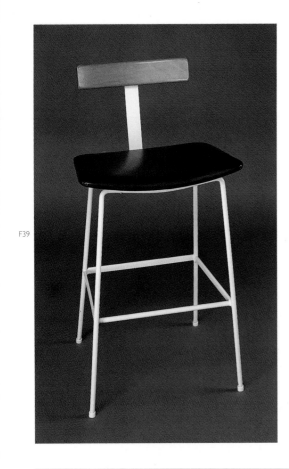

F39

F43
Lucien R. Ercolani for Ercol Furniture
Ltd, High Wycombe
Lounger chair with ottoman, 1960
Beech, elm, Pirelli rubber webbing straps,
foam upholstery covered in cotton canvas,
lounger 78.5 cm × 71 cm × 96.5 cm (31″ ×
28″ × 38″); ottoman 35.5 cm × 53.5 cm ×
66 cm (14″ × 21″ × 26″)
Foil label to frame *Ercol, made in England*
and company logo, printed patent and regis-
tration marks
PUBLISHED *Design*, no. 156, December
1961, p. 25

F44
Lucien R. Ercolani for Ercol Furniture
Ltd, High Wycombe
Windsor armchair, before 1960
Painted beech and elm, 102 cm × 61 cm ×
53.5 cm (40³/₄″ × 24″ × 21″)
Foil label to underside *Ercol, made in
England*, company logo and a stamped 7

PUBLISHED *Furniture in Britain Today*, 1964,
plate 108

F45
Sir Terence Conran (1931–) for
Conran Furniture Ltd, London
Side chair, *ca.* 1955
Painted steel-rod, plywood, upholstery cov-
ered in moquette, height 81.5 cm (32″)
PUBLISHED *Design*, no. 105, September
1957, p. 18, plate 6. Price £6. 8s. 9d.

F46
W.H. Russell for Gordon Russell Ltd,
Broadway
X6409 armchair, 1949
Mahogany with coil-sprung upholstered seat,
88.5 cm × 56.5 cm × 47 cm (34³/₄″ × 22¹/₄″
× 18¹/₂″)
Brass label to underside, *Gordon Russell Ltd,
Broadway, Worcs* and logo
PUBLISHED *Designers in Britain*, 1951, vol.
3, p. 198

F47
David Booth and **Judith
Ledeboer** for Gordon Russell Ltd,
Broadway
Sideboard, 1950
Mahogany with Bombay rosewood veneer
cut to reveal white birch, brass fittings,
84 cm × 120 cm × 45.5 cm (33″ × 48″ ×
18″)
Brass label to underside, *Gordon Russell Ltd,
Broadway, Worcs*
EXHIBITED 'Festival of Britain' (Homes &
Gardens Pavilion)
PUBLISHED *Studio Yearbook of Decorative
Art*, 1952–53, p. 50

F48
Trevor Chinn for Gordon Russell Ltd,
Broadway
R611–6 low coffee table, 1957
Mahogany and beech, 88.5 cm × 56.5 cm ×
47 cm (34³/₄″ × 22¹/₄″ × 18¹/₂″)
Brass label to underside, *Gordon Russell Ltd,
Broadway, Worcs* and logo

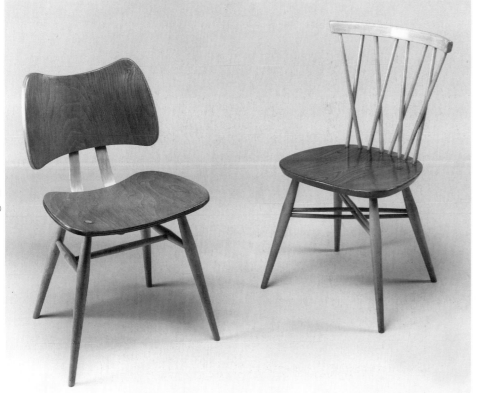

F41
F40

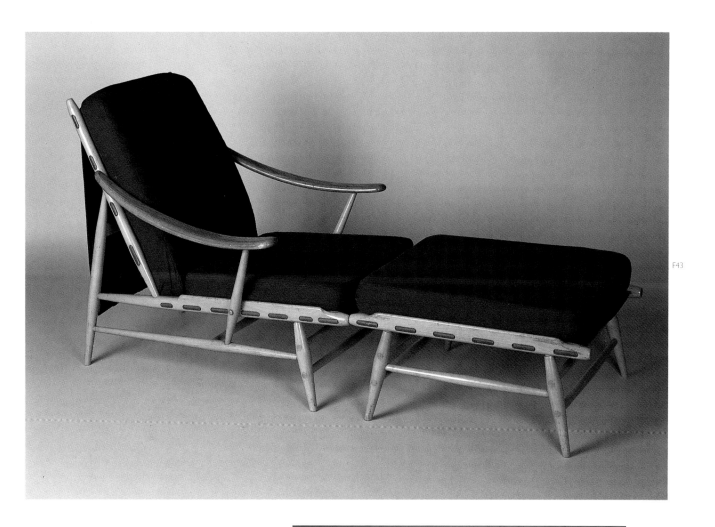

F43

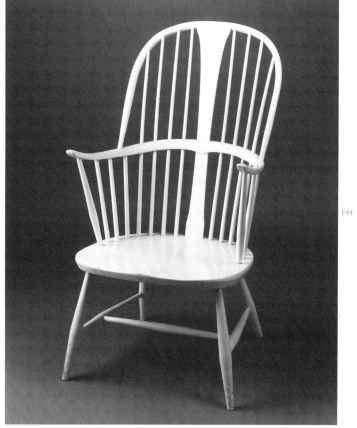

F44

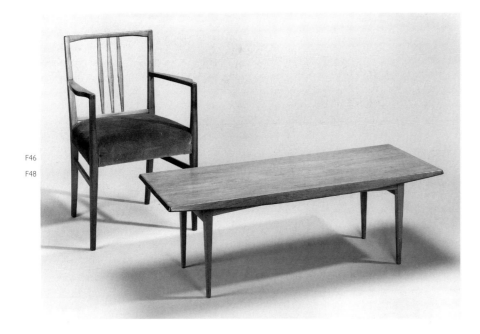

F46
F48

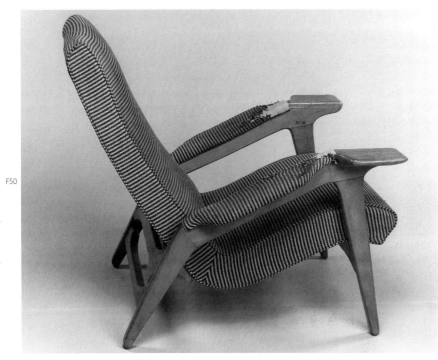

F50

F49
Prof. R.D. Russell (1903–1981) for
Gordon Russell Ltd, Broadway
Chair designed for Coventry Cathedral,
1960
Oak, 61 cm x 66 cm x 71 cm (24" x 26"
x 28")
PUBLISHED *Furniture in Britain Today*, 1964,
plates 67–69
LENT BY Andrew McIntosh Patrick

F50
Andrew John Milne for E. Horace
Holme Ltd, Camden Town
Reclining lounge chair, *ca.* 1950
Beech, upholstery covered in woven cotton
material, 81.5 cm x 77.5 cm x 81.5 cm
(32" x 30½" x 32")
Ivorine plaque to frame, *Holme Oak, E.
Horace Holme Ltd, Camden Town, London
NW1.* Cloth label with utility mark and
remnants of retailer's label
PUBLISHED Noel Carrington, *Design &
Decoration in the Home*, 1952, p. 60

F50a
Andrew John Milne for Heal & Son
Ltd.
Armchair, *ca.* 1950
Painted, perforated steel sheet and rod,
77 cm x 58 cm x 71 cm (31" x 22¾" x 28")
This chair was designed by Milne for use at
the 'Festival of Britain' and was Heal's princi-
pal contribution to the Festival.
PUBLISHED *The Architectural Review*, vol.
110, no. 656, August 1951, p. 119

F51
Andrew John Milne for Heal & Sons
Ltd
Dining room suite, *ca.* 1953
Solid and veneered rosewood, mahogany
and brass, table 71 cm x 315 cm x 1148 cm
(28" x 126" x 45½"); chair 90.5 cm x 56 cm
x 58.5 cm (35½" x 22" x 23"); sideboard 90
cm x 180 cm x 51 cm (35½" x 72" x 20")
PUBLISHED S.H. Glenister, *Contemporary
Design in Woodwork*, 1955, p. 19 (chair); *The
Daily Mail Ideal Home Book*, 1957, p. 73
(suite)
Heal's chose to depict the chair from this
suite under the heading Chair Makers on the

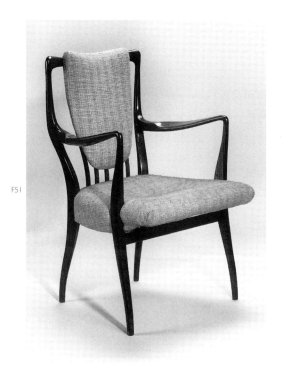

F51

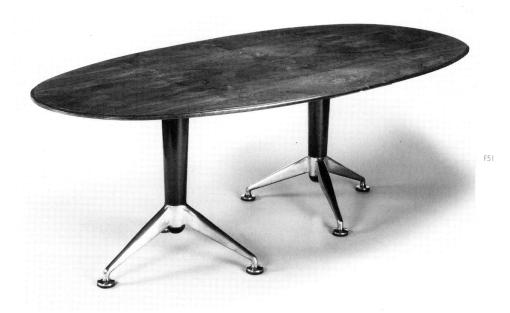

F51

F52

ceramic frieze of trade sign panels by John Farleigh, which extends across the façade of the Heal's extension, completed in 1962 A.J. Milne's close links with Heal's during the 1950s may, in part, be explained by his teaching in the interior design department of the Central School of Arts & Crafts, London, under Nigel Walters who was head of the department. Walters, like Milne, also produced many furniture designs for Heal's. Milne, Walters, H.E. Long and Robert Heritage, under Christopher Heal's direction, appear to have constituted the Heal's design team during the 1950s

F52
(Attrib.) **Andrew John Milne**, probably for Heal & Sons Ltd
Breakfast table, mid 1950s
Painted steel, plywood, particle board, plastic laminate, 73.5 cm x 134 cm x 75 cm (29″ x 53½″ x 29½″)
Laminate designed by Jacqueline Groag for Warerite Ltd. A related laminate by Groag is illustrated on p. 79 of *Decorative Art in Modern Interiors*, 1961, a Studio Book production. The form of the table's base is closely related to that of Milne's table of *ca.* 1953. Both Milne and Christopher Heal designed much elegant furniture in black-painted metal for Heal's during the 1950s

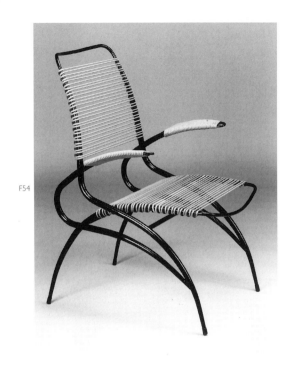

F54

F53

The 'Lusty' Design Studio for
Lusty & Co. Ltd
Armchair from the Boulevard range,
ca. 1955
Painted extruded metal tubing with plastic
strung seat, 79 cm x 51 cm x 56 cm (31" x
20" x 22")
Transfer to frame *Boulevard a Lusty product*
Lusty & Co. manufactured the well known
Lloyd Loom range of furniture

F54

The 'Lusty' Design Studio for
Lusty & Co. Ltd
Armchair from the Boulevard range, *ca.*
1955
Painted extruded metal tubing with plastic

strung seat, 88.5 cm x 69 cm x 70 cm
(34³/₄" x 27¹/₄" x 27¹/₂")
Remnants of Lusty transfer to frame

F55

Ewart Myer for Horatio Myer & Co Ltd
Occasional table, 1953
Beech, plywood and removeable ceramic
bowl by Denby Pottery, 48.5 cm x 77 cm x
45.5 cm (19" x 30¹/₄" x 18")
Foil label to underside *Myers*
PUBLISHED *Design*, no. 62, February 1954,
p. 11

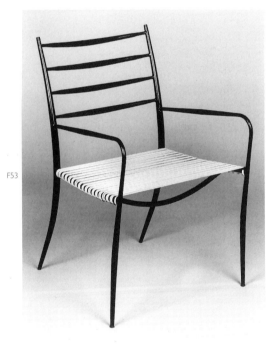

F53

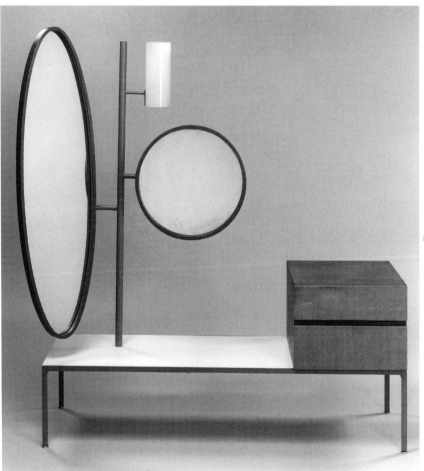

F59

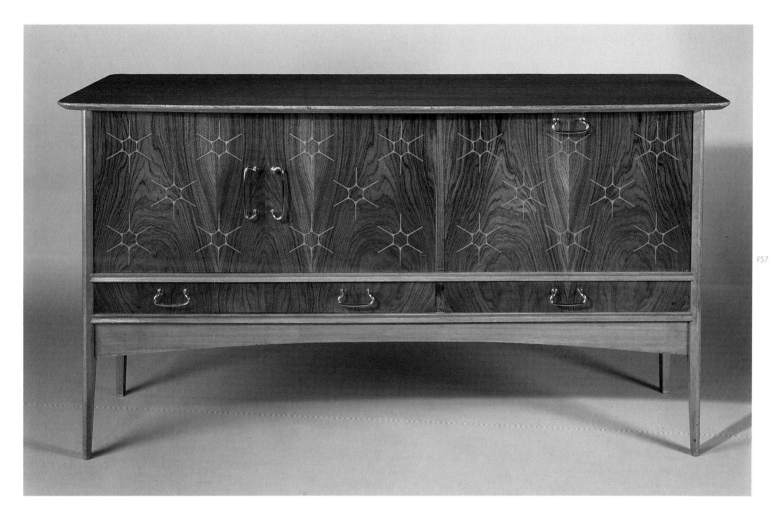

F57

F56
Unknown designer for Waring & Gillow
Hallstand, mid 1950s
Laminated and solid wood with veneer,
brass, height 182.5 cm (73½")
Printed stamp to underside *Waring & Gillow*
and braised marks *E.R* and a crown
This hallstand was made as contract furni-
ture for use in government buildings

F57
Peter Hayward for W.G. Evans &
Sons Ltd, London
Sideboard, *ca.* 1953–54
Painted and grained mahogany, rosewood
veneer routed to reveal birch laminate,
glass, brass, 86.5 cm x 164 cm x 53.5 cm
(34" x 65½" x 21")
PUBLISHED *The Daily Mail Ideal Home
Book*, 1956, p. 115

F58
Robert Heritage (1927–) for Archie
Shine Ltd, London
Hamilton sideboard, 1956–57
Mahogany, rosewood veneer, brass, 76 cm x
225 cm x 51 cm (30" x 90" x 20")
Metal label to back *A Shine Product*
PUBLISHED *Design*, no. 110, February
1958, p. 39. Price £60. 12s. 8d.
Design Centre Award, 1958

F59
Nigel V. Walters for Heal & Sons Ltd
Dressing table, 1958
Painted metal frame, solid and plywood,
with plastic laminate and cedar of Lebanon
veneer, mirror glass, acrylic and grass cloth,
153 cm x 135 cm x 47 cm (61" x 54" x
18½")
PUBLISHED Susannah Goodden, *At the Sign
of the Four Poster – A History of Heal's*, 1984,
p. 116

Walters frequently designed furniture for
Heal's. He was head of the Interior Design
department at the Central School of Arts &
Crafts, London

F60
John Reid (1925–1992) and **Sylvia
Reid** for the Stag Cabinet Co. Ltd,
Nottingham
S320 dining table and chairs, *ca.* 1959
Table, stainless steel, teak; chairs, stainless
steel, afromosia, latex foam covered in
leather; table 69 cm x 190 cm x 99.5 cm
(27¼" x 76" x 39¼"); chair 78 cm x 42 cm
x 51 cm (30¾" x 16½" x 20")
Metal label to underside *Stag Furniture* and
logo
PUBLISHED *House & Garden*, May 1960, p.
15. Price of chair July 1960 £8. 15s. 0d.

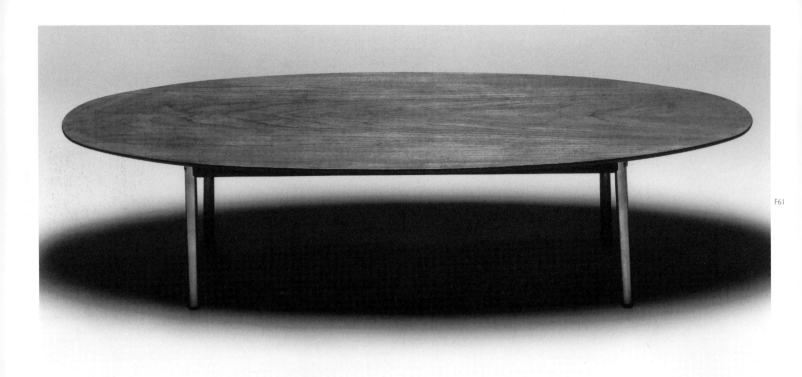

F61

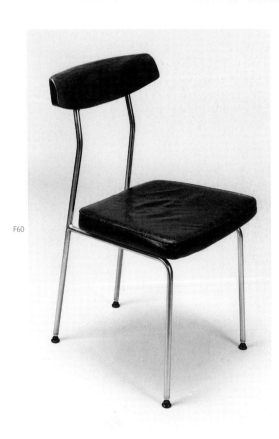

F60

F61
John Reid and **Sylvia Reid** for the
Stag Cabinet Co. Ltd, Nottingham
Low coffee table, *ca.* 1959
Stainless steel, laminated wood with teak
veneer, 32.5 cm x 149 cm x 49.5 cm (12³/₄″
x 59¹/₂″ x 19¹/₂″)
Metal label to underside *Stag Furniture* and
logo

F62
David W. Pye (1914–1996)
Inscribed wooden bowl, *ca.* 1962
Rosewood, diameter 35.5 cm (14″)
Incised carving to rim, *Alex Gardner-Medwin
CoID. 1948–1962*
LENT BY Alexander Gardner-Medwin
David Pye, as Professor of Furniture at the
RCA, was influential in bringing about the
post-war craft revival in furniture-making.
He was particularly well known for his
handcrafted wooden bowls. This particular
bowl was commissioned by the members of
the Council of Industrial Design as a
farewell gift to Alexander Gardner-Medwin,
Principal Design Officer of the CoID, who
subsequently became a director of Race
Furniture Ltd

Textile Design

RICHARD CHAMBERLAIN

The post-war era witnessed a resurgence in the vitality, inventiveness and originality of British textile design, unequalled since the achievements of the Aesthetic and Arts and Crafts movements of the late nineteenth century. This was in part due to an extensive and committed body of painters, sculptors and architects, as well as a distinguished group of *émigré* textile designers, becoming increasingly involved within the industry.

In the austerity period immediately following the War, few textiles, other than those conforming to the Utility standards of the Board of Trade, or made for export, were available. The eminent textile designer Enid Marx was commissioned by the Board of Trade, between 1943 and 1947, to design a series of Utility furnishing textiles with small-scale patterns, woven in cotton. Marianne Straub also designed textiles which conformed to the Utility standard, many of which were chosen by Ernest Race as coverings for his furniture. Within the restrictions of the severely limited resources available to them, Marx and Straub had managed to produce an impressive range of fabrics by achieving, through a number of ingenious solutions, a wide variety of different effects from the same basic cloth.

Dress fabrics had been as severely affected by wartime conditions as furnishing textiles, with a meagre production of prints, mainly destined for export. In these limited circumstances, the headscarf's inexpensiveness, easy availability and adaptability brought it to the fore as the principal fashion accessory following the War. The year 1945 witnessed its apogee as style icon, in a fusion of fine and applied art at a highly prestigious level, with the introduction of 'artist squares' by the husband-and-wife team of Zika and Lida Ascher. They had settled in London in 1939 following the annexation of their home country, Czechoslovakia. In 1942 they founded Ascher (London) Ltd, which quickly established a high and exclusive profile for itself within the design and fashion world.

This was initially brought about by Ascher's confident commissioning of designs from leading artists of the modern movement. The first 'artist squares', *London 1944* and *Coloured checks*, were the work of the Polish *émigré* painter Feliks Topolski. In 1946 Ascher added designs by Graham Sutherland and Henry Moore to the range. Designs by these eminent artists and others by Lida Ascher and the Ascher studio formed the central focus of Ascher's displays at the highly influential 'Britain Can Make It' exhibition.

Translating the artists' designs into successfully printed squares was a long and painstaking process involving many months of experimentation to overcome the lack of suitable materials, inks and dyes. The designs of the squares were in the new Contemporary style and had a seminal influence on the development of British textile design of the period. Graham Sutherland's design, *Black trellis*, a dynamic *tachiste*-like rendering of the subject, anticipates Jackson Pollock's drip paintings of the later 1940s and early 1950s. The design was starkly executed in black and printed on rayon dyed in a variety of cool pastel shades.

The importance of the Ascher company's reputation was cemented in the autumn of 1947 with an exhibition of thirty-seven artist squares held at the Lefèvre Galleries, London. By that time the collection had been greatly expanded to include designs by Matisse, Cocteau, Hepworth, Nicholson and Piper. Many of these were issued as limited editions and shown framed and displayed on easels. A review of the exhibition in *The Observer* (14 September 1947) described them as "a dazzling spectacle".[1]

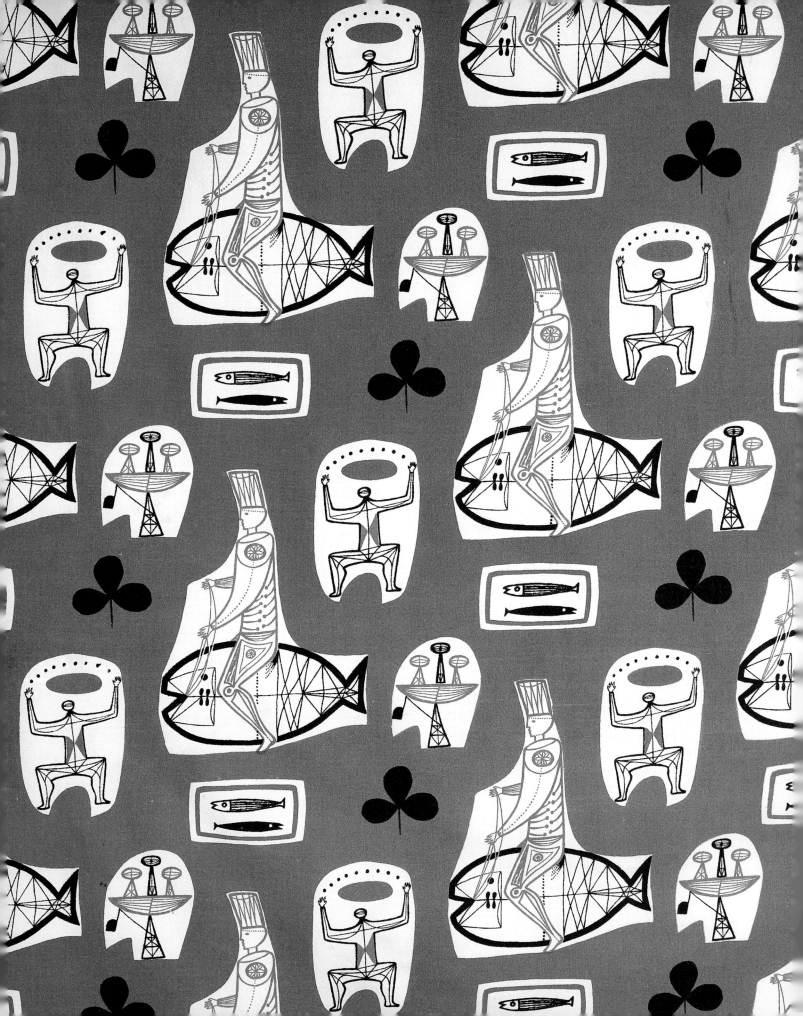

In the second half of the 1940s Michael O'Connell, a close associate of Henry Moore, brought a unique craft-based approach to post-war textiles. Whilst producing designs for block-printed fabrics for Heal's, O'Connell perfected the use of batik and painting with dyes to create 'tapestries' and wall-hangings in a high Contemporary idiom. Examples of these individual works of textile art were commissioned for the entrance hall of Australia House in London, the Time Life Building in London and for the home of the designer Ashley Havinden.[2]

British textile design in the 1940s continued to expand on the theme of organic modernism, already developed in Britain in the late 1930s by designers and artists such as Havinden and Moore. This continuing development was particularly facilitated in the later 1940s by the work of three leading *émigré* designers, Jacqueline Groag, Marian Mahler and Marianne Straub.

Groag, who had previously studied under Josef Hoffmann at the Kunstgewerbeschule in Vienna, and designed for the Wiener Werkstätte, fled to Paris in 1937 with her husband, the architect Jacques Groag, before finally settling in London in 1939. She was influential in setting the agenda for post-war Contemporary British textile design, successfully adapting her highly individual design repertoire to a variety of mediums, including textiles, plastic laminates, carpets and wallpapers.

Design magazine, in January 1951, illustrated what is probably Groag's most important textile design of the 1940s (cat. T5). This randomly spaced design makes a splendid use of collage, somewhat akin to the cut-outs of Matisse. It was commissioned in 1948 by the architect Dennis Lennon for use in the interior of the Rayon Design Centre, housed in a large Georgian mansion in Mayfair.

Groag's design was intended to harmonize with and to reflect the subtle colouring and style of the building's ornamental plasterwork.[3] This textile was subsequently produced commercially by David Whitehead Ltd, who included it on their display of twenty textiles at the 'Festival of Britain'.

Marianne Mahler, like Groag, had studied at the Kunstgewerbeschule before attending the Royal State Academy in Vienna between 1929 and 1932. She arrived in Britain in around 1937. Her woven and printed designs were derived from a wide variety of sources that ranged from a slightly irreverent and witty interpretation of classical motifs, such as centaurs and temples, to the purely abstract.

An outstanding example of Mahler's work from the 1940s, La Chasse, draws on yet another favoured theme, that of folk art. Designed for the Edinburgh Weavers in about 1948, La Chasse depicts elements of a hunting scene in a Contemporary interpretation of the woodblock. This textile is a *tour de force* of Mahler's influential signature use of skeletal vegetation and figures, outlined within organic forms.

Marianne Straub originally came to Britain from Switzerland in 1932 to study the machine production of woven textiles. Her later involvement with textile design in the Contemporary period centres initially on her work for the Helios company, for whom she was head designer from 1937 until the company's takeover in 1950 by Warner Fabrics Ltd. She continued to design for Warners until 1970.

From 1949 preparations were being made for the 1951 'Festival of Britain' which included the establishment of the Festival Pattern Group. The inspiration for this collaboration between science and design had its origins in the microscopic study of molecular structures. These, and

the geometric forms of crystals and minerals, became central to the style now associated with the South Bank exhibition. Diagrams of crystalline structures were prepared by Dr Helen Megaw of Girton College, Cambridge, for use as a source of inspiration for members of the Society of Industrial Artists, under the auspices of Mark Hartland Thomas.[4] From these diagrams Straub produced two designs for Warners derived from the structures of afwillite and nylon. The resulting textiles, Surrey and Helmsley, were accompanied by other molecular- and crystallography-inspired designs by the then director of Warners, Alec Hunter. In keeping with the scientific orientation of the Festival, Hunter's Harwell textile was named after a power station. All these textiles were used in the prestigious Regatta restaurant,[5] a focus for much of the design used at the Festival which was derived from molecular and crystalline structures. The stylistic traits resulting from the work of the Festival Pattern Group were rapidly absorbed into textile design.

The 1951 'Festival of Britain' also provided a platform for the work of Lucienne Day, probably the most celebrated and influential textile designer to emerge in Britain this century. The wife of the designer Robin Day, she commenced her career following the completion of her studies at the Royal College of Art in 1940. However, it was not until the launch at the 'Festival of Britain' of her seminally important textile Calyx that she first emerged into the spotlight.

Day had developed Calyx for use in a room-set at the Festival designed by her husband. Its production had been reluctantly sponsored by Heal's. Tom Worthington, Heal's design director, initially commissioned it more in a spirit of benevolent patronage than from a belief in its commercial viability. Calyx is a near

perfect expression of the Contemporary aesthetic in design. It was awarded a gold medal in 1951 at the Milan Triennale and in 1952 won the International Design Award of the American Institute of Decorators. Jennifer Harris considers it to be "justifiably regarded as a landmark in the history of twentieth-century design".[6]

Throughout the 1950s Day produced an unrivalled sequence of inventive and highly influential textiles for Heal's Fabrics Ltd. In 1954 she took the Gran Premio award at the Milan Triennale for a group of four textiles for Heal's: Tickertape, Spectators, Linear and Graphica. Of Day's commissions, other than those for Heal's, some of the most celebrated are her designs for British Celanese Ltd, executed between 1952 and 1953. They were expressly designed to be printed on cellulose acetate taffeta and were marketed by Sanderson.

Day's talents were employed by a wide and disparate clientele both at home and abroad, for whom she designed ranges of wallpapers, plastic laminates and carpets, as well as ceramics for the German porcelain manufacturer Rosenthal. The stylistic lead given by Day was quickly taken up by a host of companies which resulted in the rapid emergence of a general Festival style spreading throughout the textile industry. Many companies, which included Turnbull and Stockdale, Gayonnes and Grafton, produced work in this new aesthetic.

Liberty's, the doyen of avantgarde textiles at the beginning of this century, extended the scope of their by then classic ranges by employing Robert Stewart, a young Scottish painter and designer. Stewart was head of printed textiles at the Glasgow School of Art and also designed fabrics for Donald Brothers and the Edinburgh Tapestry Company, as well as supplying Liberty's with textile designs which were marketed as the Young

Liberty range.[7] Macrohamish, a screen-printed cotton, illustrates Stewart's surreal and witty interpretation of the Festival style, a style closely related in its gentle irony and whimsical humour to that of Roland Emmett.

The newly revitalized firm of David Whitehead Ltd used the 'Festival of Britain' as a springboard to launch their first major collection of Contemporary designs and quickly established themselves as market leaders. Under the direction of the architect John T. Murray, Whitehead became a pivotal link between progressive textile design and the general public, creating a company policy of making good modern design accessible to all.[8]

Whitehead's textiles were designed with small-scale patterns for use in the limited spaces of new modern housing and as backdrops for the light Contemporary furnishings of their interiors. To facilitate Whitehead's design agenda, John Murray quickly enlisted the talents of Jacqueline Groag, Marian Mahler and the young Terence Conran, who had recently completed his course of studies in textile design at the Central School of Art and Design, London. Both Conran and Groag contributed designs for Whitehead's display at the 'Festival of Britain', Conran designing Chequers, a pattern he was later to adapt for use on Midwinter ceramics. Groag modified her 1948 design for the Rayon Centre for inclusion in Whitehead's Festival display. She later created for the company a version of the textile originally designed for the Festival Information Centre at Swan & Edgar's Department Store.

An influence on Conran's work and a key figure in the development of Contemporary textile design was the sculptor Eduardo Paolozzi. Following a brief spell in Paris, Paolozzi returned to London in 1949, where he taught textile design at the Central School of Art and

Design until 1955. Shortly after Conran finished his studies he joined forces with Paolozzi, working in a studio they had set up for the production of textile design, metal furniture and ceramics. Paolozzi made great use of collage and textures in his designs for textiles and wallpapers, which reflected the influence of his primary mode of expression, sculpture. His introduction of the representation of texture into textile design was important for its development later in the decade.

Paolozzi's textile (cat. T17) for Whitehead of 1952 consists of an eclectic assortment of sculptural motifs and textural representations randomly collaged in a design haphazardly dispersed across the fabric. This design heralded the changing tide in textile design that occurred in the mid 1950s. Until the middle of the decade the work of trained textile designers dominated. They had created a strong, two-dimensional graphic style closely associated with the 'Festival of Britain', but as the decade proceeded they steadily moved away from this.

Of seminal importance in this development, of what was essentially a new aesthetic, is the influential exhibition 'Painting into Textiles' of 1953. This exhibition, held at the Institute of Contemporary Art, was sponsored by *The Ambassador* magazine. Twenty-five artists were commissioned to produce work that it was hoped would assist in stimulating fresh approaches to textile design. Importantly, David Whitehead purchased the work of six artists. The resulting textile designs, some derived from the work of Paule Vézelay, Henry Moore and Cawthra Mulock, were well received at their launch in 1954. Encouraged by this success, in 1955 Whitehead commissioned designs from John Piper, which included Foliate Heads and Church Monuments. Further artist textiles were commissioned by Whitehead from the American sculptor

Mitzi Cunliffe and the painter Louis le Brocquy.[9]

Flat, linear patterns and spikey molecular motifs gave way to an essentially abstract and painterly style in which textural representation played a large part. Textile designers responded to the lead given by artists and began to work in this new painterly aesthetic. Pattern repeats grew ever larger in scale or provided purely abstract textured backgrounds for the furnishings of a room. The painter Harold Cohen executed designs for Heal's, such as Rough Cast and Vineyard, that are the epitome of this style. Tibor Reich, founder of Tibor Ltd, made a particular feature of texture in the numerous fabrics he designed, largely for use in the contract sector of the market.

The scale and content of textile design was increasingly determined by the needs of corporate and institutional patrons, rather than those of a purely domestic nature. Corporate boardrooms, libraries and lecture halls of new universities, and the public spaces of civic centres and new hotels, demanded textiles of a large magnificence in the fashionable painterly, abstract style. Long-established companies such as the Edinburgh Weavers and Sanderson commissioned the work of leading artists for translation into textiles, which were by now developing as a fine-art medium.

In 1959, as part of their centenary celebrations in 1960, Sanderson commissioned five designs from John Piper.[10] Piper chose to translate paintings of architectural subjects such as the Salute Church in Venice, stained-glass windows at Arundel Castle and studies of Bath. The resulting majestically proportioned patterns presented a rich spectacle.

This synthesis of exclusive modern art and luxurious execution reached a pinnacle in about 1960 in the hands of the Edinburgh Weavers. The painter Alan Reynolds was one of a number of leading British painters commissioned by the Edinburgh Weavers to produce designs for a series of jacquard tapestry weaves. The range also included textiles by William Scott. Reynolds's *Crystalline Abstract* was translated into a woven textile of considerable presence. In the quality of its impact it relates to the unique woven, stitched and appliquéd textiles beginning to be commissioned for the many new churches then being built.

The greatest example of this is Graham Sutherland's tapestry, *Christ in Glory*, commissioned by its architect Sir Basil Spence as the focal point of the new Coventry Cathedral. Works of art commissioned for its interior inspired a revival in the design of ecclesiastical textiles which was facilitated by a resurgence of patronage both at a corporate and individual level. For the first time since the Arts and Crafts movement the traditional skills of sewing, embroidery, appliqué and quilting began to move to the fore in art school teaching as suitable vehicles for major artistic expression.[11] Many well known painters and designers in other fields, such as John Piper and Margaret Traheme, also began to design work for execution in these media.

Included in the 1962 exhibition, 'Artists Serve the Church', organized as part of the Coventry Cathedral festival, was the work of Susan Riley. She was amongst the first of a talented new generation then beginning to emerge from art colleges. Two major works by Riley were shown at the exhibition: the *Three Kings* wall-hanging, now in the collection of the National Museum of Scotland, and a sumptuously worked chasuble. She also developed work at a domestic level, creating original inventive and witty designs for curtains and table covers, dresses and fashion accessories.

The renaissance in all fields of textile design in Britain was generated in the energy released at the end of the War. Textile design in the early 1960s reached heights of splendour unimaginable in the austerity of the 1940s. The huge architectural scale of textiles, such as Howard Carter's design for Heal's of 1961, Sunflower, and the revival of craft techniques in creating unique pieces give some indication of the direction textile design was to take in the 'pop' sixties. In the post-war era Britain was a world leader in textile design. The work of designers like Day, Groag and Mahler, and painters and sculptors such as Piper and Paolozzi, is one of Britain's greatest achievements in the applied arts this century.

1 *Ascher. Fabric. Art. Fashion,* exhib. cat., edd. Valerie D. Mendes and Frances M. Hinchcliffe, London, Victoria and Albert Museum, 1987, p. 28.

2 Hangings and related work by O'Connell are illustrated in: 'Decorative Art', *The Studio Yearbook, 1943–1948*, p. 78; 'Decorative Art', *The Studio Yearbook, 1951–1952*, p. 115; *House & Garden*, vol. 5, no. 2, March 1951, p. 39.

3 'Dennis Lennon', *Contemporary Designers*, ed. Morgan Ann Lee, London (Macmillan) 1984, p. 357.

4 Frances Hinchcliffe, *Fifties Furnishing Fabrics*, Exeter (Webb & Bower) 1989, p. 9.

5 'A Choice of Design 1850–1980, Fabrics by Warner & Son Ltd' exhib. cat., ed. Hester Bury, travelling exhibition (Warner & Sons Ltd) 1986, p. 45.

6 *Lucienne Day: A Career in Design*, exhib. cat., ed. Jennifer Harris, Manchester, The Whitworth Art Gallery, 1993, p. 20.

7 Ed. Ruari Mclean, *Motif, A Journal of the Visual Arts*, no. 2, February 1959, p. 49

8 John Murray, 'The Cheap Need Not be Cheap and Nasty', *Design*, December 1950.

9 Alan Peat, *David Whitehead Ltd. Artist Designed Textiles, 1952–1969*, Oldham (Oldham Leisure Services) 1993, p. 16.

10 Sanderson Archive, 1996.

11 Susan Riley, interview with the author 9.12.96.

T1

Feliks Topolski (1907–1989) for
Ascher Ltd, London
London 1944, headsquare, *ca.* 1945
Screen-printed rayon, 84.5 cm x 91.5 cm
(33¼" x 36")
An example exhibited 'Ascher. Fabric. Art.
Fashion', Victoria and Albert Museum,
London, 1987
PUBLISHED *Illustrated*, 28 July 1945, front
cover

T2

Feliks Topolski for Ascher Ltd,
London
Coloured checks, headsquare, 1945
Screen-printed rayon crêpe, 84 cm x 86.5
cm (33" x 34")
An example exhibited 'Ascher. Fabric. Art.
Fashion', Victoria and Albert Museum, 1987
PUBLISHED *'Ascher. Fabric. Art. Fashion'*,
1987, p. 47

T3

Graham Sutherland (1903–1980)
for Ascher Ltd, London
Black trellis, headsquare, 1946

Screen-printed rayon, 84 cm (33") square
An example exhibited 'Britain Can Make It'
(supplementary catalogue, p. 176, group J,
no. 402, for two Sutherland squares);
'Ascher. Fabric. Art. Fashion', Victoria and
Albert Museum, London, 1987

T4

Michael O'Connell
Wall-hanging, *ca.* 1949
Batik and dye-painted woven textile, length
152.5 cm (60")
Signed to front *Mael*
PUBLISHED For related examples, *The
Studio Yearbook of Decorative Art*, 1943–48,
p. 78; *The Studio Yearbook of Decorative Art*,
1951–52, p. 115
PROVENANCE Trevor Chamberlain,
purchased from the artist

T5

Jacqueline Groag (1903–1986: see
Biography page 125) for David Whitehead
Ltd, Rawtenstall
Design of columns, urns and church win-
dows. Designed 1948, produced as a
Whitehead textile 1950

Roller-printed rayon, 35.5 cm (14") repeat
EXHIBITED 'David Whitehead Ltd, Artist
Designed Textiles 1952–1969', Oldham Art
Gallery, 1993
PUBLISHED *Design*, no. 25, January 1951,
p. 19
Originally commissioned in 1948 by the
architect Dennis Lennon for the Rayon
Design Centre. Subsequently modified, it
was one of twenty textiles David
Whitehead exhibited at the 'Festival'

T6

Jacqueline Groag for David
Whitehead Ltd, Rawtenstall
Abstract design, *ca.* 1952
Roller-printed rayon, 39.5 cm (15½") repeat
An example exhibited 'David Whitehead
Ltd, Artist Designed Textiles 1952–1969',
Oldham Art Gallery, 1993
PUBLISHED *Fifties Furnishing Fabrics*, 1989,
plate 24
This textile is a version of the one which
hung in the Festival Information Centre at
Swan & Edgar's department store

T1

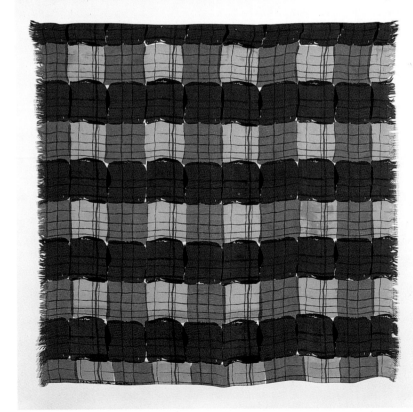

T2

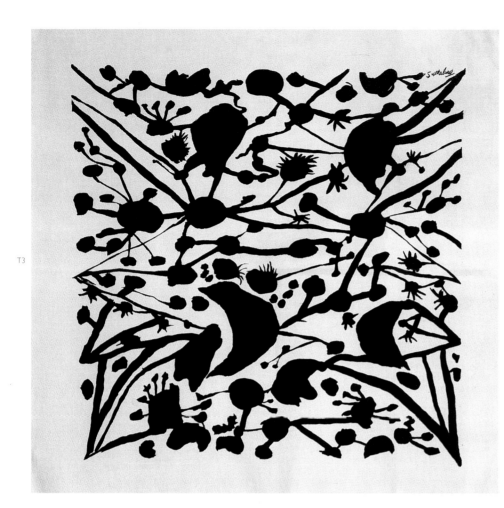

T3

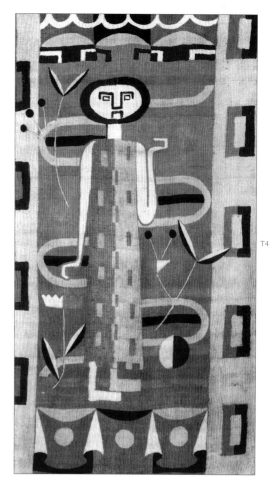

T4

T5

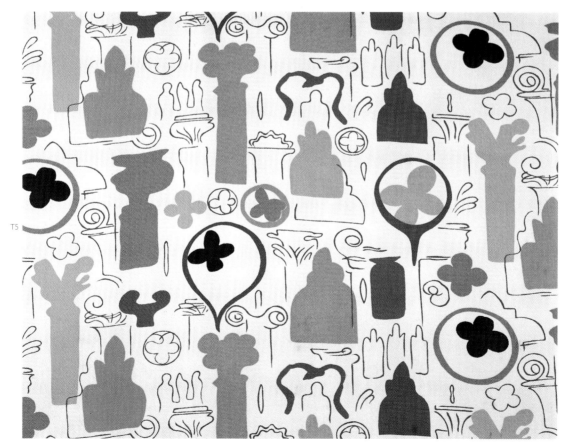

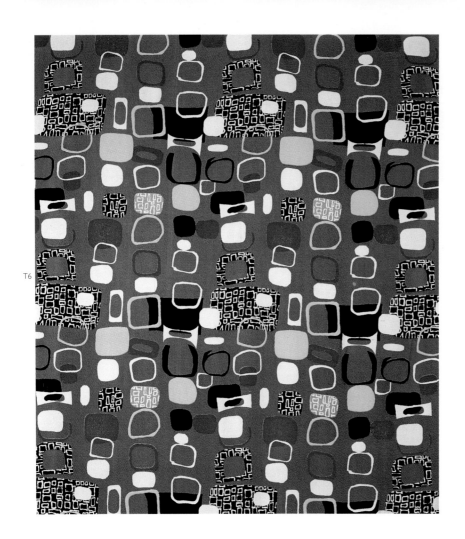

T6

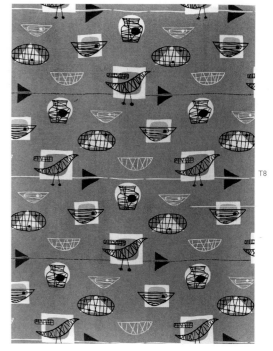

T8

T9

Marian Mahler for David Whitehead
Ltd, Rawtenstall
CP426, temple and centaur design, *ca.* 1953
Roller-printed rayon, 21.5 cm (8½″) repeat
An example exhibited 'David Whitehead
Ltd, Artist Designed Textiles 1952–1969',

T7

Marian Mahler (*ca.* 1911–*ca.* 1983: see
Biography page 125)
Artwork for La Chasse commissioned by
Edinburgh Weavers, *ca.* 1949
Paint on paper, 94 cm x 124.5 cm (37″
x 49″)
Hunting Scene and *All Vat Colors* written to
edge of artwork
PUBLISHED *The Studio Yearbook of
Decorative Art*, 1952–53, p. 83
LENT BY Courtaulds PLC

T8

Marian Mahler for David Whitehead
Ltd, Rawtenstall
Bird and bowl design, *ca.* 1952
Roller-printed rayon, 45.5 cm (18″) repeat
EXHIBITED 'David Whitehead Ltd, Artist
Designed Textiles 1952–1969', Oldham Art
Gallery, 1993
PUBLISHED Philippe Garner, *Contemporary
Decorative Arts*, 1980, p. 138

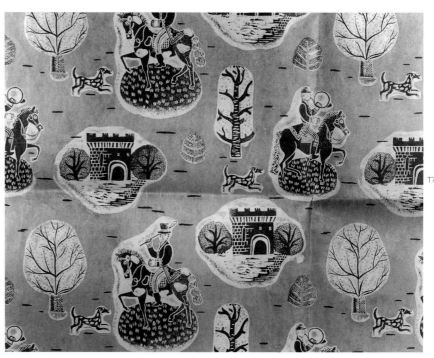

T7

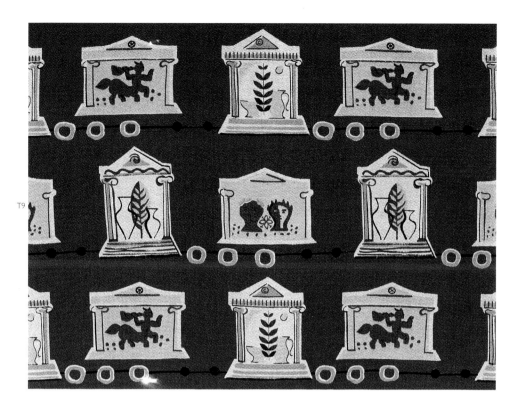

T9

T13

Oldham Art Gallery, 1993
PUBLISHED *Ideal Home*, May 1954, p. 128

T10
Marianne Straub (1909–1994) for
Warner & Sons Ltd, Braintree
Helmsley, 1951
Cotton gimp, mercerized cotton, 61 cm ×
112 cm (24″ × 44¼″)
EXHIBITED 'Festival of Britain'
LENT BY Warner Fabrics plc

T11
Marianne Straub for Warner & Sons
Ltd, Braintree
Surrey, 1951
Wool, cotton, rayon, 116 cm × 162 cm
(45½″ × 63¾″)
EXHIBITED 'Festival of Britain'
LENT BY Warner Fabrics plc

T12
Alec Hunter (1899–1958) for Warner
& Sons Ltd, Braintree
Harwell, 1951
Cotton gimp, rayon, mercerized cotton,
116 cm × 162 cm (45½″ × 63¾″)
EXHIBITED 'Festival of Britain'
LENT BY Warner Fabrics plc

T11

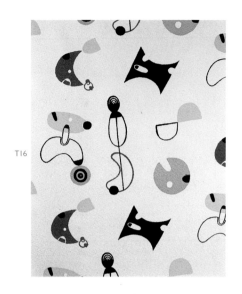

T16

T13
Unknown designer for David Whitehead
Ltd, Rawtenstall
Children's textile with design of TV controls
and screens displaying characters from the
'Muffin the Mule' show, early 1950s
Roller-printed rayon, 38.5 cm (15¹/₄") repeat
The 'Muffin the Mule' show was the first
major children's TV show of the post-war
era. It ran from 1946 to 1957

T14
(Attrib.) **Richard Guyatt** possibly for
Liberty's (manufacturer unknown)
Setting of three place mats, 1953
Screen-printed linen
These mats were made for use on
Coronation Day 1953. The style is very
close to Richard Guyatt's, in particular that
of his Coronation mug for Wedgwood. He
also carried out commissions for Liberty's at

this period. Guyatt was Professor of Graphic
Design at the Royal College of Art and was
also responsible for much of the internal
design and decoration of the Lion and
Unicorn Pavilion at the 'Festival of Britain'

T15
Sir Terence Conran (1931–) for
David Whitehead Ltd, Rawtenstall
Chequers, *ca.* 1951
Roller-printed rayon, 36 cm (14¹/₄") repeat
An example exhibited 'Festival of Britain'
PUBLISHED *House & Garden,* July 1955,
p. 17. Price 8s. 6d. per yard

T16
Sir Terence Conran for David
Whitehead Ltd, Rawtenstall
Abstract design, *ca.* 1952
Printed textured cotton, 56.5 cm (22¹/₄")
repeat

T17

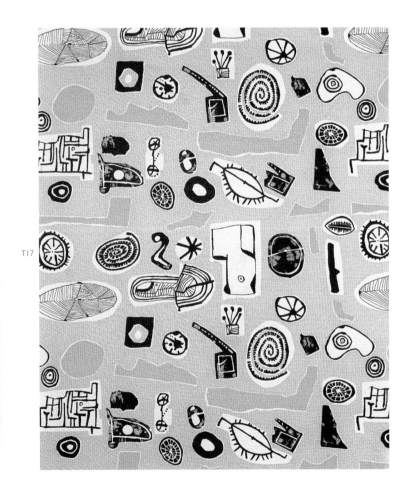

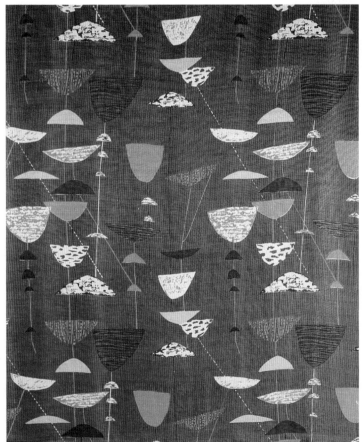

T18

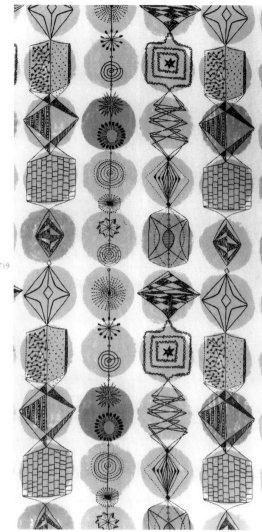

T19

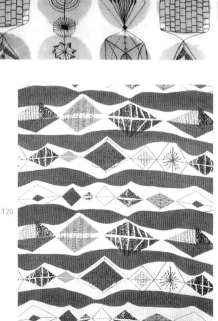

T20

PUBLISHED *The Studio Yearbook of Decorative Art*, 1953–54, p. 82

T17

Sir Eduardo Paolozzi (1924–) for David Whitehead Ltd, Rawtenstall
Collage design of random images, 1952
Roller-printed rayon, 44 cm (17¼") repeat
EXHIBITED 'David Whitehead Ltd, Artist Designed Textiles 1952–1969', Oldham Art Gallery, 1993
PUBLISHED *David Whitehead Ltd, Artist Designed Textiles 1952–1969*, 1993, p. 9

T18

Lucienne Day (1917–: see Biography page 125) for Heal's Wholesale & Export, Heal & Son Ltd
Calyx, 1951
Screen-printed linen, 66 cm (26") repeat
Printed marks to selvedge *Heal's Calyx by Lucienne Day* and company logo
An example exhibited 'Festival of Britain'; 'Design Since 1945', Philadelphia Museum of Art, 1983; 'Lucienne Day: A Career in Design', Whitworth Art Gallery, Manchester, 1993; 'Design of the Times – 100 Years of the Royal College of Art', Royal College of Art, London, 1996; The 9th Milan Triennale, 1951, awarded gold medal. Received the International Design Award of the American Institute of Decorators, 1952
PUBLISHED *The Studio Yearbook of Decorative Art*, 1952–53, p. 78

T19

Lucienne Day for British Celanese Ltd, marketed by A. Sanderson & Sons Ltd
Miscellany, 1952
Printed acetate rayon taffeta, 48 cm (19") repeat
An example exhibited 'Lucienne Day: A Career in Design', Whitworth Art Gallery, Manchester, 1993
PUBLISHED *Designers in Britain*, 1954, vol. 4, p. 40
When introduced the price for this range was between 12s. 0d. and 13s. 0d. per yard

T20

Lucienne Day for Heal's Wholesale & Export, Heal & Son Ltd
Allegro, 1952
Screen-printed linen, 41 cm (16¼") repeat

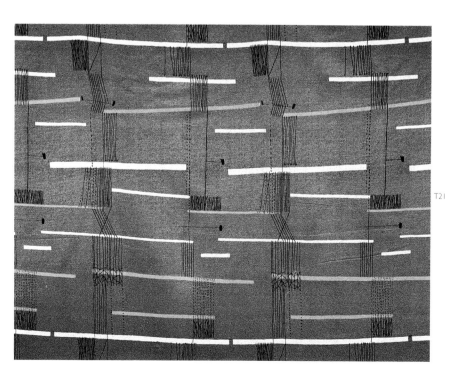

T21

Printed marks to selvedge *Heal's Allegro by Lucienne Day*
An example exhibited 'Lucienne Day: A Career in Design', Whitworth Art Gallery, Manchester, 1993
PUBLISHED *House & Garden*, April 1952, p. 11

T21
Lucienne Day for Heal's Wholesale & Export, Heal & Son Ltd
Springboard, 1954
Printed rayon satin, 61 cm (24") repeat
Printed marks to selvedge *Heal's Springboard by Lucienne Day*
An example exhibited 'Lucienne Day: A Career in Design', Whitworth Art Gallery, Manchester, 1993
PUBLISHED *Fifties Furnishing Fabrics*, plate 6

T22
Lucienne Day for Heal's Wholesale & Export, Heal & Son Ltd
Triad, 1955
Printed textured cotton, 64.1 cm (25") repeat
Printed marks to selvedge *Heal's Triad by Lucienne Day*
EXHIBITED 'Lucienne Day: A Career in Design', Whitworth Art Gallery, Manchester, 1993
PUBLISHED *Designers in Britain*, 1957, vol. 5, p. 34

T23
Mitzi Cunliffe (1918–) for David Whitehead Ltd, Rawtenstall
CP487A, sun and moon design, 1955
Roller-printed rayon, 29 cm (11½") repeat
PUBLISHED *Ideal Home*, June 1956, p. 14

T24
(Attrib.) **Ashley Havinden**
(1903–1973) for A. Sanderson & Son Ltd
ZB 108/4S, probably second half of the 1940s, first issued 1956
Automatic screenprint on cotton, 48 cm (19") repeat
Minimum retail price in 1956, 19s. 22d./yard
The Sanderson Archive has no record of this textile other than its date of issue. The design is in the organic modernist style of the late 1930s, particularly associated with the Mars Group – Edward McKnight Kauffers's poster for a Mars Group Exhibition of 1938 is closely related. Of more direct significance is Ashley Havingden's textile of 1937 for the Edinburgh Weavers, Ashleys Abstract. Many signature stylistic traits of Havingden's are shared by these two textiles. The abstract designs contained within the 1956 textile's organic forms are so close to a series of abstract paintings and drawings of the late 1930s by Havinden that they appear to have been directly derived from them. It is possible that Sanderson's commissioned this textile from Havinden in the late 1930s, but it more probably dates from the 1940s. A former Sanderson's archivist has confirmed that externally commissioned designs often lay fallow for years before the company would decide it was appropriate to issue them. It should also be noted that Sanderson's did not credit designers

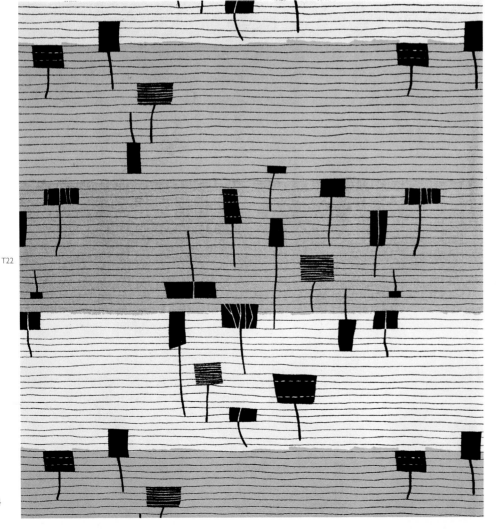

T22

T2

T24

T25
Robert Stewart (1924–1995) for
Liberty of London
Macrohamish, 1954
Roller-printed cotton, 38 cm (15") repeat
Printed marks to selvedge *Young Liberty* and
Exclusive Design Liberty of London
PUBLISHED *Fifties Furnishing Fabrics*, 1989,
plate 21

T26
Robert Stewart for Liberty of London
Mirage, 1955
Roller-printed cotton, 38 cm (15") repeat
Printed marks to selvedge *Young Liberty* and
Exclusive Design Liberty of London
An example exhibited 'Liberty 1875–1975',
an exhibition to mark the firm's centenary,
Victoria and Albert Museum, London, 1975
PUBLISHED Herbert Read, *Art and Industry*,
5th edition, 1956, p. 177

T27
Paule Vézelay (1913–1989) for Heal's
Wholesale and Export, Heal & Son Ltd
Elegance, *ca.* 1956
Printed cotton, 38 cm (15") repeat
Printed marks to selvedge *Elegance by Paule
Vézelay*
An example exhibited 'The New Look –
Design in the Fifties', Manchester City Art
Galleries, 1992
PUBLISHED *Designers in Britain*, vol. 5,
1957, p. 37, pl. 3

T28
Cawthra Mulock for David
Whitehead Ltd
Designed 1953, produced *ca.* 1954
Printed cotton, 49 cm (19½") repeat
Printed marks to selvedge *A David
Whitehead fabric, designed by Canthra Mulock*
Original artwork exhibited 'Painting into
Textiles', Institute of Contemporary Art,
London, 1953
PUBLISHED *David Whitehead Ltd, Artist
Designed Textiles 1952–1969*, 1993, p. 27
This is one of the textiles produced by
Whitehead from the work of six artists pur-
chased at the exhibition 'Painting into
Textiles' held at the Institute of
Contemporary Art in 1953.

T29
Kenneth Rowntree (1915–1997) for
Edinburgh Weavers
Full measure, *ca.* 1956
Screen-printed cotton, 54 cm (21¼")
repeat
Printed *EW* monogram to selvedge
PUBLISHED *The Studio Yearbook of
Decorative Art*, 1957–58, p. 60

T30
John Piper (1903–1992) for David
Whitehead Ltd
Church monuments, Exton, 1955
Screen-printed cotton, 45.5 cm (18") repeat
Printed marks to selvedge *David Whitehead
Ltd* and *Designed by John Piper*
An example exhibited 'John Piper', retro-
spective exhibition, Tate Gallery, London,
1983 (cat. ref. p. 76, no. D)
PUBLISHED *David Whitehead Ltd, Artist
Designed Textiles 1952–1969*, 1993, p. 14

T31
John Piper for A. Sanderson & Son Ltd
ZE 903, The stones of Bath, 1959, issued
ca. January 1962
Screen-printed Sanderlin, 53.5 cm (21")
repeat
Printed marks to selvedge *The Stones of
Bath* and *A Sanderson Screenprint*
An example exhibited 'John Piper', retro-
spective exhibition, Tate Gallery, London,
1983 (cat. ref. p. 76, no. 6)
This and the following three textiles are
four of the five textiles by Piper commis-
sioned for Sanderson's centenary in 1960

T32
John Piper for A. Sanderson & Son Ltd
ZE 906, Northern cathedral, 1959, issued
ca. January 1962
Screen-printed Sanderlin, 51 cm (20")
repeat
Printed marks to selvedge *Northern
Cathedral* and *A Sanderson Screenprint*

T33
John Piper for A. Sanderson & Son Ltd
ZE 9898, Chiesa de la Salute, 1959, issued
January 1960
Screen-printed Sanderlin, 53.5 cm (21")
repeat

T29

Printed marks to selvedge *Chiesa de la
Salute*

T34
John Piper for A. Sanderson & Son Ltd
ZE 895, Arundel, 1959, issued January 1960
Screen-printed Sanderlin, 38.5 cm (15¼")
repeat
Printed marks to selvedge *Arundel* and *A
Sanderson Screenprint*
An example exhibited 'Modern Art in
Textile Design', Whitworth Art Gallery,
Manchester, 1962 (exhib. no. 77)

T30

T31

T34

T33

T38

T35

T37

T35
Harold Cohen (1928–) for Heal
Fabrics Ltd, Heal & Son Ltd
Vineyard, 1959
Printed cotton, 54.5 cm (21½") repeat
Printed marks to selvedge *Vineyard Designed
by Harold Cohen* and *Heal's*
An example exhibited 'The New Look –
Design in the Fifties', Manchester City Art
Galleries, 1992
PUBLISHED *The New Look – Design in the
Fifties*, 1992, p. 67

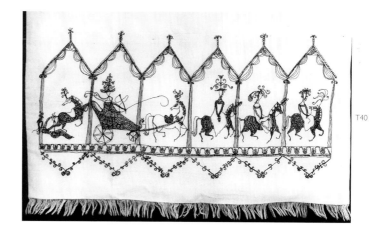

T40

T36
Tibor Reich for Tibor Ltd, Stratford-
upon-Avon
Flamingo, 1956
Screen-printed cotton
Printed marks to selvedge *Flamingo – Tibor
Fotexur print*
PUBLISHED *Design*, no. 100, April 1957,
p. 44
Flamingo was selected in 1957 as one of
twelve Designs of the Year from some
3500 designs on display at the Design
Centre. This textile was created using a
photographic method, Fotexur, developed
and patented by Tibor Reich in 1955

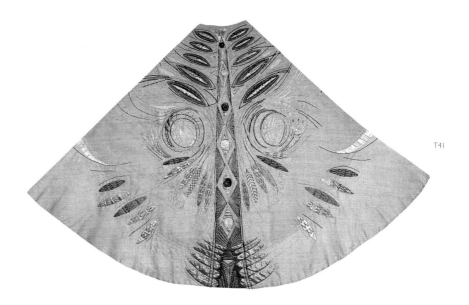

T41

T37
Alan Munro Reynolds (1926–) for
Edinburgh Weavers Ltd
Crystalline image, 1960
Woven cotton and rayon, 53.5 cm (21")
repeat

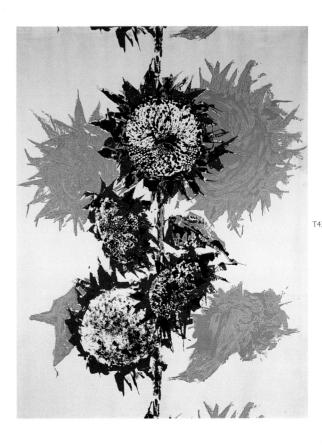

T43

PUBLISHED Edinburgh Weavers
Catalogue, Autumn 1961
Approx. retail price in 1961 £5 15s. 6d. per
yard

T38
Susan Riley (1937–)
The Hammersmith cope, 1957
Layers of silk and crystal organza applied to
a woven textile, embroidered and appliquéd
with various coloured metallic lurex threads,
Japanese gold and silver, black and red che-
nille
Worked by Beryl Dean and the students of
her course in ecclesiastical embroidery at
the Hammersmith College of Art. The work
on this cope took ten years to complete
EXHIBITED 'New Ecclesiastical
Embroidery', The Crypt, St Paul's Cathedral,
London, 1968
LENT BY The Dean and Chapter, St Paul's
Cathedral, London

T39
Susan Riley
Four studies for evening stole, 1957
Woven rayon fabric, machine-embroidered
in black cotton thread, 18 cm (7″) square
Worked by Susan Riley
These are preparatory studies for T40

T40
Susan Riley
Evening stole, 1957
Cream 'nun's' veiling, machine-embroidered
with black cotton thread, 208 cm x 74.5 cm
(82″ x 29¼″)
Worked by Susan Riley
This stole formed the centre-piece of Susan
Riley's NDD exhibition in 1957

T41
Susan Riley
Cope, originally designed and made as a
chasuble, 1958
Thai silk, appliquéd gold fabric, Japanese
gold thread, gold plate, black and white che-
nille, various cords and gold kid, worked by
Beryl Dean
EXHIBITED 'Artists Serve the Church',
Herbert Art Gallery and Museum, Coventry,

1962 (cat. no. 52); 'New
Ecclesiastical Embroidery', St Paul's
Cathedral, London, 1968; 'Raiment
for the Lord's Service, a Thousand
Years of Western Vestments', The
Art Institute of Chicago, 1975 (cat.
no. 174)
LENT BY The Reverend Canon
Peter Delaney

T42
Susan Riley
Two studies of Grecian heads,
1960
Woven rayon fabric, machine-
embroidered in black and white
cotton thread, worked by Susan
Riley
18.5 cm x 15.5 cm (7¼″ x 6″)
These are preparatory studies for
the 'Greek Banquet' supper cloth
in the collection of the Victoria
and Albert Museum, London

T43
Howard Carter for Heal Fabrics Ltd,
Heal & Son Ltd
Sunflower, 1961
Printed textured cotton, 127 cm (50″)
repeat
Printed marks to selvedge *Sunflower
Designed by Howard Carter, Design Centre
Award 1962* and *Heal's*
An example exhibited 'Design of the Times
– 100 Years of the Royal College of Art',
Royal College of Art, London, 1996
Design Centre Award, 1962

T44
Laurence Scarfe
Design for wallpaper, Rambler, 1945
Gouache on paper, 46 cm x 26 cm (18⅛″
x 10¼″)
PROVENANCE Laurence Scarfe
LENT BY The Silver Studio Collection,
Middlesex University

T45
Jacqueline Groag for John Line &
Sons Ltd
Kiddies' town, wallpaper, 1951

Colour screen print, 20 cm x 25.5 cm
(8″ x 10″)
PUBLISHED *Designers in Britain*, 1951, p.
242
LENT BY The Silver Studio Collection,
Middlesex University

T46
Lucienne Day for John Line & Sons Ltd
Provence, wallpaper, 1951
Colour screen print, 20 cm x 25.5 cm (8″ x
10″)
PUBLISHED *Designers in Britain*, 1951, p.
242
LENT BY The Silver Studio Collection,
Middlesex University

T47
John Minton (1917–1957) for John
Line & Sons Ltd
Tuscany, wallpaper, 1951
Colour screen print,
40.5 cm x 24.5 cm (16″ x 9½″)
LENT BY The Silver Studio Collection,
Middlesex University

Haute Couture

FRANCESCA GALLOWAY

The German Occupation of Paris in 1940 resulted in the closing of many of the French couture houses, giving the British fashion industry the invaluable opportunity of supplying the prosperous American market.

The Incorporated Society of London Fashion Designers (ISLFD) was thus set up in 1942 with the idea of forming an organized centre for *haute couture* in London. The original eight members were Hardy Amies, Norman Hartnell, Edward Molyneux, Digby Morton, Worth of London, Victor Stiebel, Bianca Mosca and Peter Russell. Molyneux, who brought his Paris house to London in 1940, was the mainstay of the group during the War. He designed for the government's 1941 Utility Scheme ensuring the economical use of restricted fabric. His clever use of the limited resources and his understated, elegant designs were highly influential (see HC1).

During the post-war period Haute Couture in Britain developed a distinctive style based on the expertise of traditional British tailoring and the influences of Court and Society. The resulting look was distinguished by a generally understated and refined elegance, frequently accompanied by sumptuous evening-wear.

Digby Morton worked as a designer at Lachasse before setting up his own business in 1934. Famed for his inventive cut in beautifully tailored outfits (see HC5) and practical daywear, his designs were greatly successful in both Britain and America in the 1950s.

Hardy Amies followed in Morton's footsteps at Lachasse from the 1930s, where he acquired a reputation for well tailored women's suits and sumptuous ballgowns. In 1946 he set up his own couture house in Saville Row, and in a relatively short space of time he had established himself as one of the most influential figures on the London fashion scene. An early example of work from his own label is the embroidered wool opera coat from 1947 (cat. HC2), which illustrates the transition between the angular wartime silhouette and the coming opulence of the post-war period.

Although Paris quickly snatched back its pre-eminence after the War with the advent of Dior's New Look in February 1947, it lacked some of the advantages that had benefited the British fashion industry. British couture had Royal and Court patronage, providing any number of glittering occasions to show off the latest creations. Britain had also retained its links with America and Hardy Amies's and Norman Hartnell's elaborately embroidered ballgowns were *de rigeur* for society ladies on both sides of the Atlantic. Hartnell, who opened his couture business in the 1920s, designed both the Queen's (then Princess Elizabeth) wedding dress in 1947 and her Coronation robe in 1953. Hartnell's spectacular ballgown embroidered with seaweed and shells from 1953 (cat. HC4) is typical of his work and the increasing flair of the period.

Nevertheless, as the 1950s progressed British *haute couture* fell into the shadow of the great Parisian tradition, but towards the end of the decade British designers, such as Mary Quant, once again captured world attention, this time with the emergence of Boutique and Street Fashion – a position of authority which they are yet to relinquish.

HC1

Edward Molyneux

Day ensemble, *ca.* 1942

Ensemble consisting of a dress and jacket of
fine brown-and-white wool worsted tweed.
The long three-quarter-length jacket is fitted
in the bodice with a large A-line peplum
with additional fullness in occasional pleats.
The shape of the peplum is enhanced by
parallel rows of stitching at the hem which
give the fabric extra stiffness, encouraging it
to stand out from the body and make an
interesting silhouette.

The jacket also has long sleeves and a
frontal closure with two enormous textured
buttons, possibly indicative of the surreal
influence of Schiaperelli at this time.

The dress is of similar proportions to the
jacket. The skirt of the dress creates a tiered
effect with the peplum of the jacket.

This is a rare example of couture daywear
from this period. It displays the restraint,
elegance and streamlining which are hall-
marks of Molyneux's style.

HC2

Hardy Amies (1909–)

Opera coat, *ca.* 1946

Opera coat of mauve wool serge with
padded shoulders, fitted bodice, long, loose
sleeves and full, flared, bias skirt cut on
princess lines. The coat is embroidered in
iridescent midnight-blue beads and sequins
in an abstract pattern designed for the coat.
This is an interesting transitional piece, from
the angular wartime silhouette to the opu-
lence of the post-war period. It retains the
padded shoulders and loose sleeves of the
early 1940s and yet incorporates elements
from the late 1940s, such as the princess
lines, the raglan sleeves and the full bias
skirt. This is an excellent example of the tai-
lored and restrained image favoured by the
English couturiers.

HC3

HC5

HC1

HC4
Norman Hartnell
Ballgown, 1953

PROVENANCE Lady Werner, who wore it
to a ball in honour of the Coronation, 1953
Spectacular sea-blue heavy silk taffeta ball-
gown with sweetheart neckline, thin straps
and fitted, pleated and boned corset. The
skirt, cut on the bias, falls sheath-like in front
following the shape of the body and is gath-
ered around the hips at the back, falling into
soft pleats behind, forming a full train.
The dress is elaborately embroidered in
front with coral beads, gold-glass beads and
gold shells, loops of raffia, tiny glass beads in
varying shades of blue and green and thick
gold thread in a wonderful surrealist
seascape design.
Hartnell was renowned for his use of elabo-
rate embroidery for theatrical effect.

HC3
Norman Hartnell (1901–1979)
Ballgown, ca. 1950

Strapless sheath of pale-pink, beige, brown
and black chiffon. The bodice (internally
boned and lined in silk according to the
chiffon colours of the outer garment) is
swathed horizontally in several colours while
the straight, black skirt falls to the ground.
At waist level in the back and partly in the
front is a floor-length train, gathered at the
waist and consisting of a black and brown
panel, creating the illusion of diaphanous
chiffon as the wearer moves.

HC5
Digby Morton (1906–1983)
Suit, ca. 1954

Black wool suit with long pencil skirt and
fitted jacket. The jacket is padded at the
shoulder, nipped in at the waist and
weighted at the hem. The buttons are
covered in black wool with decorative
stitching.
The severity of line, typical of the tailored
suit from the early 1950s, is softened by
false pockets in the form of inverted black
grosgrain pleats below triangular stitching in
thick, black-silk thread. The same decorative
motif appears at the centre back.

Contemporary Ceramics

ALAN PEAT

The development of a distinctive Contemporary look in post-war British ceramics was a relatively slow process. Initially it was hampered by Utility restrictions which remained in force until the early 1950s. This was followed by a 'pattern at any price' rush after restrictions were lifted in 1952; starved of colourful wares for so long the British public were not selective consumers.[1] And yet, from the mass of debased floral prints and tired scenes of rural England, a truly British Contemporary look did emerge.

Established industrial companies had resumed the production of fine ware for export after the War, and many soon began once more to employ avantgarde designers. Wedgwood in particular had a long tradition of innovative design, and towards the end of the War they employed Arnold Machin to design the Zodiac Bull, the first British Contemporary ceramic. They later went on to commission Norman Makinson's 'Festival of Britain' mug of 1950 and Richard Guyatt's Coronation mug of 1953. The work of the Danish designer Agnete Hoy at Bullers (of Milton in Staffordshire) may also be mentioned, though the enterprise was short-lived and the Bullers studio closed in 1952.

Royal Lancastrian Ceramics, owned by Pilkington's (better known for industrial glass), continued a similar tradition of using advanced designers by employing the American sculptor Mitzi Cunliffe. Her designs represent the purest manifestation of the organic style in British post-war ceramics. She designed bowls instantly recognizable for their thick-walled forms and bold free-form, modernist execution. Cunliffe's range, however, was ahead of its time and Pilkington's pottery department was closed down in 1957.

The more significant proponents of the emerging Contemporary look, however, were the studio potteries, notably the Rye Pottery, refounded by John and Walter Cole in 1947. John Cole, who was Head of Beckenham School of Art during the week, "… came back at weekends to train the apprentices … eventually we trained our apprentices to design by giving them free time as it were to experiment with individual pieces. We were rather acting like the Swedish firm Gustavsberg at that time by trying to form a small design group within the factory."[2] Some of the apprentices at Rye went on to become important figures in their own right. Denis Townsend produced a body of interesting work at his Iden Pottery and David Sharp set up the Cinque Ports Pottery with the retailer George Gray.

Rye swiftly achieved a production-line output of high-quality tin-glazed majolica, inspired by British seventeenth-century wares and earlier Moorish work from Spain. In contrast to the traditional choice of body the surface decorations were strikingly modern. A Loving Cup, illustrated in *The Daily Mail Ideal Home Book* 1951–52, includes in its decoration a crystal motif with archetypal 1950s' 'cocktail-cherry-on-a-stick' finials. A 1953 catalogue demonstrates that this is not an isolated design. *Sgraffito* decoration was applied in a Contemporary textural manner; lamp-bases were decorated with asymmetrical patterns of silhouetted irregular shapes of a kind which were later echoed in industrially produced ceramics. Rye pottery was astutely marketed and disseminated by outlets such as Heal's, Liberty's, Primavera and Dunn's of Bromley. The vibrancy of patterns such as the daisy-like star motif known at Rye as the 'Festival Star' exerted a major influence on the British Contemporary look.

Rye was not the only studio pottery to feed a public "starved of decoration for over six years", the most significant contributor being Lucie Rie. Rie's work was vitally important to the development

of Contemporary ceramics. She had experienced success as a potter in Europe in the 1930s but was as yet unknown in England where she had arrived in 1938. She met fellow refugee Hans Coper in 1946; he was initially her assistant but later became a collaborator. Together they produced not only buttons and other domestic wares but also vases which rejected rural functionalism, the impact of which is reflected in commercially produced elliptical vases of the 1950s. The refinement of Rie's pieces was commented upon in 1951: "Mrs Rie puts a fine lip on her pieces which curves over as delicately as an arum lily. There are connoisseurs who deplore this treatment. Traditional pottery must be thick, even coarse, they say. *I don't see why* Mrs Rie exclaims …."[3]

The fineness of her potting and the sophistication of her patterning (particularly the characteristic, much copied *sgraffito* decoration) was to resonate throughout the decade. David Queensberry, for example, cited Rie's work as a major influence on Midwinter pottery's decision to use a lug instead of a handle on some of the hollow ware of the Fine range, launched in 1962. Coper's work of the early 1950s was also important, and he later contributed the candlesticks for the High Altar of Coventry Cathedral.

The British Contemporary look also had whimsy and humour, notably in the work of Richard and Susan Parkinson. They founded a studio pottery at Branbourne Lees, near Ashford, Kent, in 1951 and worked there until 1963, making a series of engaging slip-cast porcelain vessels and figures, all of which were modelled by Susan. She had studied sculpture at the Royal College of Art between 1945 and 1949 under Frank Dobson and was one of the many designers in the Contemporary style to be RCA-trained. The Parkinsons' high-temperature-fired bisque porcelain figures, although undoubtedly Contemporary, very much followed in the tradition of humorous eighteenth-century Staffordshire figures and nineteenth-century flatbacks. The Parkinsons' work sold through outlets such as Primavera in London, which helped to spread their influence.

In July 1952, almost a decade after they were first imposed, restrictions on decorated pottery were lifted and the studio potters no longer had the market to themselves. Initially patterns and shapes produced by the commercial potteries were at best bland and at worst retrospective. When Roy Midwinter visited America with a range of samples produced by his father's company in August 1952, he found his traditional patterns rejected outright and he was directed to the products of West Coast firms such as Metlox and Hallcraft and the work of Eva Zeisal. These wares were the inspiration for the Stylecraft range which Midwinter launched in February 1953. Though it had been developed in only six months, Stylecraft transformed British industrial ceramics. The plates were quartic rather than circular, but the range would have been even more radical if Midwinter had had his own way: "I was after a full-blown coupe but they argued for a rim".[4]

The shapes were new and so were the surface decorations, produced by Midwinter's house designer, Jessie Tait. Among the earliest of these was Fantasy (October 1953), a wholly abstract design far removed from the then prevalent traditional patterns. The Primavera range, launched July 1954, also by Tait, was one of the 'second wave' of surface patterns, a beautiful Contemporary treatment of a traditional floral motif which combines biomorphic shapes with stylized leaves and sprigs.

Sir Hugh Casson was commissioned to produce designs for what became the Riviera range, based, according to Sir Hugh, on "about 12–20 little scribbly watercolours for the Midwinter management to choose from".[5] The Mediterranean reference struck a chord with the public, suggesting a lifestyle which many had glimpsed during the War and would seek to find again with the advent of package holidays.

The young Terence Conran also received many commissions from Midwinter for the Fashion range, first shown at the British Industries Fair in June 1954. Fashion was still more startlingly Contemporary than Stylecraft, and included in the range were true coupe ware and hollow ware with free-flowing, sinuous lines, accentuated on the teapot by an arching, strap-like handle.

Conran designed Nature Study (June 1955), which set a trend for black-and-white surface decorations. His most abstract design, however, was Chequers, a bold surface pattern combining litho printing with hand-sponged colour additions, subsequently much imitated.

Midwinter's trendsetting continued into the 1960s, notably with the Fine range, launched in 1962, which introduced designs by David Queensberry. Fine was conceived as a direct rejection of Swedish and American models, taking as its inspiration the shape of the very British milk-churn and Leeds creamware teapots. Despite the historical influences the range is undoubtedly modern; of the four patterns with which it was initially launched, three are strikingly Contemporary: Sienna and Whitehall by Jessie Tait, and Queensberry Stripe by David Queensberry.

Companies other than Midwinter were aware of the need to establish their own distinctive Contemporary style, the most successful and influential among them being Poole, who like Rye,

successfully established an immediately recognizable post-war character of its own.

The leading 1930s' modernist designer Alfred Burgess Read, who had studied metalwork at the RCA and, aged twenty-seven, had been a director at the lighting firm Troughton & Young, was appointed head of the design studio in 1953; he was joined the following year by his talented daughter Ann, who had studied at the Chelsea School of Art. Poole's first new wares, with a consciously Contemporary feel, were exhibited at the Tea Centre, Regent Street, London, in March 1953. Particularly striking were carafe shapes designed by Read, carried out in a new technique with diffused colours on a matt white glaze.

For the most part Poole, like Rye, used traditional potting and hand-painting techniques, but they took a more avant-garde approach to shape. As early as 1953 the typical 'waisted' look of vases at Poole was part of the iconography of the decade's design. Other early vases had undulating forms which related to the prevalent 'organic' style. Poole's Contemporary ceramics reached their peak in 1956 with the Free Form range designed by Read and Guy Sydenham. The strongly biomorphic shapes, elliptical mouths and overall soft-tech feel of this range gave it a truly international look. Decoration accentuated the shapes and harmonized with them in an original and influential way.

Although it is often assumed that Poole's contribution to Contemporary style ended with the work of Read in 1956, Robert Jefferson's contribution should not be overlooked. His arrival in 1958 undoubtedly helped cement Poole's post-war commercial success, for which A.B. Read had laid the foundations. Jefferson's principal task at that time was the redesigning of Poole's range of table-wares which resulted in the Contour tableware range, whose upswept handles are an unmistakeable Contemporary design feature.

Hornsea, a company founded in 1949 from very humble beginnings, deserves recognition for both its commercial and aesthetic success. Not coming from a potting background, the founders, Desmond Rawson and his brother Colin, were not shackled to safe methods of production and so were more willing to experiment.

The company was set on its feet by ranges of cheap ware which were not Contemporary in style, and it was only at the end of the 1950s, following the appointment of William John Clappison as chief designer in 1958, that Hornsea became a major force in modern design.

Clappison's first Contemporary range, Elegance, designed in the summer of 1956, derived from Scandinavian design. More highly influential and original both in their forms and decoration were the ranges introduced between 1959 and 1962, Home Decor, Studio Craft and Impasto, also the Pisces vase by Clappison's friend and fellow RCA-graduate Ronald Mitchell. Equally notable is the tableware range Summit, which remained in production between 1960 and 1965. Hornsea's work at this period is closely related to the British Brutalist architectural movement and owes little, if anything, to Scandinavian design.

The achievements of companies such as Hornsea, Midwinter and Rye undoubtedly affected the most revered of the British ceramic companies, who soon chose to include Contemporary products in their lists: Royal Doulton, for example, launched two coupe-style ranges in 1955 – the Avon shape (earthenware) and the Albion range (china).

How are we to assess the period as a whole? At the outset of the 1950s a debate about Contemporary ceramics was raging. The new designs were derided by many and yet they began to gain acceptance, helped by occasions such as the 'Festival of Britain', the influence of Lucie Rie and the enterprising spirit of men such as Roy Midwinter and the Cole brothers. By the close of the decade the Contemporary style was an accepted part of ceramic production. Its acceptance may be said to have been enshrined by the commission to Hans Coper to produce the candlesticks for the altar of Coventry Cathedral.

[1] Paul Reilly, 'Problems of Post-war Pottery', *The Daily Mail Ideal Home Book* 1957

[2] Walter Cole, letter to the author, February 1991

[3] *The Daily Mail Ideal Home Book* 1951–52, p.109

[4] Roy Midwinter, interview with the author, April 1990

[5] Roy Midwinter, interview with the author, November 1989

C1

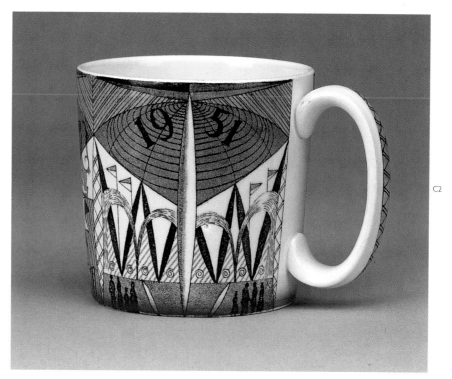

C2

C1
Arnold Machin (1911–) for Josiah
Wedgwood & Son, Barlaston
Zodiac Bull, ca. 1943–45
Earthenware with hand-coloured printed
transfer decoration, length 41 cm (16¼")
Printed mark to leg, *Wedgwood, Barlaston,
England*
An example exhibited 'Britain Can Make It'
(p. 138, no. D683)
PUBLISHED *Designers in Britain*, 1947, vol.

1, p. 234
The Zodiac bull was the first Contemporary
style ceramic to be produced in Britain

C2
Norman Makinson for Josiah
Wedgwood & Son, Barlaston
'Festival of Britain' commemorative mug,
1950
Moulded earthenware, hand-coloured
printed transfer decoration, height 7 cm (2¾")

Marks to underside, *Wedgwood of Etruria & Barlaston, Made in England*, Festival symbol. Painted number *C-6446B*
PUBLISHED Maureen Batkin, *Wedgwood Ceramics 1846–1958*, Richard Dennis Publications, 1982, p. 224

C3
Mitzi Cunliffe (1918–) for Pilkington, Royal Lancastrian
Dish, *ca.* 1949–50
Moulded earthenware with matt black glaze, length 31 cm (12¼")
Impressed marks to underside *Made in England, Royal Lancastrian* and Pilkington's logo

PUBLISHED A.J. Cross, *Pilkingtons Royal Lancastrian Pottery & Tiles*, Richard Dennis Publications, 1980, p. 72 (examples)

C4
Mitzi Cunliffe for Pilkington, Royal Lancastrian
Dish, *ca.* 1949–50
Moulded earthenware with matt black and turquoise blue glaze, length 25.5 cm (10")
Impressed marks to underside *Made in England, Royal Lancastrian* and Pilkington's logo
An example exhibited 'The New Look – Design in the Fifties', Manchester City Art Galleries, 1992

C6
C7

C6
C9

C14
C7
C8
C15

C5
Rye Design Team for Rye Pottery
Butter dish thrown by Dennis Townsend,
ca. 1948
Terracotta, tin-glazed with painted decoration, probably by David Sharp, diameter 7.5 cm (3″)
Impressed marks to underside and Rye Pottery circular stamp
These butter dishes were commissioned by Geoffrey Dunn of Dunn's of Bromley to hold the minuscule individual butter ration of the period. The dishes were part of Rye's first large commercial order

C6
Rye Design Team for Rye Pottery
Jug thrown by Dennis Townsend, beaker thrown by James Elliot
Jug *ca.* 1950, beaker *ca.* 1952, both with Green Wheat pattern
Terracotta, tin-glazed with painted decoration, jug: height 21 cm (8¼″); beaker: height 8 cm (3¼″)
Jug: impressed marks to underside, three *D*s and Rye Pottery circular stamp. Beaker: impressed marks to underside, *J* and *Rye*
PUBLISHED *The Daily Mail Ideal Home Book*, 1951–52, p. 110 (beaker)
Jugs of this type were displayed in the 'Kitchen and dining-room of a country house' shown in the *Homes & Gardens* Pavilion at the 'Festival of Britain'

C7
Rye Design Team for Rye Pottery
Mug with Cottage pattern, *ca.* 1950
Terracotta, tin-glazed with painted decoration, height 11 cm (4¼″)
Impressed mark to underside, *Rye*

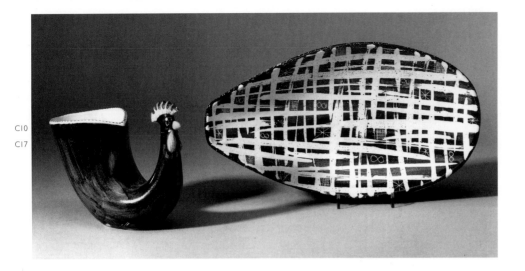

C10
C17

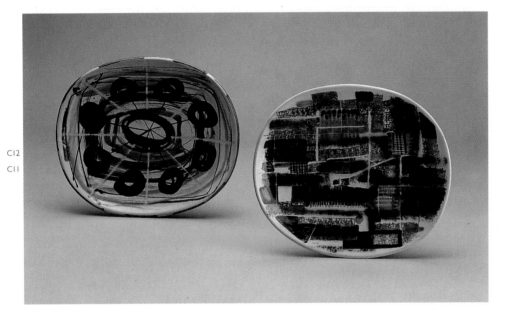

C12
C11

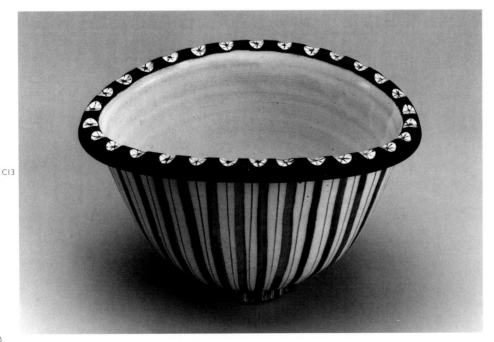

C13

C8
Rye Design Team for Rye Pottery
Mug, *ca.* 1950
Terracotta, tin-glazed with painted decoration, probably by David Sharp, height 13 cm
(5")
Impressed mark to underside, Rye Pottery
circular stamp
This mug is painted in the style of decoration developed for use at the 'Festival of
Britain'

C9
Rye Design Team for Rye Pottery
Jug thrown by Dennis Townsend, *ca.* 1950
Terracotta, tin-glazed with painted decoration, height 19 cm (7½")
Impressed marks to underside, three *D*s and
Rye Pottery circular stamp
This jug is painted with the Star decoration
developed for use at the 'Festival of Britain'

C10
Rye Design Team for Rye Pottery
Cockerel, vase, *ca.* 1952
Slip-cast terracotta, tin-glazed with painted
decoration, height 11.5 cm (4½")
Impressed mark to underside, *Rye* in a
circular stamp

C11
Dennis Townsend (1933–) for Rye
Pottery
Dish, *ca.* 1953
Buff-coloured earthenware, tin-glazed with
unique painted decoration, length 20.5 cm
(8")
Marks to underside, printed Rye Pottery
stamp and painted *DT* monogram

C12
David Sharp (1932–) for Rye Pottery
Dish, *ca.* 1953
Slip-cast buff-coloured earthenware, tin-
glazed with unique painted decoration,
length 21.5 cm (8½")
Marks to underside, printed Rye Pottery
stamp and painted signature *D.T. Sharp*

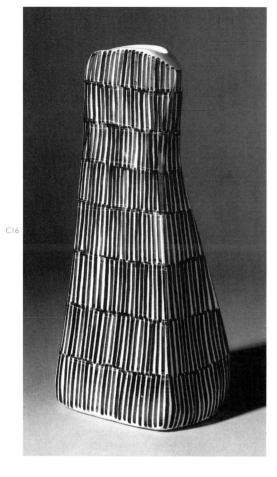

C16

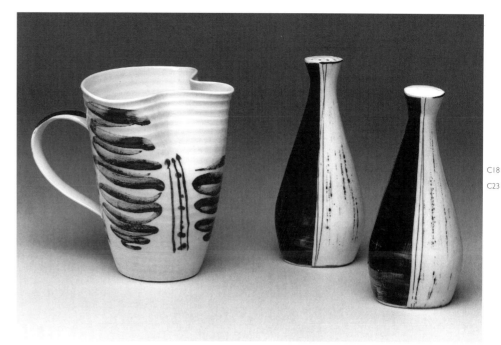

C18
C23

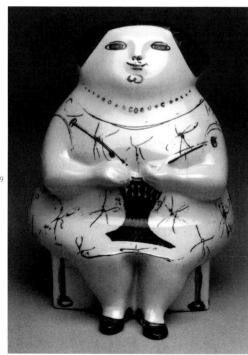

C19

C13
Rye Design Team for Rye Pottery
Bowl thrown by James Elliot, *ca.* 1953
Terracotta, tin-glazed with recessed and
painted decoration, height 12 cm (4¾")
Impressed marks to underside, *Rye* and a *J*

C14
Rye Design Team for Rye Pottery
Thrown by James Elliot
Large tankard with Lambeth pattern,
ca. 1953
Terracotta, tin-glazed with painted decora-
tion, height 18 cm (7")
Impressed marks to underside, *J* and *RYE*

C15
Rye Design Team for Rye Pottery
Thrown by Dennis Townsend
Mug with Mosaic pattern, *ca.* 1954
Buff-coloured earthenware, tin-glazed with
painted decoration, height 14 cm (5½")
Marks to underside, printed Rye Pottery
stamp and impressed three *D*s

C16
John Cole (1908–1988: see Biography
page 126) for Rye Pottery
Vase, *ca.* 1954

Buff-coloured earthenware, tin-glazed with
painted decoration, height 30 cm (11¾")
Printed Rye Pottery stamp to underside
Walter Cole has identified this vase by his
brother as being either a unique piece or
from a batch of not more than three

C17
David Sharp for Cinque Ports Pottery,
Rye
Dish, *ca.* 1957
Slip-cast terracotta, tin-glazed with painted
decoration, length 32.5 cm (12¾")
Printed *Cinque Ports* stamp to underside
David Sharp set up the Cinque Ports
Pottery after leaving Rye in 1956

C18
Richard Parkinson (1927–1985: see
Biography page 125) for the Crowan
Pottery, Cornwall
Jug, 1950
Thrown, glazed porcelain with painted dec-
oration using a wax-resist technique, height
14.5 cm (5¾")
Impressed seal to side, *R.P.* Impressed mark
to underside *Richard Parkinson*
Richard Parkinson worked at the Crowan
Pottery for the summer of 1950 only

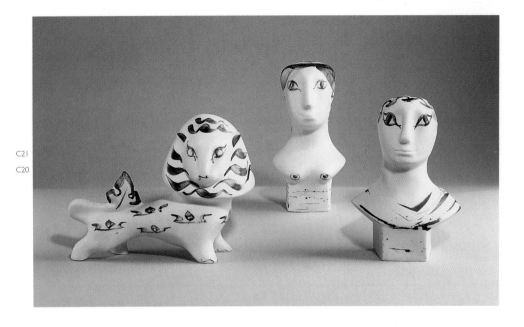

C21
C20

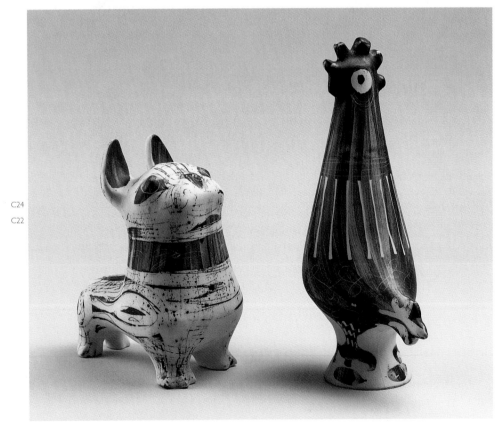

C24
C22

C19
Richard Parkinson and **Susan Parkinson** (1925– : see Biography page 125) for the Parkinson Pottery, Brabourne Lees, Ashford
Figure, seated lady knitting, early 1950s
Glazed slip-cast porcelain, with painted and incised decoration using a wax-resist technique, height 21.5 cm (8½")
Impressed marks to underside, *Richard Parkinson* and *Made in England*

C20
Richard Parkinson and **Susan Parkinson** for the Parkinson Pottery, Brabourne Lees, Ashford
A pair of 'classical' busts, early 1950s
Slip-cast bisque porcelain, with painted and incised decoration using a wax-resist technique, height 19.5 cm (7¾")
Impressed marks to underside of one bust, *Richard Parkinson*

C21
Richard Parkinson and **Susan Parkinson** for the Parkinson Pottery, Brabourne Lees, Ashford
Figure of a lion, 1953
Slip-cast bisque porcelain, with painted decoration, height 18 cm (7⅛")
Impressed marks to underside, *Richard Parkinson* and *Made in England*
This lion was also available as a pair with a unicorn. They were made to commemorate the Coronation of Elizabeth II in 1953

C22
Richard Parkinson and **Susan Parkinson** for the Parkinson Pottery, Brabourne Lees, Ashford
Figure of a cockerel, 1954
Slip-cast bisque porcelain, with painted decoration using a wax-resist technique, height 30.5 cm (12")
Impressed marks to underside, *Richard Parkinson* and *Made in England*
An example is in the Primary collection of the Victoria and Albert Museum, London

C25
C26

C23
Richard Parkinson and **Susan Parkinson** for the Parkinson Pottery, Brabourne Lees, Ashford
Cruet set, salt and pepper, *ca.* 1955
Glazed slip-cast porcelain, with painted and incised decoration using a wax-resist technique, height 16 cm (6¼")
Impressed marks to underside, *Richard Parkinson*
PUBLISHED *The Daily Mail Ideal Home Book*, 1957, p. 119
Retailed through the Primavera gallery, London

C24
Richard Parkinson and **Susan Parkinson** for the Parkinson Pottery, Brabourne Lees, Ashford
Figure of a dog, mid 1950s
Slip-cast bisque porcelain, with painted decoration using a wax-resist technique, height 21.5 cm (8½")
Impressed marks to underside, *Made in England*

C25
Robert Stewart (1924–1995) probably for the Edinburgh Tapestry Company
Tile, *ca.* 1955
Earthenware with screen-printed decoration, height 15 cm (6")
Printed signature to front of tile, *Stewart.*
Moulded marks to back of tile, *Pilkington, England*
PUBLISHED *Motif, A Journal of the Visual Arts*, no. 2, February 1959, Shenval Press, London, p. 53

C26
Robert Stewart
Tankard, *ca.* mid 1950s
Earthenware with screen-printed decoration and gilding, height 14.5 cm (5⅝")
Printed marks to underside, *Robert Stewart* and clover leaf symbol
This tankard was retailed by Liberty's, for whom Stewart designed many textiles in a high Contemporary style during the first part of the 1950s

C28

C27
Enid Seeney (1932–) and **Tom Arnold** (1928–) for Ridgeway Potteries
Dinner plate from the Homemaker range, 1955
Earthenware with printed decoration, diameter 25.5 cm (10")
Printed Homemaker stamp to underside
An example exhibited 'Design of the Times – 100 Years of the Royal College of Art', Royal College of Art, London, 1996

C28
Roy Midwinter (1923–1990: see Biography page 126) for W.R. Midwinter Ltd, Burslem
Three pieces of undecorated whiteware in the Fashion shape. Designed *ca.*1954, launched June 1955
Moulded earthenware, coffee pot and lid: height 20.5 cm (8"); teapot and lid: height 15 cm (6")
Coffee pot and lid: marks to underside printed *Midwinter Modern, Fashion Shape, Staffordshire, England*; coffee cup and saucer: marks to underside printed *Midwinter*

C29

C31

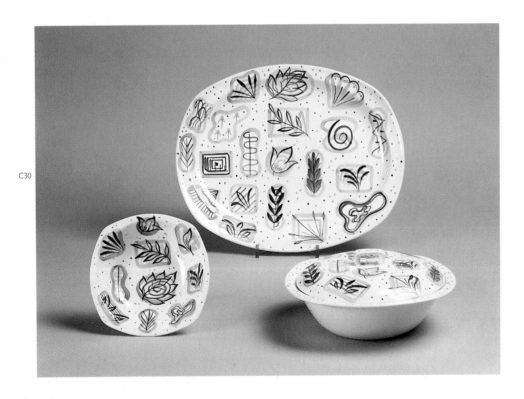

C30

Modern, Fashion Shape, Staffordshire, England and numerals *10–59*; teapot and lid: marks to underside, printed *Midwinter Modern, Fashion Shape, Staffordshire, England* and numerals *9–60*

C29
Jessie Tait (1928–) for W.R. Midwinter Ltd, Burslem
Three pieces from the Fantasy range, on the Stylecraft shape. Designed *ca.* 1953, introduced October 1953
Moulded earthenware, painted decoration, tureen and lid: height 11 cm (4¼"); plate: diameter 21.5 cm (8½"); bowl: diameter 19 cm (7½")
Tureen and lid: marks to underside, printed *Fantasy* backstamp and painted mark; plate: marks to underside, printed *Fantasy* back stamp; bowl: marks to underside, printed *Fantasy* back stamp
PUBLISHED *The Daily Mail Ideal Home Book*, 1953–54, p. 136

C30
Jessie Tait for W.R. Midwinter Ltd, Burslem
Three pieces from the Primavera range, on the Stylecraft shape. Designed *ca.* 1953, introduced July 1954
Moulded earthenware, painted decoration, plate: width 11 cm (4¼"); serving dish: length 35 cm (13¾"); bowl: diameter 15.5 cm (6")
Serving plate: marks to underside, printed *Stylecraft* backstamp and painted numeral *11*; tureen and lid: marks to underside,

printed *Stylecraft* backstamp
PUBLISHED *Design*, no. 64, April 1954,
p. 16

C31
Jessie Tait for W.R. Midwinter Ltd,
Burslem
Plate and eggcup from the Festival range, on
the Fashion shape. Designed *ca.* 1954, intro-
duced 1955
Moulded earthenware, painted decoration,
plate: diameter 16 cm (6¼″); eggcup: height
4 cm (1⅝″)
Plate: marks to underside, printed stamp
*Stylecraft Fashion tableware by Midwinter,
Staffordshire, England* and painted mark;
eggcup: painted mark
An example exhibited 'The Canadian
National Exhibition', Toronto, November
1954
PUBLISHED *The Daily Mail Ideal Home
Book*, 1956, p. 108

C32
Sir Hugh Casson (1910–) for W.R.
Midwinter Ltd, Burslem
Seven pieces from the Riviera and Cannes
ranges. The designs first introduced on the
Stylecraft shape as Riviera in 1954.
Subsequently used on the Fashion shape as
Cannes in 1960
Moulded earthenware with printed and
painted decoration, Riviera dinner plate:
diameter 21.5 cm (8½″); Cannes teapot:
height 16.5 cm (6½″); Cannes serving
plate: length 34.5 cm (13½″); Cannes
bowl: diameter 15.5 cm (6″); Cannes ash-
trays: diameter 10.5 cm (4⅛″) and 8.5 cm
(3¼″)
PUBLISHED *Design*, no. 65, May 1954, pp.
20–21

C33
Sir Terence Conran (1931–) for
W.R. Midwinter Ltd, Burslem
Three pieces from the Chequers range, on
the Fashion shape, 1957
Moulded earthenware with printed and
sponged decoration, tureen and lid: height
11 cm (4¼″); serving plate: length 30.5 cm

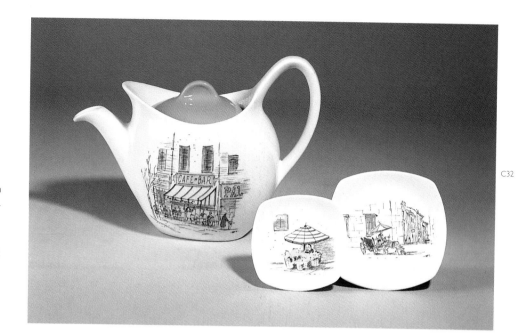

C32

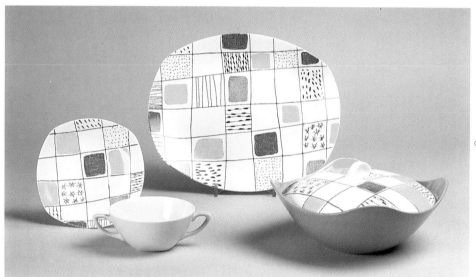

C33

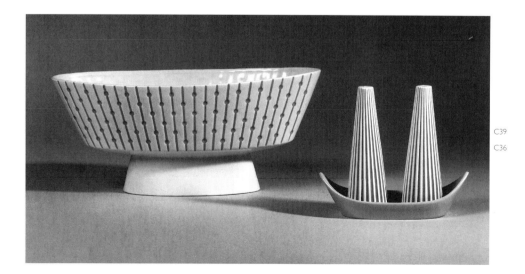

C39

C36

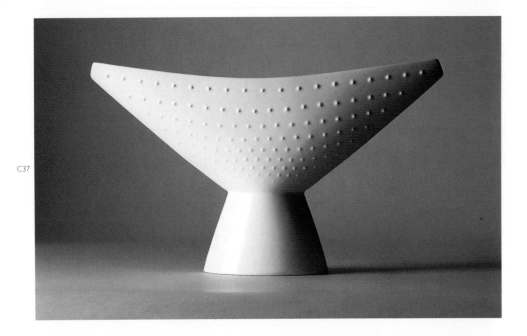

C37

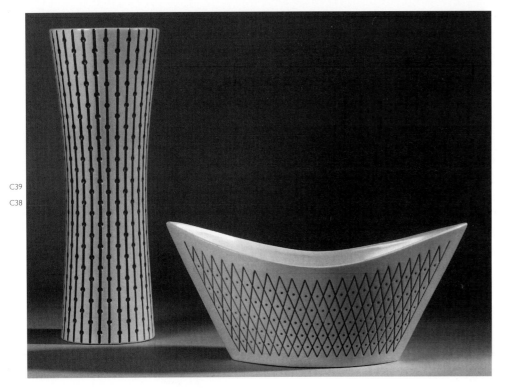

C39

C38

(12"); soup bowl and saucer: height 6 cm (2⅜")

Tureen and lid: marks to underside of tureen, printed stamp *Midwinter Modern, Fashion Shape, Staffordshire, England*; serving plate: marks to underside, printed *Chequers* backstamp; soup bowl and saucer, marks to underside of saucer, printed *Chequers* backstamp

Chequers was adapted from the textile design of the same name. It was originally designed by Conran for David Whitehead and exhibited at the 'Festival of Britain'

C34

Sir Terence Conran for W.R. Midwinter Ltd, Burslem
Three pieces from the Nature Study range, on the Fashion shape, 1955
Teapot: height 15 cm (6"); milk jug: height 11 cm (4¼"); sugar bowl: height 6 cm (2½")
Teapot and sugar bowl: printed backstamp to underside *Midwinter Stylecraft, Fashion Shape*; milk jug: printed backstamp to underside *Nature Study*
PUBLISHED *Midwinter: A Collectors' Guide*, 1992, p. 41

C35

David Queensbury (1929–) for W.R. Midwinter Ltd, Burslem
Coffee pot with Queensbury Stripe pattern on the Fine shape, 1962
Moulded earthenware with printed decoration
Awarded a gold medal at the 1962 California State Fair
PUBLISHED *Design*, no. 177, September 1963, p. 49

C36

John Clappison (1937– : see Biography page 126) for Hornsea Pottery, Hornsea
Cruet set with original packaging, from the Summit range, 1959–60
Moulded earthenware, colour inlay to recessed decoration, height 14.5 cm (5⅝")
Cruet set unmarked. Printed marks to box *Hornsea Pottery* and company logo
An example exhibited 'Style for the Mass Market – an exhibition of Hornsea pottery,

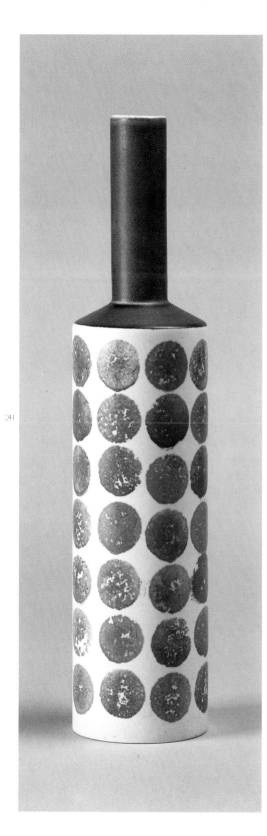

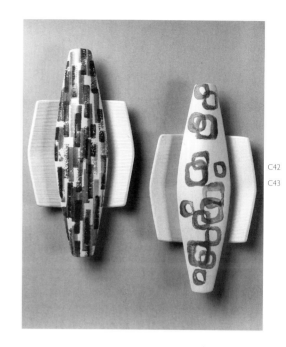

1949 to the present day', Scarborough Art Gallery, 1986 (exhib. cat., section 90–92, nos. 217, 218)

This cruet set was the first of the Summit range to be designed, the rest of the service being subsequently built round it

C37

John Clappison for Hornsea Pottery Ltd, Hornsea

Extra large jardinière, no. 352 from the Home Decor range with White Bud decoration. Designed 1958, produced 1960–62

Moulded earthenware with relief decoration and matt white glaze, height 21 cm (8¼")

Marks to underside, printed *Studiocraft* stamp and impressed *352*

An example exhibited 'Style for the Mass Market – an exhibition of Hornsea pottery, 1949 to the present day', Scarborough Art Gallery, 1986 (exhib. cat., section 76–78, no. 352)

C38

John Clappison for Hornsea Pottery Ltd, Hornsea

Fruit bowl, no. 393 from the Studiocraft range with Lattice decoration. Designed 1959–60, produced 1961–62

Moulded earthenware, matt white glaze, colour inlay to recessed decoration, height 14.5 cm (5⅝")

Marks to underside printed *Studiocraft* stamp to base, and impressed *393*

An example exhibited 'Style for the Mass Market – an exhibition of Hornsea pottery, 1949 to the present day', Scarborough Art Gallery, 1986 (exhib. cat., section 80, no. 393)

C39

John Clappison for Hornsea Pottery Ltd, Hornsea

Large vase and flower trough, nos. 373 and 380 from the Studiocraft range. Vase designed 1959–60, produced 1960–62; trough produced in 1960 only

Moulded earthenware, matt white glaze, colour inlay to recessed decoration, height 35.5 cm (14")

Marks to underside printed *Studiocraft*

stamp to base, and impressed *375*

Examples exhibited 'Style for the Mass Market – an exhibition of Hornsea pottery, 1949 to the present day', Scarborough Art Gallery, 1986 (exhib. cat., section 79, no. 375)

C40

Ronald Mitchell for Hornsea Pottery Ltd, Hornsea

Large vase, no. 721 from the Pisces range. Designed *ca.* 1960, produced in 1961 only

Moulded earthenware, with stylized fish projecting from the side of the vase. Printed decoration under a clear glaze, height 43 cm (17")

Printed marks to underside, *Hornsea, England*, company logo and numerals *721*

An example exhibited 'Style for the Mass Market – an exhibition of Hornsea pottery, 1949 to the present day', Scarborough Art Gallery, 1986 (exhib. cat., section 98, no. 721)

C41

John Clappison for Hornsea Pottery Ltd, Hornsea

Vase, no. 713 from the Impasto range Designed *ca.* 1960, produced briefly in 1961

Moulded earthenware, matt white and blue glaze, with sponged decoration, height 29.5 cm (11⅝")

Printed marks to underside *Hornsea,*

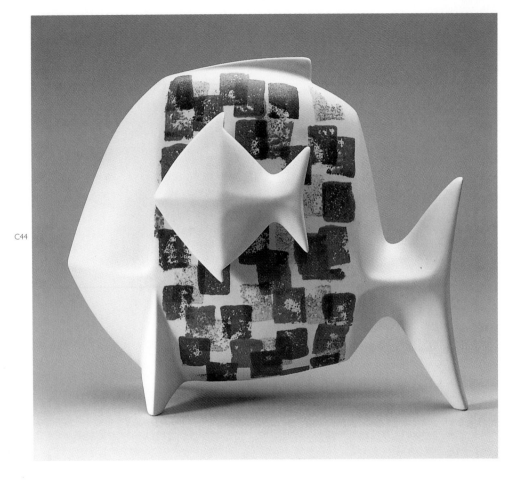

C44

C45

Printed marks to back *Hornsea, England*, company logo and *703B*. Paper tag label printed with *Designer John Clappison, produced by Hornsea Pottery* and a photograph of Clappison

An example exhibited 'Style for the Mass Market – an exhibition of Hornsea pottery, 1949 to the present day', Scarborough Art Gallery, 1986 (exhib. cat., section 95–97, no. 703B)

C44

John Clappison for Hornsea Pottery Ltd, Hornsea

Fish light, no. 701 from the Impasto range
Designed *ca.* 1960, produced only in 1961 and 1963

Moulded earthenware, with matt white glaze and sponged decoration, height 25 cm (9³/₄″)

Printed marks to back *Hornsea, England* and numerals *701*

An example exhibited 'Style for the Mass Market – an exhibition of Hornsea pottery, 1949 to the present day', Scarborough Art Gallery, 1986 (exhib. cat., section 95–97, no. 701)

C45

John Clappison and **Michael Walker** for Hornsea Pottery Ltd, Hornsea

Lidded box with Hydrangea decoration, 1962

Moulded earthenware, matt white and grey glaze with moulded relief decoration, 7.5 cm × 7.5 cm (3″ × 3″)

An example exhibited 'Style for the Mass Market – an exhibition of Hornsea pottery, 1949 to the present day', Scarborough Art Gallery, 1986 (exhib. cat., section 108–10, no. 615)

C46

Alfred Burgess Read (1899–1973) for Poole Pottery Ltd

Vase, shape no. 700 and pattern no. PLC from the Contemporary range, *ca.* 1953

Thrown earthenware, with painted decoration, height 27 cm (10⁵/₈″)

Marks to underside, printed Poole Pottery stamp, impressed *700* and painted numbers

England and logo

This vase is one of six designs which were introduced briefly in 1961 as part of the Impasto range

C42

John Clappison for Hornsea Pottery Ltd, Hornsea

Athenia wall light, no. 703A from the Impasto range, designed *ca.* 1960, produced 1961 and 1963

Moulded earthenware, matt white glaze with sponged decoration

Marks to back, printed *Hornsea, England* company logo and a Design Centre label

C43

John Clappison for Hornsea Pottery Ltd, Hornsea

Olympia wall light, no. 703B from the Impasto range, designed *ca.* 1960, produced in 1961 only

Moulded earthenware, glazed matt white with sponged decoration, height 38 cm (14¹/₂″)

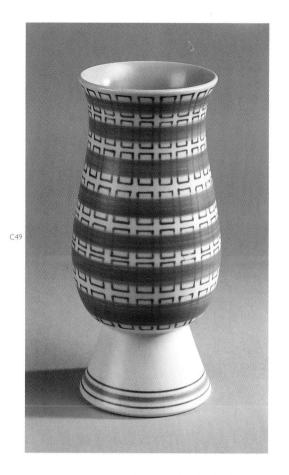

C49

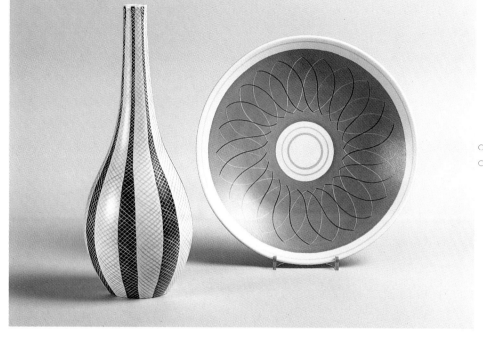

C47
C50

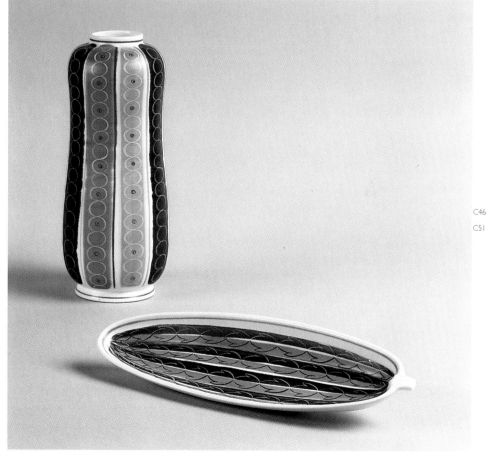

C46
C51

PUBLISHED *The Studio Yearbook of Decorative Art*, 1956–57, p. 81

C47
Alfred Burgess Read for Poole Pottery Ltd
Vase, shape no. 698 with pattern no. PKC from the Contemporary range, *ca.* 1953
Thrown earthenware, with painted decoration, height 39 cm (15¼")
Printed Poole Pottery stamp to underside
PUBLISHED *The Studio Yearbook of Decorative Art*, 1956–57, p. 81

C48
Alfred Burgess Read for Poole Pottery Ltd
Vase, no. 702 from the Contemporary range, *ca.* 1953
Thrown earthenware with 'moonstone grey' glaze, height 43 cm (17")
Printed mark to underside *Poole*

C48
C52

C53
C54

C56

C49
Alfred Burgess Read for Poole
Pottery Ltd
Vase, shape no. 704 and pattern no. PJL
from the Contemporary range, *ca.* 1953
Thrown earthenware, with painted decoration, height 28 cm (11")
Marks to underside. Printed Poole Pottery
stamp, impressed *704* and painted *X/PJL*
PUBLISHED *The Studio Yearbook of
Decorative Art*, 1956–57, p. 81

C50
Alfred Burgess Read for Poole
Pottery Ltd
Charger, with PRP decoration, from the
Contemporary range, *ca.* 1953
Thrown earthenware, with painted decoration, diameter 33 cm (13")
Printed Poole Pottery stamp to underside

C51
Alfred Burgess Read for Poole
Pottery Ltd
Dish, from the Contemporary range, pattern by Ruth Pavey, *ca.* 1954
Moulded earthenware with painted decoration, length 32 cm (12½")
Marks to underside, printed Poole Pottery
stamp and painted */TNCX*

C52
Alfred Burgess Read and **Guy
Sydenham** (1916–) for Poole Pottery
Ltd
Vase, no. 304 from the Freeform range,
ca. 1956
Moulded earthenware with 'black panther'
glaze, length 35.5 cm (14")

C53
Alfred Burgess Read and **Guy
Sydenham** for Poole Pottery Ltd
Vase, no. 352 from the Freeform range,
ca. 1956
Moulded earthenware with ice-green glaze,
height 19.5 cm (7¾")
Printed Poole Pottery stamp to underside

shapes which they expected would lack broad market appeal. During the latter part of the decade, however, a series of interesting technical experiments took place at Thomas Webb's under the management of Sven Fogelberg, who had joined the firm in 1932 after a period at Kosta. Fogelberg encouraged the designers to travel to Denmark and Sweden, and in 1959 the technologist Stan Eveson and designer David Hammond began to experiment with techniques they had witnessed in the Scandinavian glass houses. This resulted in the production of a series of asymmetrical bowls made following a Finnish method, some with bubble decoration, which were sold in limited numbers during the early 1960s. Eveson described the series of trials for these items as follows:

Eventually, by shaping molten lumps of glass on a steel rod with the use of wads of wet paper on a glassmaker's hand, and then piercing the lump with a metal spike, followed by the application of a wet wooden tool, very attractive articles were made, some with several coloured glasses combined.[5]

Experimentation with colour and form was perhaps more characteristic of Whitefriars Glass, which at this time was enjoying a fruitful period under the managing directorship of William Wilson. Wilson was an experienced designer who made a notable contribution to the Whitefriars output, largely in the area of cutting and engraving. In 1954 he took on the RCA graduate Geoffrey Baxter as assistant designer. Baxter was to become an important influence at Whitefriars during the following three decades.

The work of Baxter and Wilson indicates a strong awareness of Contemporary Swedish and Finnish glassmaking techniques, in particular in the use of newly developed colours set within thick clear-glass casing. Wilson's lobed

vase of 1954 is an example of the range of vessels which were produced in coloured cased glass. The thick walls and the organic form of these vessels contain references to the distinctive shapes which were typical of some of the Scandinavian glass, including Orrefors and the Finnish Notsjo. As Lesley Jackson has pointed out, however, the work of Wilson and Baxter was by no means merely a copy of Scandinavian production. Instead the two designers incorporated essentially British elements to produce a body of work which was distinctively Whitefriars.[6] The company was also to collaborate with John Hutton, whose expressive style of engraving, employed in large scale on the panels comprising the Great West Screen of the new Coventry Cathedral, was repeated in the haunting attenuated figures he engraved on to blank forms manufactured by Whitefriars.

In the area of machine-produced glass, two firms in particular were to patronize the work of industrial designers. The Midlands-based company Chance Brothers had commissioned glassware from Robert Goodden at the end of the 1940s, and in the mid 1950s was to affirm its interest in the Contemporary style by commissioning designs from Margaret Casson for the Fiesta range. The asymmetrical form of the Fiesta carafe was repeated in the organic forms of the accompanying dishes. All items were produced with enamelled decoration: Swirl was launched in 1955, and Night Sky, an angular pattern in the enduring Festival style, appeared in 1957. These designs were received with critical acclaim and Swirl also proved commercially successful, remaining in production until 1963. Perhaps less successful, aesthetically if not commercially, were the Handkerchief bowls made by the firm during the 1950s in imitation of the delicate Fazzoletti vases made by the

Venetian Paolo Venini.

The firms Sherdley and Ravenhead, both owned by United Glass Bottle Manufacturers, similarly updated the look of their machine-produced glassware. These firms employed the versatile RCA lecturer and industrial designer Alexander Hardie Williamson from the close of the War until his retirement in 1974. Williamson became responsible not only for the development of new ranges but also for the design of the firm's graphics and product packaging, which were an increasingly important feature of Ravenhead's marketing strategy. Williamson's graphic skills were fully exploited in the screen-printed tumblers which were produced in large quantities from 1956. The lingering popularity of the Contemporary style is evident in designs such as Skylon, which echoes the forms and language of the 'Festival of Britain'. Amongst Williamson's most successful designs for Ravenhead were his Paris Goblets, introduced in around 1955. This range of wine glasses in simple forms was conceived specifically for inexpensive automatic machine production. Williamson commented on his rôle as an industrial designer in a lecture of 1963:

The machine production of glassware involves engineering, mathematics, precision and repetition, and the best products of such processes will reflect these qualities. If combined sensitively and directed towards the solving of a use problem, the product can be designed to have simplicity, dignity and a restrained elegance.[7]

This brief discussion of the English glass industry has sought to give an account of some of the developments in design which took place between 1945 and 1962. It has to be concluded that whilst English glass designers were unable to work at the same level of artistic freedom as their counterparts in Scandinavia,

Czechoslovakia and other European centres of glass production, they nonetheless made some significant contributions to the British design scene.

Most successful were those designers who assimilated the traditional forms and techniques of the industry and injected these forms with a Contemporary styling and ethos. In the context of handmade glass, designers such as Irene Stevens were able to develop conventional decorative motifs to produce objects which reflected Contemporary developments in style and design. The nurturing of experimentation in colour and form which took place during this period at the glass factories of Whitefriars, and to a degree at Thomas Webb's, anticipated a new direction in British glass design. By the second half of the 1960s the studio glass movement was underway. A new generation of glass craftsmen and -women began to emerge from art and design colleges in the United Kingdom – including the RCA and Stourbridge College, where Stevens herself was teaching – to carry out experimentation and design in glass with a freedom that had never been seen before. Finally, the work of consultant designers, including Margaret Casson, enabled producers such as Chance Brothers to manufacture glass in the Contemporary style using fully mechanized mass-production techniques. Similarly, the work of Williamson at Ravenhead and Sherdley demonstrated the value of the industrial designer by its skilful compromise between modernist principles, the popular modernism of the marketplace and the demands of standardized machine production.

[1] This research on the emergence of Contemporary design in English crystal glass production during the immediate post-war period was submitted in 1993 as the thesis 'Manufacture and Design in Stourbridge 1945–1955' for the V&A/RCA MA course in the History of Design.

[2] Irene Stevens 'The Resurgence of a British Tradition', *Pottery and Glass*, January 1956, pp. 1–5.

[3] Hammond's decanter was illustrated, for example, in *Design*, nos. 61 and 54, 1953 and Stevens's article of 1956.

[4] For a discussion of the glass industry's contribution to the work of the Festival Pattern Group see Lesley Jackson, '"Synchronising with Contemporary Taste" – the British Glass Industry during the 1950s', *Journal of the Glass Association*, vol. 4, 1992, pp. 26–38.

[5] S.R. Eveson, *Reflections: 60 years with the Crystal Glass Industry*, Glassworks Equipment Ltd, 1990.

[6] L. Jackson (ed.), *Whitefriars Glass: The Art of James Powell and Sons*, Richard Dennis 1996, pp. 85–86.

[7] R. Dodsworth, *Slim Jims & Tubbies: the life and work of Alexander Hardie Williamson*, Broadfield House Glass Museum, Kingswinford, 1996.

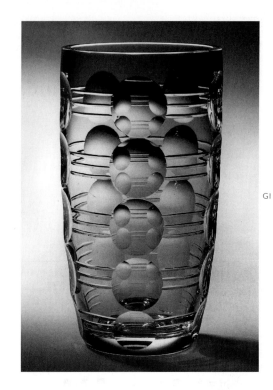

G1

G1

Irene Stevens (1917– : see Biography page 126) for T. Webb & Corbett Ltd, Stourbridge
Vase, *ca.* 1949
Clear colourless glass, cut and polished decoration, height 22 cm (8³/₄″)
Acid etched mark to base, *Webb Corbett England* with an *S* in the centre of mark. This mark used approximately between 1947 and 1949

G2

Irene Stevens for T. Webb & Corbett Ltd, Stourbridge
Vase, *ca.* 1949
Clear colourless glass, cut and decoration, height 20.5 cm (8″)
Acid-etched mark to base, *Webb Corbett England* with an *S* in the centre of mark. This mark used approximately between 1947 and 1949

G3

Irene Stevens for T. Webb & Corbett Ltd, Stourbridge
Bowl, *ca.* 1949
Clear colourless glass, cut and polished decoration, height 6.5 cm (2¹/₂″)
Acid-etched mark to base, *Webb Corbett, made in England*

G4

Irene Stevens for T. Webb & Corbett Ltd, Stourbridge
Vase, early 1950s, this example 1961 production
Clear colourless glass, cut and polished decoration, height 23 cm (9″)
Acid-etched mark to base, *Webb Corbett, made in England*, with *1961* in centre of mark

G5

John Luxton (1920– : see Biography page 126) for Stuart & Sons Ltd, Stourbridge
Vase, *ca.* 1949
Clear colourless glass, cut and polished decoration, height 24 cm (9¹/₂″)
Paper label to side of vase, *Stuart England*

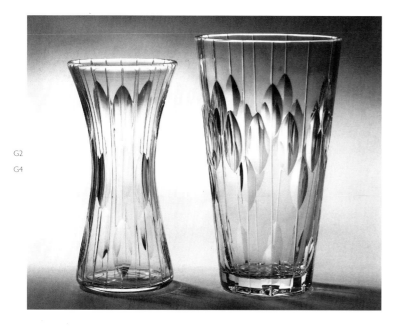

G2
G4

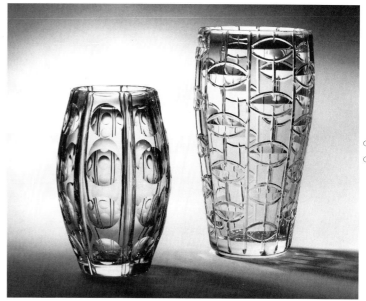

G6
G5

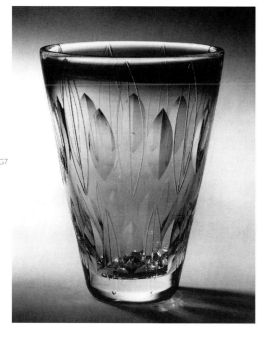

G7

G6
John Luxton for Stuart & Sons Ltd,
Stourbridge
Vase, 1949
Clear colourless glass, cut and polished
decoration, height 18.5 cm (7¹/₄″)
Acid-etched marks to base, *Stuart England*
PUBLISHED *The Studio Yearbook of
Decorative Art*, 1953–54, p. 112

G7
David Hammond (1931– : see
Biography page 126) for Thomas Webb &
Sons, Stourbridge
Vase, *ca.* 1954
Clear colourless glass, cut and polished
decoration, height 19.5 cm (7³/₄″)
Acid-etched mark to base, *Webb England*
PUBLISHED *Design*, no. 127, July 1959, p.
30, plate 10, for jug and tumbler with the
same decoration

G8
David Hammond and **Stanley
Eveson** for Thomas Webb & Sons,
Stourbridge
Dish, *ca.* 1961, from the Flair range
Green glass, cased with clear glass, bubble
decoration, diameter 25 cm (9³/₄″)
Acid-etched mark to base, *Webb England*

G9
David Hammond and **Stanley
Eveson** for Thomas Webb & Sons,
Stourbridge
Dish, *ca.* 1961, from the Flair range
Blue glass cased with clear colourless glass,
bubble decoration, diameter 19 cm (7¹/₈″)
Acid-etched mark to base, *Webb England*

G10
William Wilson (1914–1972) and
Bernard Fitch for James Powell & Sons
Ltd, Whitefriars Glass Company, London
Bowl C207, before 1950
Clear colourless glass, cut and polished
decoration, diameter 23.5 cm (9³/₁₆″)
An example exhibited 'Whitefriars Glass –
The Art of James Powell & Sons',
Manchester Art Gallery, 1996
PUBLISHED *Whitefriars Glass – The Art of
James Powell & Sons*, 1996, p. 137, item 2

G11
William Wilson for James Powell &
Sons Ltd, Whitefriars Glass Company,
London
Vase 9410, *ca.* 1954
Green glass cased in clear colourless glass,
height 14.5 cm (5⁵/₈″)
An example exhibited 'Whitefriars Glass –
The Art of James Powell & Sons',
Manchester Art Gallery, 1996
PUBLISHED *Whitefriars Glass – The Art of
James Powell & Sons*, 1996, p. 134, plate 142

G12
Geoffrey P. Baxter (1936–1995: see
Biography page 127) for James Powell &
Sons Ltd, Whitefriars Glass Company,
London
Vase 9431, *ca.* 1956
Blue glass cased in colourless clear glass,
bubble decoration, height 19.5 cm (7⁵/₈″)

G14
G11
G12
G15

G17

An example exhibited 'Whitefriars Glass –
The Art of James Powell & Sons',
Manchester Art Gallery, 1996
PUBLISHED *Whitefriars Glass – The Art of
James Powell & Sons*, 1996, p. 134, plate 142

G13
Geoffrey P. Baxter for James Powell
& Sons Ltd, Whitefriars Glass Company,
London
Bowl 9407, *ca.* 1956
Blue glass cased in colourless clear glass,
bubble decoration, height 9 cm (3⁵/₈″)

An example exhibited 'Whitefriars Glass –
The Art of James Powell & Sons',
Manchester Art Gallery, 1996
PUBLISHED *Whitefriars Glass – The Art of
James Powell & Sons*, 1996, p. 134, pl. 142

G14
Geoffrey P. Baxter for James Powell
& Sons Ltd, Whitefriars Glass Company,
London
Vase, *ca.* 1956
Blue glass cased in colourless clear glass,
bubble decoration, height 24 cm (9¹/₂″)

G15
Geoffrey P. Baxter for James Powell
& Sons Ltd, Whitefriars Glass Company,
London
Bowl 9525, *ca.* 1957
Blue glass cased in colourless clear glass,
height 12 cm (4⁵/₈″)
An example exhibited 'Whitefriars Glass –
The Art of James Powell & Sons',
Manchester Art Gallery, 1996
PUBLISHED *Whitefriars Glass – The Art of
James Powell & Sons*, 1996, p. 135, plate 147

G16
Geoffrey P. Baxter for James Powell
& Sons Ltd, Whitefriars Glass Company,
London
Jug, 1960
Ruby-coloured glass with applied handle in
colourless clear glass, height 27 cm (10¹/₂″)
PUBLISHED *Whitefriars Glass – The Art of
James Powell & Sons*, 1996, p. 83, plate 208

G17
Geoffrey P. Baxter for James Powell
& Sons Ltd, Whitefriars Glass Company,
London
Five vases, 9594, 9596 (x2), 9599, 9601,
designed 1961–62
Amethyst soda glass, 9594 height 20.5 cm
(8″); 9596 height a: 18.5 cm (7¹/₄″), b: 24
cm (9³/₈″); 9599 height 18 cm (7″); 9601
height 18 cm (7¹/₈″)
Unmarked, except 9594, paper label to the
side of the vase, *Whitefriars Crystal, Made in
England* and company logo
Developed using obsolete lighting moulds

G18
John Hutton (1907–1978)
Angel vase, 1958–59
Colourless clear glass, engraved decoration,
height 41.5 cm (16³/₄″)
Vase blank made by James Powell & Sons
Ltd, Whitefriars Glass Company, London
PUBLISHED *British Art & Design
1900–1960*, 1983, p. 185
LENT BY Broadfield House Glass Museum,
Kingswinford

G19

Company Design Team for W.E. Chance & Co. Ltd, Smethwick

Dish, Fiesta ware with Swirl decoration, *ca.* 1955

Clear colourless glass, printed decoration, length 36 cm (14⅛″)

PUBLISHED *Pottery & Glass*, November 1955, p. 342

Swirl appears to be derived from one of Margaret Casson's 1955 designs for W.E. Chance

G20

Company Design Team for W.E. Chance & Co. Ltd, Smethwick

Drinks set, Fiesta ware with Swirl decoration, *ca.* 1955

Clear colourless glass, printed decoration and gilding, tray: diameter 25.5 cm (10″); carafe: height 30.5 cm (12″); tumbler: height 12 cm (4¾″)

G21

Margaret Casson (1913–) for W.E. Chance & Co. Ltd, Smethwick

Giraffe carafe, Fiesta ware with Night Sky decoration, *ca.* 1955–56

Clear colourless glass, printed decoration and gilding, height 31 cm (12⅛″)

'Night sky' is derived from astronomical charts used for plotting star configurations.

PUBLISHED *Design*, no. 108, December 1957, p. 41

G22

Margaret Casson for W.E. Chance & Co. Ltd, Smethwick

Dish, Fiesta ware with Night Sky decoration, *ca.* 1955–56

Clear colourless glass, printed decoration and gilding, height 22.5 cm (8¾″)

G23

Margaret Casson for W.E. Chance & Co. Ltd, Smethwick

Two prototype dishes, 1955

Opaque white glass, printed decoration, a: diameter 30.5 cm (12″); b: diameter 38 cm (15″)

Margaret Casson produced six designs for Chance in 1955, only one of which went into full production

G24

Alexander Hardie Williamson (1907–1994) for the Sherdley Glassworks, United Glass

A selection of screen-printed tumblers, late 1950s–early 1960s

EXHIBITED 'Slim Jims & Tubbies – the life and work of designer Alexander Hardie Williamson', Broadfield House Glass Museum, Kingswinford, 1996

PUBLISHED *Slim Jims & Tubbies*, exhib. cat., Kingswinford, Broadfield House, 1996

LENT BY Broadfield House Glass Museum, Kingswinford

Hardie Williamson studied textile design at the RCA, where he subsequently taught, being appointed Head of Printed Textiles in 1951. From 1944 to 1974 he was employed as design consultant to United Glass. He was responsible for many classic designs of industrially produced glass, some of which, such as the Paris Goblet, are still in production

G25

Alexander Hardie Williamson for the Sherdley Glassworks, United Glass

Selection of glasses from the Worthington suite, *ca.* 1948, first produced in 1949; the Club suite, *ca.* 1948, first produced in 1949; the Paris Goblet suite, first produced mid 1950s

EXHIBITED 'Slim Jims & Tubbies – the life and work of designer Alexander Hardie Williamson', Broadfield House Glass Museum, Kingswinford, 1996

PUBLISHED *Slim Jims & Tubbies*, exhib. cat., Kingswinford, Broadfield House, 1996

LENT BY Broadfield House Glass Museum, Kingswinford

G18

G21
G20

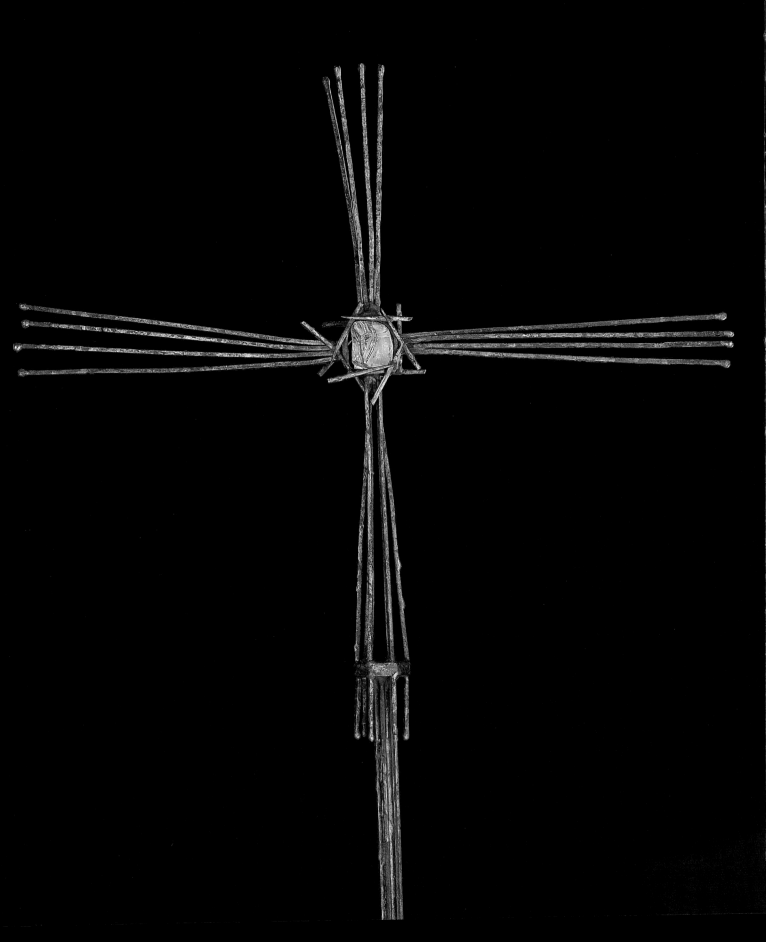

Silver and Metalwork

ANNAMARIE STAPLETON

In 1945 the silver industry was in much the same way as other British industries. During and immediately after the War there was a shortage of gold and silver and, unless classed as a masterpiece or work of art, the industry's produce was subject to huge Purchase Taxes. Little, understandably, had been produced during the war years. The bulk of inter-war production was largely reproduction antique or poor quality, art deco pastiche. Compared with other industries producing less intrinsically valuable 'arts', such as ceramics, textiles and plastics, Bevis Hillier declared, "in silverwork there was no such originality to be found". He felt that none of the exhibits at the Worshipful Company of Goldsmiths' (the Company) Modern Silver show in 1934 "rose above the Deco-traditionalism mixture". This was a harsh comment about an industry where concerted efforts had been made from the late 1920s onwards, particularly through the Company. However, it is generally true that the silver and metalwork industries were slower in developing a modern aesthetic. There was very little being made before the mid 1950s that we would now consider intrinsically new or modern. Graham Hughes admitted that the Worshipful Company of Goldsmiths found it near impossible to fill "a meagre six showcases" with post-war silver for their exhibition 'Public Patronage' in 1953.

A small number of talented designers had been working in a modern style during the 1930s and continued successfully after the War. These silversmiths were arguably most important in their rôles as teachers and facilitators to the designers of the 1950s. Alexander Styles and Eric Clements, along with their contemporaries Cyril Shiner, Leslie Durbin, R.G. Blaxendale and R.Y. Goodden, had a direct influence on the young post-war designers Robert Welch, Gerald Benney,

David Mellor and Stuart Devlin, all of whom trained at the Royal College of Art, London (RCA). Typical of the work of this older group are Goodden's 1951 Festival teaset (made by Durbin, now at the Victoria and Albert Museum, London) and his magnificent Queen's Cup made for the Coronation in 1953. These were highly acclaimed at the time but are still very much in the Arts and Crafts tradition.

Here we concentrate on five silversmiths. Although by no means the only designers producing modern metalwork in Britain, Welch, Benney, Mellor and Devlin, along with Louis Osman, and with the support of Graham Hughes, were central to the changes in the international status of the British silver industry during the latter half of the 1950s. Hughes was a significant figure in the development and marketing of the industry as Art Secretary to the Company from 1951–1961, and as sometime selector for the Council of Industrial Design and the RCA. He also attended committees at 'more practical' art schools such as the Central School of Arts and Crafts and Birmingham.

The RCA and the CoID were inextricably linked, not least through Gordon Russell whose brother R.D. Russell was Professor of Furniture Design at the RCA, and who was well acquainted with Robin Darwin, Principal of the College. Much emphasis has been laid on their joint contribution to the emergence of a modern British aesthetic and the industry's employment of young designers.

However, Graham Hughes is doubtful about the contribution of the alliance between the RCA and CoID in the silver industry, largely because of the former's emphasis on designing on paper, and the latter's feeble exhibitions which did little to persuade industry and commerce to buy and commission silver. On the other hand, individuals such as David Mellor feel it provided an essential introduction to

industry and allowed young designers like him to diversify their knowledge of other media and industries. The obvious examples are the highly successful designs produced by Welch in stainless steel, a relatively new material not yet fully exploited in the production of domestic tablewares, and in stainless steel and pewter by Benney. Mellor also produced designs for street furniture: benches, lighting and bus-stops, as well as the classic plastic disposable cutlery for Cross; Welch a water softener, bathroom fittings, tyre tread, tableware, lights and clocks, amongst other things; Devlin designed coinage for more than thirty countries, furniture, a car and also turned his hand successfully to sculpture. Even Benney, who remained most faithful to silversmithing, designed domestic desk lamps. The CoID's publications such as *Design* gave the new metalwork plenty of exposure.

It cannot be denied that the RCA was important to the silver industry that emerged during the 1950s. The small but dynamic department headed by Professor R.Y. Goodden saw Welch, Mellor and Benney as contemporary students. Their combined talents and interaction of ideas created an inspirational atmosphere. Devlin, who followed in 1958 as a postgraduate from Australia courtesy of several well earned travel grants, attributes much of the department's success to Goodden as a facilitator, providing "maximum encouragement with minimum interference".

The Worshipful Company of Goldsmiths had recognized the problems inherent in the industry in the late 1920s and had established various schemes to promote modern silver on an industrial and workshop basis and to encourage patronage for special commissions from industry and academic institutions as well as for state and ecclesiastical occasions. Their competitions, exhibitions at home

and abroad, publications and their own collection of modern silver all helped to develop links between art schools and industry, to stimulate export trade and to increase public awareness after the War.

Many young designers received their early commissions through or from the Company. Many of these pieces were given by the Worshipful Company to institutions to whet their appetites and generate further commissions. Hughes recognized Devlin's talent and commissioned a centrepiece for the Tercentenary of the Royal Society whilst he was still a student. Having completed his RCA coursework early Devlin was able to spend time working in other departments and in industrial design. He moved to the United States for a while, returning briefly to Australia and settling back in Britain in 1965. Unlike the other three RCA graduates, Devlin denies any influence from Scandinavia or elsewhere and his work is certainly diverse but instantly recognizable as his hand.

To most designers, however, the Scandinavian industry was not only influential stylistically, the status of the top silversmiths was inspirational. Henning Koppel and Sigurd Persson were highly paid, well respected members of society and minor celebrities at home. As Robert Welch says, "the philosophy of the Scandinavians, so popular at the time, designing simple, everyday objects that were functional and beautiful and which most people could afford, greatly appealed".

David Mellor describes the atmosphere of the post-war design world as very optimistic and dynamic. Young designers knew they were in a very special and exciting period of growth. Everyone wanted to create something new, something that was theirs and of their time, something truly Contemporary. Mellor's Sheffield background gave him a

natural curiosity for cutlery design and he became fascinated with trying to produce the ultimate simple design. The Pride cutlery service he designed for Walker & Hall in 1954, for whom he was design consultant, won a Design Centre Award. It combined precious and non-precious materials in a Contemporary look but was ultimately a simplification of traditional eighteenth-century flatware. He and Welch collaborated on Campden cutlery for Walker & Hall and Old Hall tableware, which won a silver medal at the Milan Trienniale in 1958 and was more successful aesthetically and commercially as a modern design than Pride. Mellor's teaset for the Pride series is one of the most enduring design classics of the 1950s. It won a CoID Award in 1959 for both aesthetic and practical reasons.

Like other designers working in metal much of Robert Welch's silver production was for special commissions, whilst work in other media was for mass production and often retail sale. It was frequently the case that the one-off commissions allowed designers more freedom than designing for mass-production. Retaining their silver workshops may therefore have been instrumental in keeping these designers developing individual styles and made their work for industry so attractive. One of the most memorable of Welch's designs for silver is the Jackson Pollock-inspired seven-rod candelabrum, but the Imperial College fruit bowl, designed in 1955, shows the development of his ideas for domestic wares better.

Whilst Mellor produced highly accomplished and acclaimed designs for immensely diverse companies, Welch arguably made the best transition to industrial design in domestic metalwares, devoting much energy to the stainless steel tableware he designed for J & J Wiggins's Old Hall tableware for whom he worked as a consultant designer after

graduating. The Campden, Oriana and Alveston ranges are instantly recognizable as his hand. Wiggins were the first firm in Britain to produce stainless-steel tableware. From about 1934 they had employed Harold Stabler to produce a series of stainless-steel plates and bowls with experimental finishes and etched decoration. Welch's designs, in contrast, rely on their distinctively modern shape, a characteristic formed during his time at the RCA under Robert Goodden and, courtesy of a travelling scholarship, in Sweden and Norway.

Benney, who was trained initially in the Arts and Crafts workshop that had been founded by Eric Gill in Ditchling, Surrey, and at Brighton College before going to the RCA, also admits to a heavy stylistic dependence on Scandinavian silversmiths in his student days. His silver teaset (1952, cat. M21) is testament to this. He recalled breaking that dependence while designing a centrepiece for an American client. The initial design was rejected as a pastiche of Scandinavian design and in a fit of fury Benney went off and produced an alternative and original piece. His new style was distinctively British: simple, clean, linear forms, related to, but not dependent on, the free-form shapes of Scandinavian and American metalwork. It was a success.

Benney is probably most readily associated with the textured finish he invented for silver in the late 1950s and later used for pewter, a personal hallmark that was much copied. This came about, in the best tradition of all good inventions, by accident. He set up his own workshop, after graduating from the RCA in 1955, and began designing silver and pewter for Viners. He was appointed as their consultant designer in 1957. The Viners Martini set (cat. M18) epitomizes the attenuated modern style that Benney developed. His Studio cutlery pattern for them became one of the best selling designs. When Benney went back to the RCA as Professor of Silversmithing and Jewellery from 1974 to 1983, he worked at reproducing a creative and fun atmosphere in the department.

Louis Osman, the elder statesman of the group, trained as an architect at the Bartlett School of Architecture and the Slade, and has been described as an inconsequential maverick, an obsessive perfectionist and a genius by his peers. When Graham Hughes wrote Osman's obituary in 1996 he described him as an "... architect, goldsmith, draftsman, art historian and art patron. Most of all he was a creator of genius". As an architect Osman rebuilt the bomb-damaged Covent of the Holy Child of Jesus in Cavendish Square in 1950, commissioning Jacob Epstein's *Mother and Child* sculpture. He also commissioned Geoffrey Clarke to design the stained glass for the Principal's Lodge of Newnham College, Cambridge, and whilst restoring Shere Church, Surrey, collaborated with Clarke on altar furnishings. He later worked with Graham Sutherland on the Ely Cathedral Cross. Sutherland wrote to him as "the only architect I know who can draw". Unfortunately, like many of Osman's commissions, it ran over budget and was consequently rejected by Ely. Peter Jenkins, a close associate at the Worshipful Company of Goldsmiths and instrumental in many of the commissions Osman received via the Company, suggested that the design was too avantgarde for the authorities at the Cathedral. Jenkins helped find a home for the cross in a private collection and it has since been donated to Dallas Museum, Texas.

Louis Osman's work has a very hands-on feel: the Alpha and Omega dish, 1958, at Goldsmiths Hall quite literally shows the way he pushed and dragged the metal to create the textured surface he desired. One of his most fantastic commissions, although outside the remit of this essay, was Prince Charles's Investiture Crown, now in the National Museum of Wales, Cardiff.

Osman turned to silversmithing, or more accurately to goldsmithing, and registered a hallmark in 1958, having been so impressed by the royalties from his friend Gerald Benney's Studio series for Viners. These reputedly gave Benney an income greater than that of the ICI Chairman at the time. Osman was a leading figure in the international success of Britain's jewellery industry from the early 1960s, winning the coveted De Beers British Jewellery Competition in 1961 with a gold and diamond necklace. His designs were never intended for mass-production or for mass appeal, nor really even to please his clients. He created exquisite and often extremely expensive pieces and cost was never a consideration. Once Osman had an idea he had to fulfil his vision. Commissioned to create the Government gift to the United States, for their Bicentennial Celebrations, Osman insisted that a piece of pink granite from the Outer Hebrides be helicoptered to him to be incorporated into the gold and enamel box for the Magna Carta (the original was briefly on loan and later replaced by a gold replica made by Osman). The cost of the materials and transport, which symbolized the link between Britain and the United States, ensured that the cost of the commission was double that expected and the shortfall bankrupted him.

Athol Hill and Brian Asquith are among notable others whose work also reflects the mood and influences of the time. By the mid 1960s there were thirty or forty designers producing modern work, but it is these five who really brought British silver into the modern world and Contemporary silver and metalwork into the modern home, becoming household names in the process.

M1
Robert Welch (1929– : see Biography
page 127) for Old Hall, J & J Wiggin Ltd
Toast rack from the Campden range, 1956
Stainless steel, length 19 cm (7½")
Stamped on base *Old Hall/England/Designed*
by R Welch/18/8 Stainless steel
An example exhibited 'Robert Welch
Designer/Craftsman. A Retrospective
Exhibition 1955–1995', Cheltenham, 1995
PUBLISHED *Design*, April 1957, p. 29
Awarded Design Centre Award, 1958

M4
M12

M2
Robert Welch for Old Hall, J & J
Wiggin Ltd
Coffee set from the Campden range, 1956
Stainless steel with wooden handles, coffee
pot height 18.5 cm (7¼")
Stamped on base *Olde Hall/Stainless*
Steel/Made in England/1 PT
PUBLISHED *Design*, April 1957, p. 30

M3
Robert Welch for Old Hall, J & J
Wiggin Ltd
Coffee set from the Campden range, *ca.*
1957
Stainless steel with teak handles, coffee pot
height 18.5 cm (7¼")
Stamped on base *Olde Hall England/*
Designed by R.Welch/18/8 Stainless Steel
An example exhibited 'The New Look –
Design in the Fifties', Manchester, 1992;
'Robert Welch Designer/ Craftsman. A
Retrospective Exhibition 1955–1995',
Cheltenham, 1995; 'Design of The Times:
One Hundred Years of the Royal College of
Art', London, 1996
The now familiar appearance of the
Campden coffee set differs somewhat from
Welch's original design for Old Hall. Welch
reworked the handle and knob, refining the
proportions and shape. The earlier version,
illustrated in the April 1957 *Design*, was
replaced very quickly by this second version
which bears the updated manufacturer's
stamp.

M2

M4
Robert Welch for Old Hall, J & J
Wiggin Ltd
SP304 cruet set, comprising salt, pepper and
mustard pots and spoon, 1957
Stainless steel, salt and pepper height
11.5 cm (4½")
Stamped on base *Old Hall England/Designed*
by R.Welch/18/8 Stainless Steel
An example exhibited 'Robert Welch
Designer/ Craftsman. A Retrospective
Exhibition 1955–1995', Cheltenham, 1995

PUBLISHED *Design*, no. 123, March 1959,
p. 31

M5
Robert Welch for Old Hall, J & J
Wiggin Ltd
Three-part candleholder, 1957
Stainless steel and teak, maximum height 23
cm (9")
Stamped *Stainless/Old Hall/England*
An example exhibited 'Robert Welch
Designer/ Craftsman. A Retrospective
Exhibition 1955–1995', Cheltenham, 1995

M5

M8
M6

M9

M6

Robert Welch for Old Hall, J & J Wiggin
Ltd
Jug from the Oriana range, 1958
Stainless steel, height 21 cm (8¼")
Etched on base *Shipco* and stamped
*Designed by R.Welch/Old Hall/England/18/8
Stainless Steel*
An example exhibited 'Robert Welch
Designer/Craftsman. A Retrospective
Exhibition 1955–1995', Cheltenham, 1995
The Oriana range won a Design Centre
Award in 1963. It was designed for use on
the P & O Line ships and the pieces made
specifically for this purpose are marked
Shipco. The range was also sold commer-
cially by Old Hall under the name Oriana
and these pieces do not bear the *Shipco*
mark.

M7

Robert Welch for Old Hall, J & J Wiggin
Ltd
Small serving dish from the Oriana range,
1958
Stainless steel, 14.5 cm (5⅞")
Etched on base *Shipco* and stamped
*Designed by R. Welch/Old Hall/England/18/8
Stainless Steel*
PUBLISHED *Design*, June 1963, p. 64
The serving dishes from the Oriana range

were awarded a Design Centre Award in
1962, a year before the entire range was
awarded the same prize.

M8

Robert Welch for Old Hall, J & J Wiggin
Ltd
Oval serving dish from the Oriana range,
1958
Stainless steel, length 40 cm (15¼")
Etched *Shipco* and stamped *Designed by
Robert Welch/Old Hall/England/18/8 Stainless
Steel*
PUBLISHED *Design*, June 1963, p. 64

M9

Robert Welch for Old Hall, J & J Wiggin
Ltd
Teapot, water jug, milk jug and sugar bowl,
from the Oriana range, 1962
Stainless steel, teapot height 15 cm (6¾")
Milk jug and sugar bowl etched *Shipco* and
all pieces stamped *Designed by Robert
Welch/Old Hall/England/18/8 Stainless Steel*

M10

Robert Welch for Mappin & Webb Ltd
Oriana cutlery: knife, fork and spoon, 1957
Stainless steel, length 20.5 cm (8")
Stamped *Mappin & Webb Ltd Sheffield 18/8*

M10

M11
Robert Welch for Old Hall, J & J
Wiggin Ltd
Teapot, hot water jug and milk jug from the
Alveston range, 1962
Stainless steel, teapot height 11.5 cm (4½")
Stamped *Designed by Welch/Old Hall/
England/18/8 Stainless Steel*
An example exhibited 'Robert Welch
Designer/Craftsman. A Retrospective
Exhibition 1955–1995', Cheltenham, 1995;
and 'Design since 1945', Philadelphia, 1984
PUBLISHED *Design*, no. 181, January 1964,
p. 31
The Alveston range won a Design Centre
Award in 1965

M12
Robert Welch for Old Hall, J & J Wiggin
Ltd
Cruet set from the Alveston range, 1962
Stainless steel and plastic, height 5 cm (2")
Stamped *Designed by Welch/Old Hall/
England/18/8 Stainless Steel*

M13
Robert Welch for Old Hall, J & J Wiggin
Ltd
Vase from the Alveston range, 1962
Stainless steel, height 25 cm (10")
Stamped *Designed by Welch/Old Hall/
England/18/8 Stainless Steel*

M14
Robert Welch for Old Hall, J & J Wiggin
Ltd
Cake dish with handle, *ca.* 1962
Stainless steel, diameter 25.5 cm (10")
Stamped *Designed by R. Welch/ Old Hall/
England/18/8 Stainless Steel*

M15
Robert Welch
Double bowled fruit-bowl with engraving,
made for Imperial College, London, 1955
Silver and silver gilt, length 57.5 cm (22½")
PUBLISHED Design drawing illustrated in
Hand & Machine, Robert Welch, 1986, p. 40
LENT BY Imperial College, London

M13

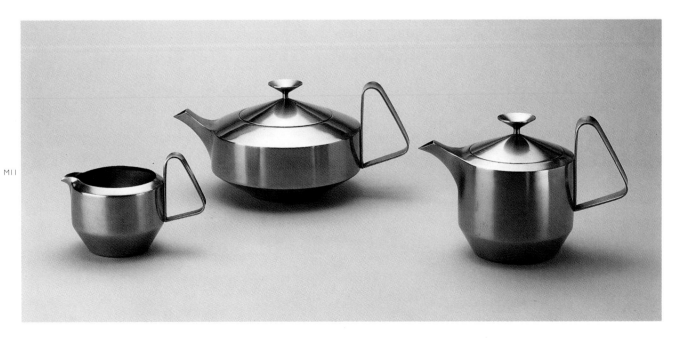

M11

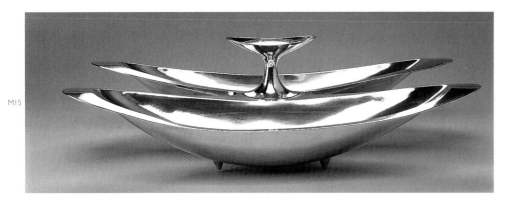

M15

M19
M20

M17

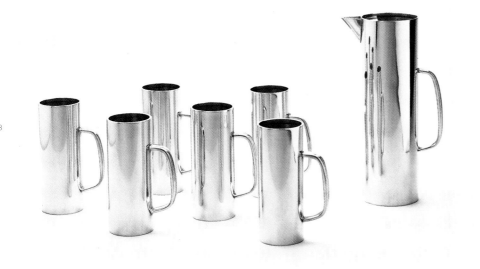

M18

M16
Robert Welch
Presentation cup, 1960
Silver and silver gilt, height 21.5 cm (8½")
This cup was commissioned for presentation to the architect Leslie Gooday as first prize for his exhibition stand design for Tube Investments at the British Exhibition, New York, in 1960
LENT BY Leslie Gooday

M17
Gerald Benney (1930– : see Biography page 127) for Viners of Sheffield
Three candlesticks and tray, *ca.* 1957
Pewter, max. height 8.5 cm (3¼"), length 34 cm (13½")
Stamped *English Pewter Made by Viners of Sheffield Designed by Gerald Benney Made in England*

M18
Gerald Benney for Viners of Sheffield
Martini set, comprising a jug and six mugs, *ca.* 1957
Pewter, jug height 25.5 cm (10")
Stamped *English Pewter Made by Viners of Sheffield Designed by Gerald Benney*
PUBLISHED Brian Larkman and S.H. Glenister, *Contemporary Design in Metalwork*, 1963, p. 75
This design is in the Victoria and Albert Museum's permanent collection.

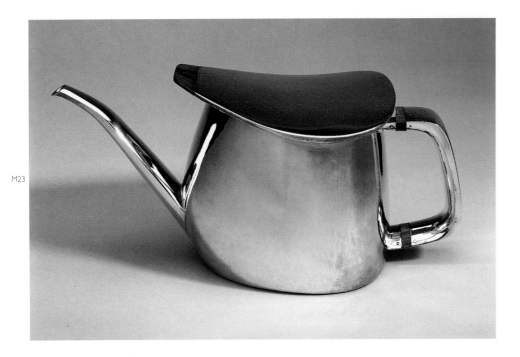

M19
Gerald Benney for Viners of Sheffield
Studio carving set in original packaging,
early 1960s
Stainless steel, knife length 33.5 cm (13⅛″)
Etched and impressed *Viners of Sheffield/
Stainless/ England*
PUBLISHED Richard Stewart, *Modern
Design in Metal*, 1979, p. 42

M20
Gerald Benney for Viners of Sheffield
Studio fish eaters, six pairs of knives and
forks in original packaging, early 1960s
Stainless steel, knife length 22.3 cm (8¾″)
Stamped *Viners of Sheffield/England/Stainless
Steel*

M21
Gerald Benney
Teaset on tray, 1952
Silver, length of tray 60 cm (24″)
Hallmarked with marker's mark *A.G.B.* and
dated *1952*
This is one of Benney's degree pieces, made
at the Royal College of Art
LENT BY Gerald Benney

M22
Gerald Benney
Cruet set, comprising salt and pepper and
mustard pot with spoon, 1955
Silver, height of pots 9 cm (3½″)
Hallmarked with maker's mark *A.G.B.* and
dated *1955*
LENT BY Imperial College, London

M23
Gerald Benney
Teapot, 1962
Silver, height 14.5 cm (5¾″)
Hallmarked with maker's mark *A.G.B.* and
dated *1960*
LENT BY Graham Hughes

M24
David Mellor (1930– : see Biography
page 127) Walker & Hall, Sheffield
Pride teaset, 1955
Silver with leather covered handles, teapot
height 16.5 cm (6½″)
Stamped *Walker and Hall/Sheffield/53718*
and hallmark for Walker & Hall 1964
PUBLISHED This design is illustrated in
Design, 1959, p. 38. An electroplate version
from the museum's permanent collection is

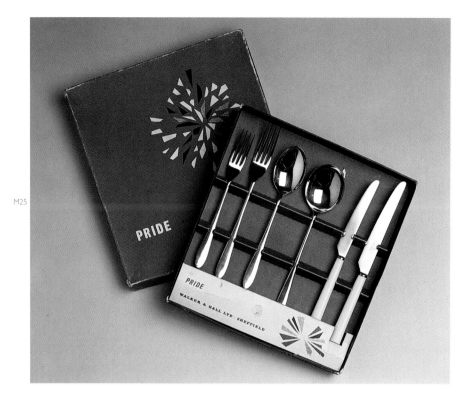

illustrated in *British Art & Design 1900–1960*, Victoria & Albert Museum, 1983

M25
David Mellor for Walker & Hall, Sheffield

Pride six-piece place setting, in original packaging, 1954
Electroplated silver with nylon handles, knife length 20.5 cm (8")
Stamped variously *Walker & Hall/Sheffield/Pride*
An example exhibited 'Design of the Times: One Hundred Years of the Royal College of Art', London, 1996
The Pride cutlery range was highly praised on its launch, winning a Design Centre Award in 1957

M26
Louis Osman (1914–1996: see Biography page 127)
Processional cross for St James's Church, Shere, 1956
Brazed steel with shagreen grip
EXHIBITED 'Artists Serve the Church', Coventry, 1962, an exhibition organized by the Exhibition Committee of the Coventry Cathedral Festival to coincide with the consecration of the Cathedral.
Osman and Geoffrey Clarke also designed an altar cross, candlesticks and three altar frontals for Shere
LENT BY The Parish Council, St James's Church, Shere

M27
Stuart Devlin (1931–)
Teapot, 1958
Gilding metal, length 20 cm (8")
EXHIBITED '25 Years of Stuart Devlin in London', The Worshipful Company of Goldsmiths, 1983
This prototype was made while Devlin was still at the Royal College of Art. The final piece in silver was purchased by The Worshipful Company of Goldsmiths
LENT BY Stuart Devlin

M28
Stuart Devlin
Tercentenary centrepiece, 1959
Silver and silver gilt, diameter 42 cm (16½")
Maker's marks and hallmarks for 1959
Commissioned to celebrate the tercentenary of the founding of the Royal Society
LENT BY The Royal Society

Domestic Equipment and Product Design

RICHARD CHAMBERLAIN
AND GEOFFREY RAYNER

Leaving apart the pre-war work of modernists such as Wells Coates, Serge Chermayeff and A.B. Rhead, the concept of industrial design initially played a limited part in British post-war industry. It was not until the early 1960s that the rôle of the industrial designer became more widely understood and accepted. In the post-war era, despite the founding in 1936 of the prestigious Royal Designer for Industry award by the Royal Society of Arts, industrial design remained a minority interest. Wally Olins writes that industrial design in the 1950s was seen as "quaint, somewhat precious and only of peripheral significance in the real world".[1]

Both in the light of these circumstances, and because of the severe manufacturing restrictions on industry and shortages of raw materials following the end of the War, the number of well designed pieces of domestic hardware displayed at the 'Britain Can Make It' exhibition of 1946 is somewhat extraordinary. The exhibition, held at the Victoria and Albert Museum in London, was organized by the newly formed Council of Industrial Design, which throughout the late 1940s and 1950s became, under the direction of its chairman, Gordon Russell, the principal propagandist for implementing a modernist, functionalist agenda for what the Council considered to be good design.

The peacetime application of new technologies and materials developed to meet wartime needs was a central theme of the exhibition, which could easily have been termed 'from a Spitfire to a saucepan'.[2] A particular range of saucepans shown, Daleware by New Era Domestic Products Ltd, was to have some considerable commercial success throughout the late 1940s and was again exhibited at the 1951 'Festival of Britain'. The design was well thought through and, like much other domestic hardware of the 1940s, was made from surplus wartime aluminium alloy. Amongst other cooking utensils shown at the exhibition was the Rada range of casseroles, manufactured by Radiation Ltd. The range, made of enamelled cast iron, is remarkable for its elegant advanced design, one that could easily be mistaken for a Contemporary-styled Scandinavian design of some ten or fifteen years later. A further and lively example of the original use of surplus aluminium alloy shown at the exhibition was a witty zoomorphic juice press by Condrup Ltd.

This extensive use of aluminium for domestic appliances continued throughout the 1940s. Probably the best known of them, and justifiably so, was the elegant and sculptural reworking of the Cona coffee percolator by the graphic designer Abram Games for the 'Festival of Britain'. Yet another classic of the period was Lesley J. Thomas's electric fan for the General Electric Company. Also made of enamelled cast aluminium, it was organic in form with blades of rubber and was included as part of GEC's display at the exhibition.

The lively quirkiness and originality of some aspects of British domestic product design in the 1940s faded in the early 1950s. The lifting of manufacturing restrictions and increasing availability of materials, coupled with a growing general affluence and easy access to credit through hire/purchase arrangements, greatly accelerated the demand for consumer durables. Items such as refrigerators, washing machines, foodmixers and hairdryers, symbols of the American dream, began to figure largely in consumer demands, and it was American styling that was required to sell them. The large majority of British manufacturers at this period incorporated a generic American style into the design of their products.

Much American product design in the

1950s was often little more than a restyling of products from a repertoire of 'stick on' goodies and the continued use of 1930s 'streamlining' in attempts to boost a company's market share. The American pioneer industrial designer Raymond Loewy gave some rationale for this when he wrote that "Between two products equal in price, function and quality the better looking will out-sell the other."[3]

The extreme styling of American cars of the period and the excessive use of chrome trims and ornamentation are a classic example of what was known amongst the American design fraternity as Borax. Jonathan Woodham writes that:

Automobile-derived styling and ornament was typical of many products during the 1950s; cooker instrument panels reflected car dashboards; the chromium plated character of other domestic appliances looked to car door handles and makers marques and badges; even radio's shared similar technologically orientated ornament and styling.[4]

However, despite the all pervasiveness of American styling in domestic hardware, radio was one of several areas of product design in Britain where the employment of leading designers within the industry had been established practice since the 1930s. The modernists Wells Coates and Serge Chermayeff had designed a number of radios for the Ekco Company during the 1930s, and Gordon Russell's brother, R.D. Russell, became design consultant to the Murphy Radio Company.

With the end of the War Murphy reinstated their design team, which consisted of Russell, the architect Eden Minns and the designer A.F. Thwaites. At the 'Britain Can Make It' exhibition, Murphy launched the first of a series of radical new radio designs based on the 'baffle board' principle. The use of the baffle board was an attempt to improve sound quality by eliminating the resonance of the then standard box design of radios.[5] The resulting solution, by Thwaites, consisted basically of a flat board which was lent against a wall for support.

The design was far too radical for public taste and between 1946 and 1948 Murphy produced four further radios based on the baffle board which were more conventional in that they were self-supporting. However, it was not until the launch in 1948 of R.D. Russell's well known console version, the A146, that the baffle concept achieved a much wider public acceptance. The A146 proved successful and sold well into the 1950s. A restyling of its design, the 146ᶜ by David Ogle, later founder of the pioneer design practice David Ogle Associates, was shown by Murphy at the 'Festival of Britain'.

However, the majority of radios produced after the War continued to be variations of the standard valve radio. An extremely successful radio of the type was the FB10, known as the 'Toaster' by Kolster Brandes Ltd. It was small and compact with a one-piece moulded plastic case, and had the distinction of being the first British radio to achieve over a million sales. Its popularity was confirmed by exhibition at the 'Festival of Britain'.

Of far greater significance in the post-war development of the radio was the introduction at the 'Britain Can Make It' exhibition of the Romac Personal, 106. The Romac was an extremely elegant, small portable radio in a smart, black suede carrying case. Such a thing had not been possible before the War and was the result of the miniaturized valves developed for use by the United States military during the War.[6] In its elegant design, with its carrying case and shoulder strap, it was also a fashion accessory. More importantly it was the precursor of what was to become a dominant theme in post-war radio design, personalization through miniaturization and portability. The major breakthrough in this process was the development of the transistor. The first successful British transistor radio was produced in 1956 by PAM, a subsidiary of W.S. Pye & Co. A little later David Ogle designed what was probably the most successful transistorized portable radio of the 1950s, the Bush TR 82 of 1958. Equally significant for the future of radio as the transistor was the introduction in 1956 of the Very High Frequency waveband. Although the main development of VHF broadcasting lay in the future, numbers of early VHF receivers, such as Ferguson's model 627U of 1960, were manufactured in the late 1950s and early 1960s.

As with radio, portability was also to the fore in the development of television. The post-war era was the golden age of television. At the resumption of broadcasting in 1946 it was still a novel luxury entertainment for a wealthy minority living in London and the Home Counties. By 1962 it was, more or less, widely available nationwide and rapidly being seen as an essential of life. The Pye company came to the fore as a leading manufacturer of radios, televisions and record players. They had made a considerable amount of money carrying out government contracts during the War, which was wisely reinvested in the company. Pye's commitment to both high-quality technical production and case design is demonstrated by their employing Robin Day in the late 1940s as design consultant. Day designed radios, television sets and record players for Pye throughout the 1950s.

The B18ᶜ is an early example of Pye's restrained modernist style. Released in 1948, its small size and fine but simple detailing make it stand apart from the majority of post-war television design. It was the first transformerless set com-

patible for use with both AC and DC electrical currents, and had the distinction of being selected by the BBC for use as monitors in their outside broadcast units.[7] Other similar distinguished designs of the 1940s were the remarkable modernist-styled sets designed for Murphy by Eden Minns and R.D. Russell.[8]

The majority of television design in the 1950s, however, consisted of either attempts at concealment by enclosing sets in cabinets, flashily veneered and vaguely Georgian or 'Jacobethan' in style, or adorning them with various gold trims, baroque makers' logos, wood-grained and other decorative laminates and, frequently, a set of splayed, tapering, gilt and lacquered legs. It was not until 1960 or 1961 that a major breakthrough in the development of British television occurred with the release by Perdio of the Portarama, Britain's first fully transistorized portable television. Perdio was a young company committed, under the direction of its founder, Derek Wilmot, to the development of transistorized radio and television. Unfortunately the Portarama was withdrawn shortly after its release because of a number of design problems. An improved version, the Portarama Mk.II, was successfully released in August 1962.[9] The Portarama was small and compact in size and its intelligent case design, formed from injection-moulded plastic, unashamedly proclaimed itself to be nothing other than a piece of electronic equipment.

The 1950s witnessed a dramatic acceleration in the technological progress of the most personal piece of electronic audio equipment, the record player. Long-playing records had only begun to be produced in quantity in 1950.[10] To meet the growing demand for record players suitable for their use, the Decca Company produced in 1949 the Deccalian. This record player was designed by Harvey Schwarz, who had earlier developed the

Decca Navigator system, an early form of radar used in the Normandy landings of 1944. The Deccalian's sophisticated and advanced detailing provided a benchmark for the design of record players well into the 1960s. The year 1958 saw the pioneering development of stereophonic recording.[11] In response Pye produced a number of elegant modernist stereophonic record players. These included a stereo version of Pye's minimalist Black Box, a prestigious style icon which was 'cool' amongst the more 'turned on' young in the late 1950s.

As with radio, some British lighting manufacturers, such as the makers of the anglepoise Herbert Terry & Sons, Best & Lloyd and Troughton & Young, who had employed A.B. Rhead as designer, pursued a modernist agenda throughout the 1930s. This situation was continued by many companies after the War, which resulted in the creation of a refined and intelligent Contemporary style in British lighting.

A form of lighting particularly associated with the era is the TV lamp. It was designed to sit on a television and give a soft light, which was thought would help prevent any damage to the eyes resulting from watching television in the dark. The Dream light of the late 1940s is, in its organic sculptural form, a particularly fine example of the type.

An important early range of lighting, the Chrysaline, was designed by Beverley Pick in 1950 for GEC. The organic forms of the shades resulted from Pick's imaginative use of liquid plastic sprayed on to a wire framework. This plastic had originally been developed as a spray-on protective coating for guns and battleships 'mothballed' at the end of the War.[12] As a result of the success of the range, Pick designed a further range of Chrysaline lighting for GEC between 1951 and 1952. The American George Nelson subse-

quently produced a series of bubble lamps for Herman Miller in 1952, which were closely related, both in form and manufacturing process, to Pick's Chrysaline range.

In the early 1950s the talented husband-and-wife team John and Sylvia Reid produced lighting of a subtle refinement for Forrest Modern and Rotaflex, the former winning a silver medal in 1954 at the Milan Triennale. J.M. Barnicott, designer for Falk Steadmann, was responsible for an elegant, pendant light fitting which was selected by the CoID for display on their stand at the Brussels World Fair in 1958.[13] A versatile range of lighting, the Chelsea, was designed in 1958 by Richard Stevens and Peter Rodd for Atlas, a subsidiary of Thorn.[14] The variously shaped and coloured blown-glass shades were manufactured by James Powell & Sons at the Whitefriars Glassworks. The Chelsea range received one of the three Design Centre Awards presented to Richard Stevens, chief designer for Atlas, for street, display and decorative lighting in 1960.[15] He had previously been awarded a gold medal for street lighting for Atlas at the Milan Triennale in 1957. The Merchant Adventurers, Troughton & Young, Hiscock Appleby, Oswald Hollman & the Mac Lamp Co. were amongst a large number of British companies to commission and produce much other imaginative lighting in the Contemporary style.

Post-war Britain witnessed an increasing involvement of designers working within the plastics industry. Central to this was the establishment of an advisory design research unit in 1952 by British Industrial Plastics Limited. The Design Director A.H. Woodfull, with assistants such as John Vale and Ronald Brookes, developed designs for a large number of domestic items for a variety of companies. Woodfull's sculptural cruet set

designed in 1946 for Beetleware Ltd proved extremely popular and was produced well into the 1960s.

The use of plastics for tableware was increasingly seen as a viable alternative to ceramics, and was viewed at the time as the tableware of the future. Several firms developed ranges in a variety of colours, for use in the 'mix-and-match' and 'harlequin' sets so popular in the 1950s. The most renowned of these were the Gaydon and Melaware ranges, and less well known are the extremely futuristic cups and saucers of the Fiesta range designed by Ronald E. Brookes.[16] Many in the ceramics industry were threatened by the development of plastic tableware, so much so that the highly successful ceramics firm of W.R. Midwinter Ltd marketed their own plastic range, Midwinter Melmex Modern, under the slogan "Tomorrow's tableware today".[17]

A further development in the domestic use of plastics was that of laminates. They were extremely versatile and transformed the furniture industry in the 1940s and 1950s. The principal manufacturers of laminates, Formica and Warerite, employed the services of many leading designers. Jacqueline Groag proved extremely successful in this medium, creating a series of brilliant designs for Warerite.[18] She was also a member of the De La Rue Design Group, from whom her work was commissioned by Formica.[19]

Despite the dispersed and patchy development of post-war product design, British designers achieved some remarkable results, especially in the areas of lighting and audio-visual equipment. In particular, the establishment of pioneer professional design groups, such as Milner Gray and Misha Black's Design Research Unit and David Ogle's Design Group, founded in the 1940s and 1950s, led to the establishment in the 1960s and 1970s of companies such as Kenneth Grange and Theo Crosby's Pentagram group, laying the foundations of what has become a highly respected British design industry.

1 Wally Olins, 'The Industrial Designer in Britain, 1946–82', *Did Britain Make It? British Design in Context, 1946–86*, ed. Penny Sparke, London (The Design Council) 1986, p. 60.

2 *Ibid.*, Giles Velarde, interview with James Gardner, p. 9.

3 Philippe Garner, *The Contemporary Decorative Arts from 1940 to the Present Day*, London (New Burlington Books) 1980, p. 178.

4 Jonathan Woodham, *Twentieth Century Ornament*, New York (Rizzoli) 1990, p. 206.

5 Gerald Wells, curator of the Vintage Wireless Museum, interview with the authors 3.4.97.

6 David Grant, member of the Vintage Wireless Society, interview with the authors 24.4.97.

7 Gerald Wells, interview with the authors 3.4.97.

8 *Art & Industry*, vol. 47, July–December 1949, p. 107.

9 Gerald Wells, interview with the authors 3.4.97.

10 Peter Lewis, *The 50s*, London (Heinemann) 1978, p. 244.

11 *Ibid.*

12 *The Architectural Review*, June 1951, p. 321.

13 *Design*, no. 123, March 1959, illus. p. 16.

14 *Design*, no. 132, December 1959, illus. p. 10.

15 *Design*, no. 174, June 1963, p. 64.

16 *Design*, no. 132, December 1959, illus. p. 10.

17 Alan Peat, *Midwinter, A Collectors Guide*, Cameron & Hollis, 1992, p. 56.

18 *Decorative Art in Modern Interiors, 1961–62*, London (Studio Books) 1961, illus. p. 80.

19 Fiona MacCarthy and Patrick Nuttgens, *Eye for Industry: Royal Designers for Industry 1936–1986*, London (Lund Humphries) 1986, p. 93.

PD1

PD2

PD3

PD5

PD1

P.H. Davies for New Era Domestic
Products Ltd, London
Set of three saucepans and lids from the
Daleware range, *ca.* 1945
Aluminium and plastic, a: length 36 cm
(14¼"); b: length 44 cm (17¼"); c: length
47.5 cm (18¾")
Moulded marks to handles *Daleware* and
registered design number
Examples exhibited 'Britain Can Make It' (p.
65, nos. 231–33); 'Festival of Britain' (p. 52,
no. Y724 and p. 133, no. C735)
PUBLISHED *Ideal Home*, April 1948, p. 52

PD2

Unknown designer for Radiation Ltd,
Birmingham
Casserole pot with lid from the Rada range,
ca. 1945
Enamelled cast iron, height 10 cm (4")
Impressed marks to underside, *Rada* and
Radiation
An example exhibited 'Britain Can Make It'
(p. 65, no. 246)
PUBLISHED *The Studio Yearbook of
Decorative Art*, 1943–48, p. 63

PD3

Unknown designer for Condrup Ltd,
London
Fruit squeezer from the Empire range,
1945–46
Aluminium, height 24 cm (9½")
Moulded marks to handle *Empire, instant
juice press no. 2* and registration and patent
numbers
An example exhibited 'Britain Can Make It'
(p. 62, nos. 141 and 141A)
PUBLISHED Penny Sparke, *Electrical
Appliances*, 1987, p. 22

PD4

Unknown designer for A. & M.G. Sassoon,
London
Atomic, coffee machine, *ca.* 1947
Aluminium, plastic, height 25 cm (9¾")
Metal label to top *Atomic* and patent num-
bers and date 1947

PD5

Unknown designer for Valezina Ltd,
Brighton
Butterfly, corkscrew with original packaging,
registered design, 1948

Anodized aluminium, height 172 cm (6¾")
Impressed mark to top, *Valezina*. Impressed
marks to inside, *Made in England* and regis-
tered design marks. Printed marks to box,
The Valezina Trade Mark Butterfly Corkscrew

PD6
Leslie J. Roberts for General Electric
Company Ltd (manufactured by Electric
Fans & Controls Ltd, High Wycombe)
Kingsway 10, electric fan, late 1940s
Painted aluminium and rubber, height
33 cm (13")
Metal label to underside *Kingsway 10*, and
Electric Fans & Controls Ltd, High Wycombe
An example exhibited 'Festival of Britain'
PUBLISHED *Design in the Festival*, 1951,
p. 23

PD7
Unknown designer for Best Products,
Felixstowe
Callboy, whistling kettle, KG18, *ca.* 1950
Anodized aluminium and plastic, height
19 cm (7½")
Impressed mark to handle *Best*. Impressed
marks to underside of kettle *Best Products –
etc, Callboy Cat.KG18*
PUBLISHED *The Daily Mail Ideal Home
Book*, 1953–54, p. 160

PD8
Abram Games (1914–1996) for Cona
Ltd, London
Rex, coffee machine, 1950
Painted aluminium, heat-resistant glass,
height 30 cm (11¾")
Moulded marks to underside of frame *Cona
Rex* and registered design marks. Printed
marks to glass *Cona, Model Rex*
An example exhibited 'Festival of Britain'
PUBLISHED *Festival of Britain*, advertise-
ment section no. ixxxxv

PD9
Abram Games for Cona Ltd, London
Coffee machine, 1962
Chrome-plated and painted aluminium alloy,
heat-resistant glass, plastic, height 328 (12½")
Moulded marks to underside of frame,
Cona. Printed marks to glass *Cona* and regis-
tered design marks

PD10
Frank Watkins for Lane & Girvan Ltd,
Bonnybridge
Caloray, freestanding open fire, 1953
Enamelled cast iron and steel mesh, height
63.5 cm (25")
Printed metal label to back *Caloray, Lane &*

PD7

Girvan Ltd, Bonnybridge
This fire won the Royal Society of Arts'
Bursary Competition, 1953
PUBLISHED *Design*, no. 63, March 1954,
p. 25

PD11
Unknown designer for Sofono Ltd
Electric fire, *ca.* 1958
Painted and chrome-plated steel, metal alloy
and plastic, height 68 cm (26¾")
Printed metal label to side, *Sofono* with reg-
istration and specification numbers

PD6

PD8

PD12

W.J. Avery for Ericsson Telephones (UK) Ltd

Telephone from the 700 series, *ca.* 1956–57, first introduced in 1958

Plastic, height 13 cm (5″)

PUBLISHED *Design*, no. 173, May 1963, p. 48

PD13

Martyn Rowlands (1923–) for Standard Telephones & Cables Ltd

Deltaline, intercommunicating telephone, developed 1961–62

Plastic, length 22 cm (8½″)

PUBLISHED *Design*, no.173, May 1963, p. 50

PD14

Desmond Sawyer for Desmond Sawyer Designs Ltd, Topsham

Planter with stand, *ca.* 1953

Plastic-coated metal rod, wicker, height 44.5 cm (17½″)

Sawyer's designs epitomize the use of wicker in the 1950s. They were marketed through Heal & Sons Ltd.

Examples of Sawyer's work can be found in various volumes of the *Studio Yearbook of Decorative Art*

PD15

Desmond Sawyer for Desmond Sawyer Designs Ltd, Topsham

Hanging lampshade, *ca.* 1953

Plastic-coated metal rod, wicker, height 25 cm (9¾″)

Paper label, *Desmond Sawyer Designs*

PD16

Desmond Sawyer for Desmond Sawyer Designs Ltd, Topsham

Bottle holder, *ca.* 1953

Plastic-coated metal rod, cane and plastic, height 18 cm (7″)

Examples of this bottle holder are known with Sawyer labels

PD16
PD15
PD14

PD17

Desmond Sawyer for Desmond Sawyer Designs Ltd, Topsham

Planter with stand, *ca.* 1953

Plastic coated metal road and woven plastic cord, height 61cm (24″)

An example exhibited 'David Whitehead Ltd, Artist Designed Textiles 1952–1969', Oldham Art Gallery, 1993

PD18

Unknown designer for Romac Industries Ltd, London

Personal, portable radio from the Olympic range, 1946

Coated aluminium and chrome-plated metal with glass and plastic. Carrying case in suede leather incorporating a small handbag compartment. Rubber shoulder strap with concealed metal aerial running through it, height

PD18

PD19

PD23

146 cm (5³/₄")
An example exhibited 'Britain Can Make It'
(supplementary catalogue, p. 219, group
Y.Y. no. 20 (ii))
PUBLISHED *Wireless & Electrical Trader*
supplement, 10 July 1948, *Trader* service
sheet no. 940. Price 14 guineas plus pur-
chase tax
LENT BY The Vintage Wireless Museum
Exhibited in the 'War and Peace' section of
the exhibition, which dealt with examples of
wartime technological innovations used in
peacetime applications. In the case of the
Romac, miniaturized valves developed dur-
ing the War for use in spy radios were
given their first domestic use

PD19
Eden Minns for Murphy Radio Ltd,
Welwyn Garden City. Case manufactured
by Gordon Russell Ltd, Broadway
A122, radio receiver from the Baffleboard
range, 1947
Laminated and solid wood veneered and
painted. Plastic, glass and woven cloth,
height 47.5 cm (18³/₄")
Printed marks to back, *Murphy Radio Ltd,
Welwyn Garden City etc* and *Radio Receiver
Type A122*
PUBLISHED *Wireless & Electrical Trader*
supplement, *Trader* service sheet no. 962.
Price £17. 7s. 6d.

PD20
A.F. Thwaites for Murphy Radio Ltd,
Welwyn Garden City. Case manufactured
by Gordon Russell Ltd, Broadway
A124, radio receiver from the Baffleboard
range, *ca.* 1948, release date July 1948
Laminated and solid wood with veneer, plas-
tic and woven cloth, height 32.5 cm (12³/₄")
Printed marks to back, *Murphy Radio Ltd,
Welwyn Garden City etc* and *Radio Receiver
Type A124*
PUBLISHED Murphy Service Manual, *ca.*
1948. Price £16. 10s. 0d. plus purchase tax

PD21
Prof. R.D. Russell (1903–1931) for
Murphy Radio Ltd, Welwyn Garden City.
Case manufactured by Gordon Russell Ltd,
Broadway
A146CM, console radio receiver from the
Baffleboard range, 1948
Laminated and solid wood with veneer,
plastic and woven cloth, height 83 cm
(32³/₄")
PUBLISHED Murphy A146 Service Manual,
ca. 1950. Price £28. 12s. 9d. plus purchase
tax

PD22
A.F. Thwaites for Murphy Radio Ltd,
Welwyn Garden City. Case manufactured
by Gordon Russell Ltd, Broadway
A130, radio receiver from the Baffleboard
range, 1949
Laminated and solid wood with veneer, plas-
tic and woven cloth, height 35.5 cm (14")
Printed marks to back, *Murphy Radio Ltd,
Welwyn Garden City etc* and *Radio Receiver
Type A130*
PUBLISHED *Wireless & Electrical Trader*
supplement, *Trader* service sheet no. 994.
Price £17. 7s. 6d.

PD23
Lawrence Griffin for Kolster Brandes
Ltd, Sidcup
FB10, radio receiver, 1950
Plastics, glass, woven cloth, height 23 cm
(9")
Moulded marks to underside, *K.B. Kolster
Brandes Ltd etc* and printed label with
model no. *FB10*
An example exhibited 'Festival of Britain'
(exhib. cat. p. 29, no. F530)
PUBLISHED *Wireless & Electrical Trader*
supplement, *Trader* service sheet no. 969.

PD24
PD25

Price £8. 17s. 1d. plus purchase tax
This radio was the first popular British radio
to reach a million sales

PD24
David Slingsby Ogle (1921–1962:
see Biography page 128) for Bush Radio Ltd
VTR103, portable VHF radio,1958
Plastic, leathercloth and chrome-plated
metal, height 27 cm (10¾″)
LENT BY Patrick Rylands
This was probably the most successful
British radio of the 1950s. It was first issued
as a valve model before being redesigned as
a transistor. This VHF model is the last in
the series

PD25
David Ogle for Bush Radio Ltd
TR102, radio receiver, 1960
Plastic and metal, height 22 cm (8¾″)
LENT BY Patrick Rylands

PD26
(Attrib.) **Richard Stevens** (1924–1997:
see Biography page 128) for Ferguson Radio
Corporation Ltd
G27U, VHF radio receiver, released May
1960
Wood, vinyl, brass, plastic and glass, height
33 cm (13″)
Printed marks to back *Ferguson Radio
Corporation Enfield* etc and plastic label
printed *Model No. 627U*
PUBLISHED *Wireless & Electrical Trader*
supplement, *Trader* service sheet no. 1486.

Price £21. 9s. 3d. plus purchase tax
Richard Stevens designed radios for
Ferguson in 1960 only. The intelligent layout
of the display, the sophisticated use of
colour and the overall architectural treat-
ment of the case would indicate Stevens's
involvement in the design of this radio

PD27
Unknown designer for Pye Ltd
B18C, console television set, 1947, released
for sale 1948
Solid and plywood, veneered and painted,
vacuum-formed plastic, height 76 cm (30″)
The first transformerless television. Due to
its simple and functional design the BBC
chose it as monitors for their outside
broadcasting units

PD28
Derek Wilmot for Perdio Ltd
Portarama, television Mk. II, 1962
Injection-moulded plastic case, height
24 cm (9½″)
Plastic label to front, *Perdio* and logo
PUBLISHED *Wireless & Electrical Trader*
supplement, *Trader* service sheet nos. 1652
and 1653. Price £53. 0s. 5d. plus purchase
tax
The Portarama was the first British transis-
torized portable television

PD29
Harvey Schwarz for Decca Record
Co. Ltd, London
Deccalian, gramophone record player,
1949
Plywood with leathercloth-type covering
and plastic, height 22 cm (8⅝″)
Printed mark to interior *Deccalian*
An example exhibited 'Festival of Britain' (p.
147, no. F654)
The Deccalian is one of the first British
record players designed to play 78, 45 and
33 rpm record speeds
LENT BY Trevor Chamberlain

PD28

PD31

PD30
Unknown designer for Pye Ltd
Black Box, record player, 1953
Solid and laminated wood with mahogany
veneer, plastic, height 30 cm (12″)
PUBLISHED The Pye *Black Box* service
sheet, 1954
The Black Box was produced by Pye in col-
laboration with the American company
CBS. The stereo version of this record
player was developed in the early 1960s

PD31
Unknown designer
Dreamlight, *ca.* 1948
Coloured and clear acrylic, painted ply-
wood, height 28 cm (11″)
Label to underside, *Dreamlight, Pat. Applied
For*

PD32
Unknown designer for Courtney Pope Ltd,
London
Wall-mounted uplighter, *ca.* 1950
Anodized aluminium, chrome-plated steel,
length 28.5 cm (11¼″)
Transfer label to inside of shade *Courtney
Pope (Electrical) Ltd*
PUBLISHED *House & Garden*, January
1951, p. 70, for a version without piercing
to shade. Sold by Storey's of Kensington.
Price 40s. 9d.

PD33
Beverley Pick for the General Electric
Company Ltd, London, manufactured by
W.S. Chrysaline Ltd
Hanging lampshade from the Chrysaline
range, 1950
Painted metal frame with plastic cocoon,
height 28 cm (11″) approx.
From the first range of Chrysaline lamp-
shades designed by Beverley Pick in 1950.
The Studio Yearbook of Decorative Art,
1952–53, illustrates two shades from this
range on pages 68 and 70. Both utilize a
white plastic cocoon covering. Later
Chrysaline ranges designed by Pick from
*ca.*1952 use a Champagne-coloured cocoon

PD33

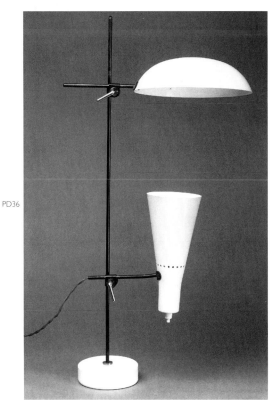

PD36

PD34
Unknown designer for (attrib.) the
Merchant Adventurers Ltd
Adjustable desk lamp, 1950s
Anodized and painted aluminium and steel,
length 66 cm (26")
A closely related desk lamp of anodized
aluminium with a ball counterweight is
illustrated on p. 69 of *The Studio Yearbook of
Decorative Art*, 1951–52. Designer, Robert &
Roger Nicholson for Merchant
Adventurers Ltd

PD35
John Reid (1925–1992) for Forrest
Modern, George Forrest & Co. Ltd
Adjustable table/desk lamp, *ca.* 1952
Painted steel, aluminium and brass, height
54.5 cm (21½")
Impressed registered design number to
shade
An example exhibited the 10th Milan
Triennale, 1954, awarded a silver medal
PUBLISHED *Designers in Britain*, 1954, vol.
4, no. 3, p. 17

PD36
John Reid for Forrest Modern, George
Forrest & Co. Ltd
Adjustable lamp, 1952
Painted steel, aluminium and brass, height
65 cm (25½")
Impressed registered design number to
shade
An example exhibited the 10th Milan
Triennale, 1954, awarded a silver medal
PUBLISHED *Design*, no. 64, April 1954,
p. 10

PD37
John Reid and **Sylvia Reid** for
Rotaflex Lighting Ltd, London
Adjustable floor lamp, *ca.* 1956
Painted sheet and square section steel and
brass, height 151 cm (59½")
Printed paper label to shade, *Designed and
manufactured by Rotaflex*

PD38
John Reid and **Sylvia Reid** for
Rotaflex Lighting Ltd, London
Adjustable floor lamp, *ca.* 1956
Painted sheet and square section steel, brass
fittings, height 151 cm (59½")
An example exhibited 'David Whitehead
Ltd. Artist Designed Textiles, 1952–69',
Oldham Art Gallery, 1993

PD38

PD39
(Attrib.) **Beverley Pick** for the GEC,
London
Adjustable floor-standing lamp, *ca.* 1954
Painted steel rod, brass, teak, painted
aluminium, height 155 cm (62")
PUBLISHED *The Daily Mail Ideal Home
Book*, 1956, p. 125
Beverley Pick was appointed as design con-
sultant for GEC in 1954 when he designed
a new range of Contemporary light fittings
for them. This floor-standing light is closely
related to other GEC lighting by Pick. An
example is illustrated in *The Studio Yearbook
of Decorative Art*, 1959–60

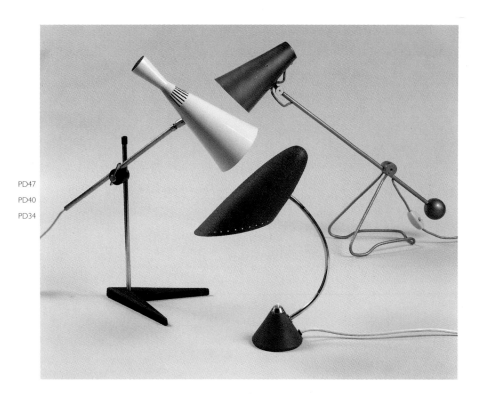

PD47
PD40
PD34

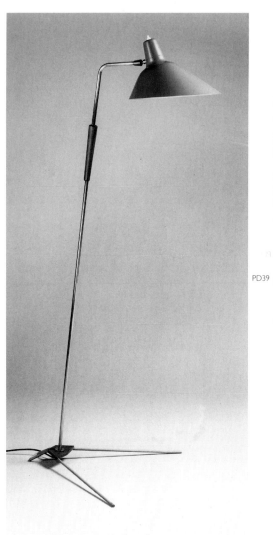

PD39

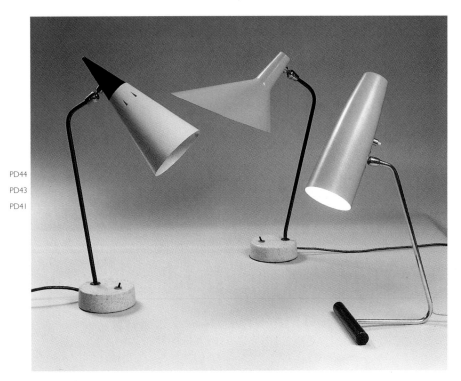

PD44
PD43
PD41

height 45. 5 cm (18")

PD42
(Attrib.) **R.C. Hiscock** for Hiscock,
Appleby & Co. Ltd, London
Adjustable floor-standing lamp, *ca.* 1955
Cast iron, painted steel, aluminium and
brass, adjustable max. height 162.5 cm (65")
PUBLISHED *House & Garden*, July 1960,
p. 95

PD43
Unknown designer for Troughton & Young
Ltd, London
Adjustable table/desk lamp, *ca.* 1955
Painted aluminium, oil-dipped steel tube,
terrazzo and brass, height 49.5 cm (19¹/₂")
PUBLISHED *Design*, no. 104, August 1957,
p. 34

PD40
J.M. Barnicott for Falk Steadman &
Co. Ltd, London
Mira desk lamp, *ca.* 1954
Coated aluminium, steel and brass, height
34 cm (13¹/₂")
PUBLISHED *Design*, no. 83, November

1955, p. 9

PD41
Unknown designer for (attrib.) Oswald
Hollman Ltd, Beckenham
Adjustable desk lamp, *ca.* 1955
Painted aluminium and brass,

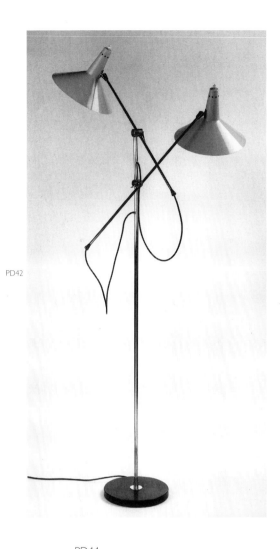

PD42

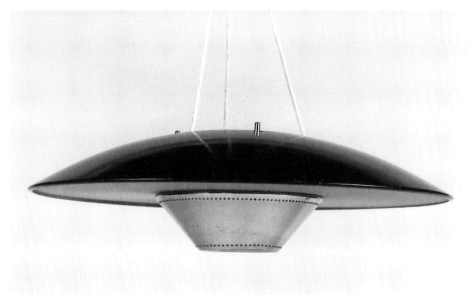
PD45

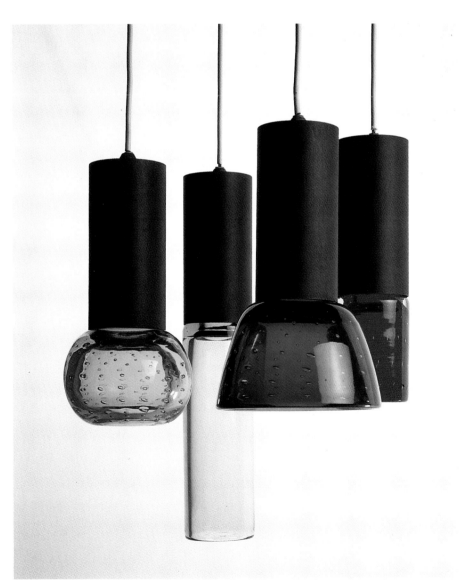
PD46

PD44
Unknown designer for Troughton & Young
Ltd, London
Adjustable desk lamp from the Harlequin
range, *ca.* 1955
Painted aluminium, oil-dipped steel tube,
terrazzo and brass, height 52 cm (20½")
PUBLISHED *Design*, no. 108, December
1957, p. 34. Price £6. 15s. 10d.

PD45
J.M. Barnicott for Falk Steadman &
Co. Ltd, London
Europa pendant lighting from the Falk range,
ca. 1957
Painted aluminium, brass and glass, diameter
51 cm (20")
An example exhibited Brussels World Fair,
1958. Chosen by the CoID for display on
their stand
PUBLISHED *Design*, no. 123, March 1959,
p. 16

PD50

PD49
PD51

PD46

Richard Stevens and **Peter Rodd**
for Atlas Lighting Ltd, a subsidiary of Thorn
Lighting, London. Glass shades by James
Powell & Sons Ltd, Whitefriars Glass
Company
Pendant light fitting from the Chelsea range,
1958
Painted steel, clear coloured glass shades,
three with bubble decoration
Design Centre Award 1960 for the Chelsea
range
PUBLISHED *Design*, no. 132, December
1959, p. 17

PD47

G.A. Scott for the MacLamp Co. Ltd,
London
Adjustable desk/table lamp, *ca.* 1958
Coated cast iron, brass, painted aluminium
and plastic, adjustable height 53.5 cm (21")
PUBLISHED *Contemporary Design in
Metalwork*, 1963, p. 39, for wall-mounted
version

PD48

A.H. Woodfull (1912– : see Biography
page 128) for the Beetle-ware Products
Company
Cruet set, developed 1942–1946, produced
1946
Beetle urea formaldehyde, height 9 cm
(3¹/₂")
Moulded marks to bases, *Beetleware, made
in England*
An example exhibited 'Festival of Britain'
PUBLISHED *Classic Plastics – from Bakelite
to High Tech*, 1984, p. 81

PD52
PD48
PD53

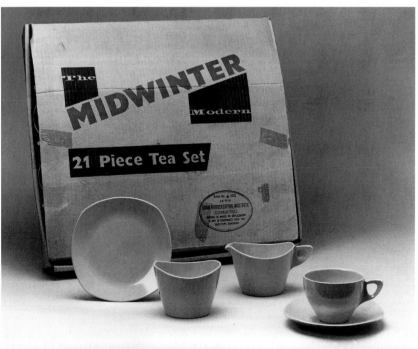

PD54

PD49

Gunther Hoffstead for Dorset Light
Industries Ltd, Bridport
Electric table lighter, late 1940s
Plastic and chrome-plated metal, height
12 cm (4³/₄")
Moulded marks to underside *Dorset Light
Industries, Bridport, Dorset* and patent and
registration numbers
PUBLISHED *Designers in Britain*, 1951, vol.
3, p. 211

PD50

A.H. Woodfull for Cadbury's Bournville
Sleeping Beaker, mug with lid/saucer, 1949
Beaker: Beetle urea formaldehyde; night cap
lid/saucer: polythene and cellulose acetate,
height 4¹/₄"
Moulded marks to base of beaker,
Cadbury's, Bournvita
PUBLISHED *The Bournville Works Magazine*,
vol. XLVIII, no.11, November 1950
Designed and developed by British Industrial
Plastics Ltd. Manufactured by Streetly
Manufacturing Company Ltd

PD51

David Douglas for Acca Ltd
Salad bowls, *ca.* 1955
Plastic, chrome-plated steel, diameter
27.5 cm (11")
Moulded marks to underside of large bowl,
Acca, David Douglas and *Hand finished*

PD52

A.H. Woodfull for Ranton & Co.
Distributed by Melaware
Cup, saucer and plate, *ca.* 1956
Melamine, cup and saucer: height 7.5 cm
(3"); plate: diameter 18 cm (7")
Impressed mark to underside of plate, cup
and saucer, *Melaware*
PUBLISHED *Design*, no. 99, March 1957,
p. 27, plate 8

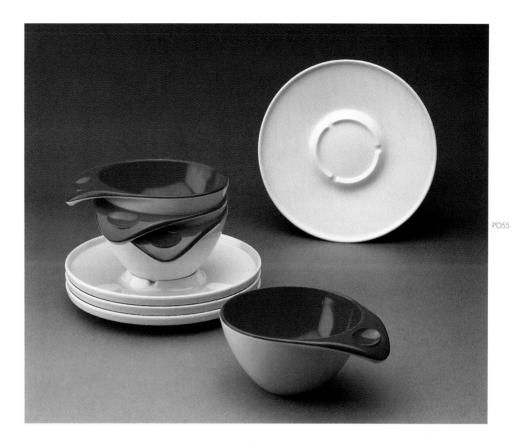

PD55

PD53

A.H. Woodfull for Ranton & Co.
Distributed by Melaware
Cup, saucer and plate, *ca.* 1958
Melamine, cup and saucer: height 7 cm
(2³/₄"); plate: diameter 18 cm (7")
Impressed mark to underside of plate, cup
and saucer, *Melaware*
PUBLISHED *Design*, no. 126, June 1959, p.
51. Price for cup and saucer: 7s. 3d.

PD54

A.H. Woodfull, **John Vale** and
Roy Midwinter
Midwinter Modern twenty-one-piece tea
set, with original packaging, *ca.* 1956
Melmex, melamine, cup and saucer: height
7.35 cm (3"); plate: diameter 16 cm (6¹/₄");
milk jug: height 7.5 cm (3"); sugar bowl:
height 7.5 cm (3")
Impressed mark to underside of all pieces,
*Break resistant tableware, Midwinter Modern,
made in England*

PUBLISHED *Design*, no. 99, March 1957,
front cover and pp. 26 and 27. Retail prices,
including tax: small plate 3s. 9d.; cup 4s. 3d.;
saucer 3s. 0d.
The designs and their manufacture were a
close collaboration between the designers
(A.H. Woodfull and John Vale of the
Product Design Service, British Industrial
Plastics Ltd), the moulder (the Streetly
Manufacturing Co. Ltd) and the converter
(W.R. Midwinter Ltd)

PD55

Ronald Brookes for Brookes &
Adams, Birmingham
Four stacking cups and saucers, from the
Fiesta range, *ca.* 1958
Melamine, height 7 cm (2³/₄")
Impressed mark to underside of cups, *Fiesta.*
Moulded mark to underside of saucer *B&A
263*
PUBLISHED *Design*, no. 132, December
1959, p. 10

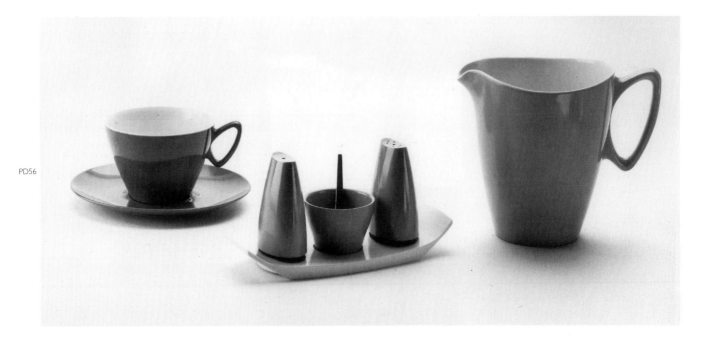

PD56

PD57

PD56
A.H. Woodfull for Gaydon, manufactured by Streetly Manufacturing Co. Ltd
Jug, cup and saucer and cruet set, *ca.* 1960
Melmex melamine, stainless-steel mustard dab, jug: height 13.5 cm (5¹/₄″); cup and saucer: height 7 cm (2³/₄″); cruet set: height 8.5 cm (3³/₈″)
Impressed marks to underside of all plastic pieces, *Gaydon Melmex* and logo. Impressed mark to mustard dab *Gaydon*

PD57
Jacqueline Groag (1903–1986) for Warerite, The Bakelite Group, Ware Alexandretta, printed plastic laminate used as a top for an occasional table by Lusty, late 1950s
Diameter 51 cm (20″)
Marks to underside of table *Lustycraft*
PUBLISHED *Decorative Art in Modern Interiors*, 1961–62, p. 80 (laminate)

Graphic Design
and Typography

BRIAN WEBB

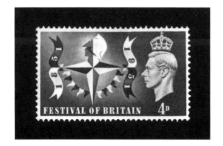

Abram Games, 'Festival of Britain' 4d stamp, 1948

The War left a mixed legacy to British artists and designers, fame for some who gained recognition as War artists; loss for the families and furthermore to the world at large for those, such as Eric Ravilious, who died on active service.

Many well known designers of the pre-war period did return, however, but to an uncertain future, some to commercial design when available, but otherwise to teaching and painting. Many designers like Abram Games, Tom Eckersley and others had a direct effect on post-war design. Games, who was largely self-taught, became well known for his wartime posters. He often combined photography and illustration with brief but powerful messages, including his 'Your Britain Fight for it NOW'. The urgency of messages during the War had completely changed the tone of printed communication.

Jan Lewitt and George Him had worked together since the early 1930s in Warsaw. They came to Britain in 1937 and were quickly designing posters for the GPO and later during the War for the Ministry of Information. Throughout the 1940s they produced advertising for

Kia-Ora and together with many other designers were involved in the 'Festival of Britain'. Lewitt & Him also illustrated and sometimes wrote children's books including *The Football's Revolt* in 1944. They drew the pictures for the first of Diana Ross's *Little Red Engine* books, published in 1952.

Hans Schleger had worked in the Berlin office of W.S. Crawford in the 1920s and then for advertising agencies in New York before settling in London. His reputation grew as a poster designer for Shell, and his combination of European modernist design and an American approach to the business of design enabled him to develop corporate identity design in Britain.

F.H.K. (Henri) Henrion, who was also born in Germany, became a forerunner in changing design from an individual 'artist'-based activity into a 'group' business. He worked for advertising agencies in the 1940s and as a designer for the 'Festival of Britain', later teaching at the Royal College of Art. His corporate identity schemes for companies like Blue Circle Cement and KLM Airlines are still in use, with later

Lewitt-Him, illustration for Diana Ross,
The Little Red Engine Gets a Name,
London (Faber & Faber) 1952

F.H.K. Henrion, *Christmas card, ca.* 1945–46, gouache on newspaper

modifications, as are Schleger's John Lewis Partnership and Tate & Lyle symbols.

In the immediate post-war period and well into the 1950s, the printing industry had a variety of problems to contend with. Labour shortages were common. The use of paper was severely restricted both in quality and quantity. Printing technology was also changing, with half tone and colour reproduction improving. Photolitho, which suited European designers skilled in photomontage, and other forms of communication were developing. Television in the early 1950s, boosted by the whole nation wanting to watch the 1953 Coronation, soon ousted picture magazines like *Illustrated, Everybody's John Bull* and *Picture Post,* whose photojournalism was legendary through the 1930s and during the War.

The late 1940s and early 1950s were also the heyday of British film making. Ealing Studios films were promoted with posters commissioned from well known artist–designers, 'Johnny Frenchman' from Barnett Freedman, 'Pink String' and 'Sealing Wax' by John Piper, 'Dead of Night' by Leslie Hurry, 'Hue and Cry' and

'The Titfield Thunderbolt' by Edward Bawden. Misha Black and Milner Gray of the Design Research Unit, and the exhibition designer James Gardner, worked on numerous post-war exhibitions including 'The Builder and the State', 'The Health of the People', 'The Nation and the Child' and the now best remembered 'Britain Can Make It'. In the pre-television era exhibitions were an effective way to promote products and ideas. They were also fun and culminated with the 'Festival of Britain' on the South Bank in 1951.

The 'Festival' provided work for a great many designers of every discipline. Abram Games won the competition to design the symbol for it in 1948 against Henrion, Robin Day, Tom Eckersley, Milner Gray, Peter Ray and Lynton Lamb.

Curiously the typography of the 'Festival of Britain' looked back to Victorian poster typestyles. One new typeface, Festival, was designed by a team at the London Press Exchange advertising agency to celebrate 1951, but even with an influx of designers well versed in modernism typography did not develop noticeably at first. Jack Beddington, who had been an

inspirational advertising manager at Shell before working in advertising agencies in the 1940s, wrote an introduction to 'Designers in Britain' in 1947 in which he makes a plea for special courses to teach typography. During the 1940s and 1950s the Central School of Art became the centre for more advanced methods of graphic design and typographic teaching.

One of the first post-war surveys of design and illustration was *Graphic Design,* written by John Lewis and John Brinkley and published in 1954. It introduced in its title the idea that graphic design embraced a wide range of activities relating to printed material. Brinkley had been responsible for the lettering and typography in the Lion and Unicorn building at the 'Festival of Britain' and both were teaching at the RCA. John Lewis went on to produce many books on design, including the standard work *Printed Ephemera,* published by W.S. Cowell in 1962.

Another review of design, with a radically different point of view, was *Advertising and the Artist* by Ashley Havinden, 1956. While Lewis and Brinkley wrote about Nash, Ravilious and Bawden,

John Minton, illustration for Odo Cross, *The Snail that Climbed the Eiffel Tower and Other Stories*, London (John Lehmann) 1947

Havinden concentrated on work by European and American designers illustrating what could be seen as a national split between those designers born and trained in Britain and the incomers born and trained in Europe.

In the immediate post-war period, resourcefulness became a way of life for printers and publishers alike. Despite shortages they wanted not only to make books that would sell to a book-starved market but to produce books that were attractively illustrated. It was difficult for anyone who had produced quite lavish

books before the War to learn the new rules of austerity.

Many artists working in the 1940s and 1950s were also producing illustrations for books and magazines. The pre-war market for private press books had all but disappeared, but commercial publishers like Faber and John Lehmann commissioned covers from artists including John Minton, Lucien Freud, Edward Burra, Keith Vaughan and Barnett Freedman. John Minton's graphic painting style was particularly suited to illustration. He had a strong sense of black and white which he

used for Alan Ross's *Time was Away* in 1948 and for Elizabeth David's *French Country Cooking*, a book that did as much for the way Britain changed its eating habits two decades later as Minton and his contemporaries did for illustration. Minton was also skilled in the use of limited colour which he demonstrated brilliantly in the unchildlike children's book *The Snail that Climbed the Eiffel Tower* by Odo Cross, published by John Lehmann, one of the small number of adventurous publishers to risk books by new authors and illustrators.

Painting, Prints and Sculpture:
a note on the 1950s

RICHARD INGLEBY

The War, according to William Scott, "was a significant fact in the history of British painting",[1] creating a generation of artists cut off from the mainstreams of modern art at the crucial stage of their developing careers. This isolation, combined with the inevitable patriotism of wartime, helped to define the nostalgic mood of much British painting in the 1940s from "the cool, hassock scented interiors of country churches",[2] as John Betjeman put it when describing the work of his friend John Piper, to the understated landscapes of Edward Bawden and the engaging eccentricities of Stanley Spencer.

By the end of the War this fondness for the Englishness of English life had begun to be infected by what a young painter called John Bratby described as "the colour and mood of ration books, the general feeling of sackcloth and ashes". "The painting of my decade", he has recalled, "was an expression of its *Zeitgeist* – introvert grim, khaki in colour, opposed to prettiness, and dedicated to portraying a stark, raw, ugly reality. The word angst prevailed in art talk."[3]

Bratby was only twenty-two when the 1950s began, but he soon found critical support and a measure of fame together with Jack Smith, Edward Middleditch and Derrick Greaves under the 'kitchen sink' label.[4] Grouped, rather against their will, they were dubbed 'the angry young men' of British painting, a phrase borrowed from J.B. Priestley's description of the literary scene, but which was soon applied across the arts to anyone with realist tendencies. All four exhibited with Helen Lessore's Beaux Arts Gallery (and so earned yet another label as 'the Beaux Arts Quartet') and shared public success as Britain's representatives at the 1956 Venice Biennale. It was the peak of a collective career which slid downhill fast.

William Scott, who represents a very different strain of British painting in the 1950s, was less of a celebrity, but his reputation has fared rather better. In very broad terms the Beaux Arts Quartet and Scott were on opposite sides of the question that dominated the decade – the debate between realism and abstraction, or, as it was described by the Artists International Association in 1952, between 'the mirror and the square'.[5]

Both sides of this debate were well served by the 'Festival of Britain' in 1951, an extravagant display of public confidence which provided welcome work for the nation's painters and sculptors. Scott was commissioned to give it all a public face by designing a poster for London buses – one of which was sent on a tour of continental Europe, a cheerful and reassuring symbol of English life, a double-deckered ambassador of national pride and purpose.

The celebrations were centred on the South Bank in London where, to name just a handful of many visual attractions, there were displays of new sculpture (including Hepworth's *Contrapuntal forms* and Paolozzi's *Fountain*), Ben Nicholson and Victor Pasmore's murals for the Regatta restaurant and Graham Sutherland's *Origins of the land* in a pavilion dedicated to the history of the British countryside.

It was an important occasion which did little to cheer the likes of Bratby, but which provided many others with a way out of the post-war gloom. The key event for painters was the exhibition '60 for 51', a bold attempt by the newly formed Arts Council to make artists work on a grand scale and to encourage public collections to invest in the results. Free canvas was given to sixty painters with the stipulation to make a picture no less than 45 by 60 inches. The only rule now was to think big and be confident.

There were fifty-four paintings in the

final exhibition (six got lost along the way) in a diverse selection which spanned such ageing talents as Duncan Grant, Vanessa Bell and Mathew Smith, names which belong to a pre-war world, and such new ones as Patrick Heron, Peter Lanyon and Prunella Clough. The youngest participant was Lucian Freud who, although only twenty-seven, was already an accomplished painter and whose *Interior, Paddington* was one of the highlights of the show.

Of all the artists associated with the 'Festival of Britain' Lucian Freud undoubtedly has the greatest presence in our own time. As his star has risen, the legend of his early life has become indelibly linked with the pubs and clubs of Soho. Soho in the 1950s was haunted by the likes of Edward Burra, Keith Vaughan, John Minton and the two Roberts – MacBryde and Colquhoun – and even, occasionally, by the aged Augustus John, but as the decade progressed the group of artists gathered around Freud and his friend Francis Bacon became the most notable. Their collective identity, which history has termed the 'School of London',[6] was bound by friendship and alcohol rather than ideology, but for all the time spent between Wheelers and the Colony Room this was the decade in which both Bacon and Freud made much of the work that established their reputations.

Bacon was one of two particular enthusiasms of David Sylvester, one of the most distinctive critics to emerge in the 1950s and arguably the lasting voice of his generation; his other favourite was Alberto Giacometti. "The most obvious difference between the art of today and the art of the inter-war period", he wrote anonymously in *The Times* of 2 August 1955, in an essay which linked his two heros, "is that rough surfaces have taken the place of smooth ones." Smoothness, he continued, was the outward sign of

aspiration to order and impersonality, roughness of an aspiration to freedom and singularity.[7]

The spirit of Giacometti looms large over the age: he was much admired by painters such as Bacon and Auerbach and especially by a new generation of sculptors who had been raised on a (smooth) diet of Henry Moore and Barbara Hepworth. Both Moore and Hepworth continued to make important and widely acclaimed work throughout the decade but increasingly they shared the stage with Kenneth Armitage, Robert Adams, Lynn Chadwick, Bernard Meadows and Reg Butler, all of whom were included alongside Moore in 'New Aspects of British Sculpture' at the Venice Biennale of 1952. Modelling and welding took over from carving: metal was forged and hammered into shapes described by Herbert Read in a now famous phrase as "the geometry of fear".[8]

'New Aspects of British Sculpture' also included work by Eduardo Paolozzi and William Turnbull, both expatriate Scots involved with the Independent Group, an informal 'think tank' founded at the ICA in 1952 by the artist Richard Hamilton and critic Lawrence Alloway. Their main themes were technology and the ever increasing rôle of the mass media at the mid-point of the twentieth century – subjects best addressed in the years ahead by Paolozzi's dehumanized sculptures and collaged images.

Paolozzi and Turnbull were not the only forward-thinking artists to emerge from Scotland at the end of the 1940s. Two painters, William Gear and Alan Davie, also reacted against the legacy of paint and colour which dominated teaching at the Scottish art schools, particularly at Edinburgh under William Gillies and the younger William MacTaggart. Paolozzi, Turnbull, Gear and Davie all travelled on the European mainland and

lived in Paris for a couple of years before settling in London in the early 1950s and, with the exception perhaps of Paolozzi, all still have bigger reputations on the Continent than at home.

Today Eduardo Paolozzi looks like the biggest of the four in every sense. Aside from his sculptural achievements, the collaged images that he presented as a slide lecture at the ICA in 1952 (later published as screenprints under the title *Bunk*) were probably the earliest appearance of the phenomenon that came to be known as Pop Art. They pre-date Peter Blake's painting *Children reading comics* (Carlisle Museum and Art Gallery) by a full two years and were five ahead of Richard Hamilton's announcement, "Pop art is Popular (designed for a mass audience), Transient (short-term solution), Expendable (easily forgotten), Low cost, Mass produced, Young (aimed at youth), Witty, Sexy, Gimmicky, Glamorous, and Big Business."

By the end of the decade the various strands of Pop Art were well established with Lawrence Alloway as chief apologist, but in 1954 Alloway had broader sympathies and had accepted an invitation (from the artists themselves) to introduce *Nine Abstract Artists*, a slim volume which grouped some of those associated with abstraction in St Ives with their London-based colleagues. St Ives is about as far as you can travel from London whilst still remaining in England, but despite this geographical separation there were a number of connections, not least the friendship of Adrian Heath (London) and Terry Frost (St Ives) forged during the War at Stalag 388, a Bavarian prisoner-of-war camp.

In the early 1950s Heath organized a number of exhibitions at his London studio, which prepared the ground for *Nine Abstract Artists*, showing work by Ben Nicholson, Roger Hilton, Terry Frost and William Scott alongside the London

constructivists Kenneth and Mary Martin and Victor Pasmore. Alloway was a strange choice for author, and never seems quite convinced, especially when discussing the landscape-based abstraction of St Ives: "In St Ives", he wrote in his slighting introduction, "... they combine non-figurative theory with the practice of abstraction, because the landscape is so nice no one can quite bring themselves to leave it out of their art."

A much more unifying voice came from Patrick Heron whose own painting remained tied to the figurative legacy of Braque and Matisse until 1956, but whose support for English, particularly St Ives, abstraction in the pages of the *New Statesman* provided a welcome sense of direction from as early as 1947.

The landscape around St Ives has always attracted artists, but the town's credentials as a modernist painting place were properly established in 1939 when Ben Nicholson and Barbara Hepworth arrived to stay with Adrian Stokes and Margaret Mellis. During the War they were joined by Naum Gabo, John Wells and Wilhelmina Barns Graham and soon after by Frost, Hilton and Bryan Wynter. Patrick Heron had spent part of his childhood there and returned regularly from 1947, before buying 'Eagles Nest', a few miles down the coast at Zennor, in 1956. Peter Lanyon had lived there all his life.

The history of this extraordinary flourishing in the west has been well documented elsewhere, but in the context of the 1950s the contributions made by Scott and Heron look particularly significant. Like Heron, Scott was a summer visitor from about 1947, but as Head of Painting at Bath Academy of Art (based at Corsham) he was able to employ Lanyon, Frost and Wynter on his staff and so ensure that currents continued to flow in the winter months. In this company his own work became increasingly

simplified, edging towards abstraction, although of a sort that stayed tied to the tabletop that had become his favoured landscape. Form was gradually flattened and colour reduced until, as Scott put it, "I was finally left in 1953 with a table top in black and white." These combinations of black lines on creamy white fields are some of the most restrained and subtle pictures of his career.

The year 1953 was also the year that Scott visited America and encountered Abstract Expressionism at first hand. He was, with Heron, one of the first British painters to grasp what was happening there and his meetings with Pollock, Kline and De Kooning left him impressed, but not seduced: "My impression at first was bewilderment. It was not the originality of the works, but the scale, audacity and self-confidence." He saw Rothko, in particular, in peculiarly British terms: "a synthesis of Turner and Nicholson".

Of all the American artists whose work began to have influence in Britain in the 1950s Mark Rothko was the one who meant most to Patrick Heron. "The best of the living Americans", he called him, acknowledging Rothko's influence on his own work in the late 1950s, particularly the stripe paintings made shortly after his move to 'Eagles Nest'.

Heron, whose critical obsession with form and space lost him his job with the *New Statesman* in 1950, was one of three young critics whose ideas dominated the decade. David Sylvester was the second and John Berger, the chief supporter of Bratby and the Beaux Arts Quartet, was the third. The debate between abstraction and realism continued in their columns, particularly between Heron and Berger, but as time passed some of Berger's enthusiasms began to look a little shaky. "I think that it is possible that [Jack] Smith is a genius",[9] he wrote in 1954, but as Sylvester warned a few months later in

the article that gave the kitchen sink school its name: "It is as well to remember that the graveyard of artistic reputations is littered with the ruins of expressionistic painters who once took the world by storm."[10]

By the end of the decade Smith had switched sides to abstraction and Bratby was writing novels.

It was not just the realists who enjoyed and subsequently lost their superstar status. In the abstract corner there were new and highly publicized developments from Richard Smith (who also crossed into the world of Pop) and Robin Denny, both of whom first came to public attention in 'Place', an exhibition at the ICA in 1959, and in the Situation exhibitions in 1960 and 1961.[11]

Other quieter talents like Leonard Rosoman and particularly Prunella Clough have proved more durable. In the late 1940s Clough's work, like that of her friends Colquhoun and MacBryde, was much influenced by Picasso, but as the 1950s progressed her work slid away from the 'mirror' towards the 'square' – towards a personal brand of close-toned abstraction that has outlasted those of many of her more celebrated contemporaries.

Clough, Heron, Freud and Paolozzi are, in their different ways and with their differing degrees of fame and fortune, among the most lasting voices to have emerged from the post-war years. All were involved in the 'Festival of Britain' at the outset of their careers, and as the century draws to a close all four are still working at the top of their powers. In their continuing contributions to the history of British art the legacy of the 1950s is very much alive.

1 Quoted in Alan Bowness, *William Scott, Paintings, Drawings & Gouaches 1938–71*, exhib. cat., London, Tate Gallery, 1972

2 Quoted in Frances Spalding, *British Art Since 1900*, London (Thames & Hudson), 1986, p.129.

3 John Bratby, 'Painting in the Fifties', *The Forgotten Fifties*, exhib. cat., Sheffield, Graves Art Gallery, 1984, p. 46.

4 A phrase coined by David Sylvester writing in *Encounter* in December 1954

5 *The Mirror and the Square, an Exhibition of Art Ranging from Realism to Abstraction*, AIA, New Burlington Galleries, December 1952

6 A phrase first used by the painter R.B. Kitaj in his introduction to *The Human Clay*, Arts Council, 1978

7 Quoted in David Sylvester, *About Modern Art*, London (Chatto & Windus) 1996, pp. 49–52.

8 Herbert Read, Introduction to *New Aspects of British Sculpture*, Venice Biennale catalogue, 1952

9 *The Forgotten Fifties*, Sheffield, Graves Art Gallery, 1984, p. 34.

10 David Sylvester, *Encounter*, December 1954, quoted in *About Modern Art*, p. 18

11 The *Situation* exhibitions also introduced John Hoyland and and Gillian Ayres

P4

P1
Graham Sutherland (1903–1980)
Maize, 1948
Lithograph, 38 cm × 54.5 cm (15″ × 21½″)
Printed by Ravel, Paris, for Redfern Gallery, edition of 60

P2
Graham Sutherland
Thorn cross, 1955
Lithograph, 45.5 cm × 63.5 cm (18″ × 25″)
Printed by Fernand Mourlot for Berggruen & Cie, edition of 100

P3
Graham Sutherland
Study for *Origins of the land*, 1952
Gouache on paper, 57 cm × 54 cm
(22½″ × 21¼″)
Signed initials and dated 1952 (t.l.)
EXHIBITED Curt Valentine Gallery, New

York, 1953 (22); Mercury Gallery, 1984
Origins of the land (Tate Gallery) was commissioned in 1950 for the British Pavilion at the 'Fesival of Britain'.

P4
Graham Sutherland
The bird, 1953
Lithograph, 43.5 cm × 44 cm (17″ × 17½″)
Signed and inscribed *épreuve d'artiste*

P5
Ben Nicholson (1894–1982)
San Gimignano, 1953
Etching, 21 cm × 27.5 cm (8¼″ × 10¾″)
Inscribed title, signed and dated (l.l.)

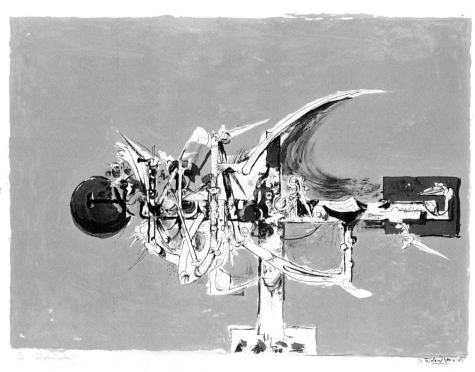

P1

P5

P2

P7

P6

Ben Nicholson

Pisa, 1951

Etching, 25.5 cm × 19 cm (10″ × 7½″)

Signed and dated (ll) and numbered *10/20*

(l.r.)

P7

Terry Frost (1915–)

Long green and blue painting, 1954

Oil on board, 143 cm × 53 cm (56½″

× 21″)

Signed, dated and inscribed verso with title

P8

P12

P8
William Scott (1913–1989)
Blue, black & brown, 1961
Gouache, 48.5 cm x 61 cm (19¼″ x 24″)
Signed (l.l.)
EXHIBITED Hanover Gallery, London,
1961 (22)

P9
William Scott
Still life – mushrooms, 1949
Lithograph, 33 cm x 44 cm (13″ x 17³⁄₈″)
Signed in pencil *W. Scott*; edition of 25

P10
William Scott
Still life – three pears and pan, 1955
Lithograph, 35.5 cm x 51 cm (14″ x 20″)
Signed in pencil *W. Scott* and dated 55 (l.r.);
a proof aside from edition of 50

P11
Prunella Clough (1919–)
Still life with tools, 1948
Oil, 40 cm x 39.5 cm (15³⁄₄″ x 15½″)
Signed (b.r.)
PROVENANCE Roland Browse &
Delbanco; Dr T.W. Sutherland

P12
Martin Froy (1926–)
Seated woman
Oil, 151 cm x 120.5 cm (59½″ x 47½″)
EXHIBITED Hanover Gallery, London (1.)

P11

P13

Carel Weight (1908–1997)
The strange bird, ca. 1952
Oil on canvas, 91.5 cm × 91.5 cm
(36″ × 36″)
Signed (b.l.)
EXHIBITED Zwemmer Gallery, London,
1954
PUBLISHED R.V. Weight, *A Haunted
Imagination,* 1994, p. 54
The setting for this painting is Cannizaro
Park, Wimbledon

P14

Carel Weight

The dark tower, 1956
Oil, 122 cm × 91.5 cm (48″ × 36″)
Signed and dated
EXHIBITED Royal Academy, London, 1957
(528); John Moores, Liverpool, 1957–58
(168); Reading, 1970 (44); Royal Academy,
London, 1982 (43) and tour to York,
Rochdale, Penzance, Folkestone
PUBLISHED M. Levy, *Carel Weight,* 1986,
p. 65 (ill); R.V. Weight, *Carel Weight: A
Haunted Imagination,* 1994, p. 64 (ill)

P15

Sir Eduardo Paolozzi (1924–)
Two forms on a rod, 1948–49
Bronze, 48 cm × 64.5 cm (19″ × 25½″)
Impressed artist's name and numbered *3/6*
EXHIBITED 'Eduardo Paolozzi Birthday
Celebration', Yorkshire Sculpture Park, 1994
PUBLISHED Diane Kirkpatrick, *Eduardo
Paolozzi,* 1970, p. 18; S. Nairne and N.
Serota, *British Sculpture in the Twentieth
Century,* 1981, p. 132; Frank Whitford *et al.,
Eduardo Paolozzi,* 1987 (cat. 2)
PROVENANCE Institute of Contemporary
Art (Gift of the artist); ICA sale, Sotheby's
23/6/66 (lot. 51)

P15

P16

Kenneth Armitage (1916–)
Children playing
Bronze, 31.5 cm (12³/₈″)
Impressed A
EXHIBITED 'Kenneth Armitage', Yorkshire
Sculpture Park, 1995
LENT BY Kenneth Armitage Esq.

P16

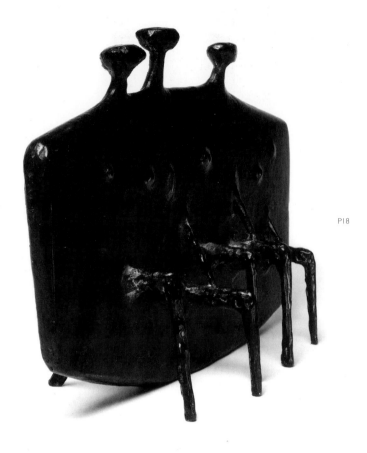

P18

P19

P20

P17
Kenneth Armitage
Seated nude, 1954
Black ink, 56 cm x 43 cm (22″ x 17″)
Signed with initials and dated (l.r.)
LENT BY Kenneth Armitage Esq.

P18
Kenneth Armitage
Maquette for *Triarchy*, 1957
Bronze
EXHIBITED 'Kenneth Armitage', Yorkshire
Sculpture Park, 1995

LENT BY Kenneth Armitage Esq.

P19
Kenneth Armitage
Brompton Cemetery, 1949
Oil on canvas, 63.5 cm x 76 cm (25″ x 30″)

P22

P21

P20
Gertrude Hermes (1901–1983)
The spate, 1952
Linocut, [image size] 61 cm × 83 cm
(24″ × 32½″)
Signed (l.r.) and inscribed *The Spate 22/30*

P21
Ceri Richards (1903–1971)
Reclining nude, 1954
Watercolour. 38.5 cm × 57 cm (15¼″ ×
22½″)
Signed and dated (l.r.)

P22
Jack Smith (1928–)
Ice cream glasses, 1955
Lithograph, 38.5 cm × 56.5 cm (15¼″ ×
22¼″)
Signed and dated (l.r.)

P23
Leonard Rosoman (1913–)
Studio table, ca. 1957
Oil, 67.5 cm × 55 cm (26½″ × 21½″)
EXHIBITED 'Peinture Britannique
Contemporaine', Galerie Crenze, Salle
Balzac, Paris, October 1957 (68); AIA
Exhibition, London, n.d.

P24
Peter Lanyon
Gunwalloe Church, 1954
Gouache and crayon on paper, 58 cm × 47
cm (22¾″ × 18½″)
Signed and dated '54 (l.r.) and titled
EXHIBITED Gimpel Fils Gallery, London,
March 1954 (18)

P23

P24

P25

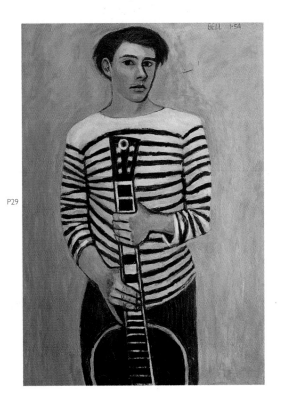

P29

P25
Francis Bacon (1909–)
Man in blue II, 1954
Oil on canvas, 152 cm × 117 cm (60″ × 46″)
EXHIBITED 'Francis Bacon', Hanover Gallery, London, 1954; 'Hepworth, Scott, Bacon', Martha Jackson Gallery, New York, 1954 (as *Man trapped*)
PUBLISHED Ronald Alley and John Rothenstein, *Francis Bacon*, no. 83

P26
Ceri Richards
Study for mural, *ca.* 1950s
Gouache, 56 cm × 53.5 cm (22″ × 21″)

P26
Alan Reynolds (1926–)
Village, October 1953
Oil, 76 cm × 106.5 cm (30″ × 42″)

P28
Robert Adams (1917–1984)
Screen form
Steel, 47 cm (18¹/₂″)
Impressed artist's name

P29
Trevor Bell (1930–)
Young man with guitar, 1954
Oil, 105 cm × 71 cm (41¹/₂″ × 28″)

P30
Sir Jacob Epstein LG (1880–1959)
Maquette for *Madonna and Child*, Cavendish Square, London, 1950
Lead with brass wire, 35 cm (14″)
EXHIBITED 'Jacob Epstein and Theo Garman', The Fine Art Society, London 1989 (32)
PUBLISHED Evelyn Silber, *The Sculpture of Jacob Epstein*, 1986, p. 208, no. 437 (8)
PROVENANCE Lady Epstein; Beth Lipkin

28

P32

30

P31
Patrick Heron (1920–)
Blue painting (squares and disc), 1958–59
Oil on canvas, 152.5 cm x 121.5 cm
(60″ x 48″)
Signed, dated and inscribed with title verso
EXHIBITED 'Four English Middle
Generation Painters', Waddington Galleries,
London, 1965 (24); 'English Contrasts',
Articurial, Paris, 1984; 'New Beginnings',
Scottish National Gallery of Modern Art,
Edinburgh, 1992 (34)
LENT BY Kenneth Powell Esq.

P32
Mary Martin (1907–1969)
Spiral movement, ca. 1950
Fibreglass, 29 cm x 29.5 cm (11¹/₂″ x 11³/₄″)
This piece is one of a number produced for
sale at the Tate Gallery, London, by Pan-Art
Reproductions, Rugby
LENT BY Kenneth Powell Esq.

P33
Henry Moore (1898–1986)
Figures in settings, 1949

Colograph on paper, 57.5 cm x 40 cm
(22¹/₂″ x 15³/₄″)
A trial proof printed in blue, yellow, red,
grey and black, before the edition of 75

P34
Henry Moore
Woman holding cat, 1949
Colograph on paper, 30 cm x 49 cm (11³/₄″
x 19¹/₄″)
A trial proof printed in four colours, before
the edition of 75

P35
Victor Pasmore (1908–)
*Transparent relief construction in white,
black, green, lilac and maroon*, 1960–61
Painted wood and perspex, 53.5 cm x 56
cm (21″ x 22″)
Inscribed verso with initials, name and date
EXHIBITED 'Recent Paintings and
Constructions by Victor Pasmore:
Retrospective Exhibition 1925–1965', New
London Gallery, London, 1965 (163)
LENT BY Kenneth Powell Esq.

P31

P3

P36
Victor Pasmore
Abstract in blue, 1951
Glazed pottery, 24.5 cm (9½″) diameter
Signed on base with monogram
PROVENANCE The artist; Louis and
Kathleen Blood (the artist's sister and
brother-in-law); Private collection
This is one of two plates painted by
Pasmore in 1951 (the other one owned by
the artist), the year in which he also painted
the ceramic mural for the Regatta
Restaurant at the 'Festival of Britain'.

P37
William Brooker (1918–1983)
Studio interior, 1954
Oil, 70 cm × 44.5 cm (27½″ × 17½″)
Inscribed name and title verso

P38
William Brooker
Model resting, 1959
Oil, 75 cm × 45 cm (29½″ × 17¾″)
Signed and dated

P39
Edward Middleditch (1923–1987)
North End Road, West Kensington
Oil, 51 cm × 76 cm (20″ × 30″)

P40
Lynn Chadwick (1914–)
Second maquette for *Unknown political
prisoner*, 1953
Welded iron, 30.5 cm × 38 cm (12″ × 15″)

P41
Lawrence Toynbee (1922–)

The District Line – South Kensington, 1950
Oil on board, 40 cm × 53.5 cm (15¾″ × 21″)
Initialled and dated (t.r.) and inscribed verso
title, date and signature
EXHIBITED 'Artists of Fame and Promise I',
Leicester Galleries, London, 1950 (159)

P42
Harry Bush (1883–1957)
Rusty fence, 1953
Oil, 60 cm × 104 cm (23½″ × 41″)
Signed and dated (l.l.)

P43
Paul Feiler (1918–)
The red curtain, 1954
Oil, 45.5 cm × 66 cm (18″ × 26″)
PROVENANCE The Redfern Gallery; Guy
Holdford-Dixon Esq.

P34

P37

P39

P44

P44
Lucian Freud (1922–)
Small Zimmerlinde, 1947
Oil on panel, 21.5 cm × 17 cm (8¹/₂″ × 6³/₄″)
EXHIBITED The London Gallery, May 1947 (as *The plant*); 'Lucian Freud: Paintings and Works on Paper', The British Council (touring exhibition), 1991–93; 'Lucian Freud: Early Works', Robert Miller Gallery, New York, 1993
PUBLISHED Lawrence Gowing, *Lucian Freud*, 1982, pl. 54

P45
Alan Davie (1922–)
Untitled female, 1951
Oil on board, 99 cm × 114 cm (39″ × 45″)

P46
John Bratby (1928–1992)
Raincoat over railings, 1954
Oil on board, 51 cm × 61 cm (20″ × 24″)
EXHIBITED Bratby's degree show at the Royal College of Art, London, 1954

Select Biographies

FURNITURE

Ernest Race
RDI FSIA 1913–1964

Educated St Paul's School, London

1932–35 Studied interior design, Bartlett School of Architecture, London

1935–39 Employed as a designer by Troughton & Young, the lighting manufacturers, under the direction of A.B. Read, later founded Race Fabrics, a textile design firm and shop

1939–45 Served in the Auxiliary Fire Service, London

1945–61 Director and Chief Designer, in partnership with Noel Jordan, of Race Furniture Ltd

1961–64 Consultant furniture designer for Cintique & Isokon furniture

Ernest Race was one of the most original and outstanding British furniture designers of the century. Included amongst his most well known designs are the BA3 chair of 1945, winner of the gold medal at the 10th Milan Triennale, 1954, and the Antelope chair for the 1951 'Festival of Britain', winner of the silver medal at the 10th Milan Triennale.

Robin Day
OBE ARCA RDI FCSD 1915–

1930–33 High Wycombe Art School, Bucks.

1934–38 The Royal College of Art, London

1942 Married the textile designer Lucienne Conradi

1940–47 Taught design, Beckenham School of Art, Kent

Since 1945 Freelance exhibition, interior and furniture designer, London

Robin Day is one of the most influential British furniture designers of this century. His work is particularly associated with the furniture manufacturers Hille. Amongst his more well known designs are the Hillestack and Hilleplan ranges of 1950 and 1951 respectively, his outstanding chairs for the Royal Festival Hall, 1951, and his groundbreaking, injection-moulded polypropylene Polyprop chair, ca. 1960.

In 1948 Day and Clive Latimer, his assistant whilst teaching at Beckenham, jointly won first prize for the design of low-cost furniture in the international furniture design competition held by the Museum of Modern Art, New York. Day subsequently won a gold and a silver medal at the 1951 and 1954 Milan Triennales, two Design of the Year awards in 1957, and design awards from the Council of Industrial Design in 1961, 1962, 1965 and 1966.

Frank Guille
DesRCA 1926–

1941–43 Beckenham School of Art, Kent, studied under Robin Day, with John Cole as head of department

1944–47 Served in the Royal Navy

1947–49 Studied furniture design at the Royal College of Art, London, under Professor R.D. Russell

1950 Studied at the Kunst Akadamiet, Copenhagen

1951–53 Assistant to the modernist architect Wells Coates

1953–92 Freelance designer, this included work as consultant designer for Kandya Ltd, 1953–76, and designs for Heal & Sons and West of Scotland Furniture

1960–92 Lecturer, Senior Lecturer and Deputy Head of Furniture (Reader), the RCA

1974–92 Design partnership with Frank Height, Professor of Industrial Design at the RCA. Clients included Artifact, Black & Decker, Insulator Ltd and Lesco Products. Their work for Black & Decker won a Design Award in 1976

During his career Frank Guille has produced a significant body of work, the most outstanding being that which he created over a twenty-three-year period for Kandya. He designed for Kandya some of the most refined, subtle and intelligently thought-out British furniture of the post-war period. This elegant functionalist approach is also characteristic of the work he produced in collaboration with Frank Height. He added considerably to the quality of British furniture design through his long teaching career at the RCA.

Lucian R. Ercolani
OBE FRSA 1888–1976

ca. 1904 Studied furniture design at Shoreditch

1909–20 Worked as a freelance furniture designer, first with Frederick Parker, later Parker Knoll, and then with Ebenezer Gomme, later G Plan, both of High Wycombe. Also taught part-time at High Wycombe Technical College

1920–76 Founder, Chief Designer and Managing Director of Ercol Furniture

Lucian Ercolani was born in Italy, the son of a picture-frame maker who had worked for the Uffizi Gallery, Florence. He came to live in England with the rest of his family whilst still a baby. He was greatly influenced by the teachings of Morris and the Arts and Crafts movement, not only from the movement's aesthetic and craft-orientated approach to furniture and its design, but also from its sociological point of view. In developing and elevating traditional Windsor country furniture, he was very much following in the footsteps of Morris and Ernest Gimson who had previously refined the Sussex and Ladderback chairs for use in what were then modern environ-

ments. It was particularly in the 1940s and 1950s that Ercolani was able to achieve a satisfactory synthesis between tradition and modernity in the simple and elegant Contemporary furniture he designed in the post-war period.

Ercol is still run as a family business and their continuing commitment to modernism is reflected in the recent appointment of Floris Van Den Broecke as consultant designer to the company.

TEXTILES

Jacqueline Groag

RDI FSIA 1903–1986

1903 Born Hilde Blumberger, Prague

Early 1920s Studied at the Vienna Kunstgewerbeschule under Josef Hoffmann and Franz Cizek

ca. 1930 Worked as a textile designer in Vienna, which included designs for the Wiener Werkstätte

1937–39 Emigrated to France with her husband the architect Jacques Groag, a former assistant of the proto-modernist Adolf Loos. Whilst in Paris she designed fabrics for Lanvin and Schiaparelli. She and her husband finally settled in Britain in1939

1940 Worked as a freelance designer of textiles, wallpapers and plastic laminates. These included textiles for David Whitehead and laminates for Warerite and Formica Ltd

ca. 1965 Retired

Jacqueline Groag's strong and sophisticated approach to textile design made a considerable contribution to the success of the British textile industry in the post-war period. She was one of a number of distinguished European designers who brought an awareness to Britain of the ideas of the International Modern movement and the teachings of the Bauhaus.

Marianne Mahler

MSIA ca. 1911–ca. 1983

ca. 1911 Born in Austria and educated at the Vienna Grammar School

1929–32 Studied at the Vienna Kunstgewerbeschule under Josef Hoffmann

ca. 1932 Attended the Royal State Academy

1937 Emigrated to Britain and worked as a freelance designer of dress and furnishing fabrics

ca. 1951 Worked under contract for David Whitehead Ltd until the early 1960s

Marianne Mahler arrived in Britain around 1937 and worked as a freelance textile designer. This initially included some work for Allan Walton Ltd. In the mid 1940s her eclectic and often witty designs were mainly commissioned by the

Edinburgh Weavers, but from the early 1950s onwards she produced a series of stunning Contemporary-styled textiles for David Whitehead Ltd. She also designed children's books, wrapping papers and other paper-based items for companies in the UK, USA, France and Germany under the name 'Marian'.

Lucienne Day

RDI ARCA 1917–

1934–37 Studied art at the Croydon School of Art, London

1937–40 Studied textile design at the Royal College of Art, London

1942 Married the designer Robin Day

1942–47 Taught at the Beckenham School of Art, Kent

Since 1948 Full-time freelance designer, London

Lucienne Day is the leading British textile designer of the post-war era. She has designed not only fabrics but also carpets, wallpapers, plastic laminates and porcelain. She is best known for the textiles she designed over a twenty-year period for Heal's of London. Day also worked for many other companies, both at home and abroad. Amongst these were the Wilton Royal Carpet Company and the West German company Rosenthal China.

Day's best-known design is her groundbreaking fabric of 1951, Calyx, launched at the 'Festival of Britain'. Calyx won a gold medal in 1951 at the 9th Milan Triennale and in 1952 the international design award from the American Institute of Decorators, given for the first time outside America. She has been the recipient of numerous other awards. Since the late 1970s Day's work has become more craft-orientated and she has produced a series of one-off wall-hangings which she terms 'silk mosaics', many of which have been commissioned for use in formal architectural interiors.

Robert Stewart

1924–1995

1942–47 Studied at the Glasgow School of Art

1947–48 Awarded Diploma in Design and won a travelling scholarship which he used to tour Europe in 1948

From 1948 Freelance textile, ceramic and graphic designer and painter

1949 Teacher of design for printed textiles, Glasgow School of Art

1949–78 Became head of department of printed textiles

1979–80 Appointed head of design

1981–84 Deputy Director of the Glasgow School of Art

1984 Retired

During the late 1940s and 1950s Robert Stewart, in addition to being a painter and teacher, worked as a freelance designer principally of textiles and ceramics. His work was produced mainly for Liberty's of London and the Edinburgh Tapestry Company. Stewart appears to have functioned almost as a house designer for Liberty's during the 1950s, designing many textiles for them in the Contemporary style, and other decorated items such as silk scarves and wastepaper baskets. He also ran a small workshop producing screen-printed ceramics, some under his own name, which were marketed in London through Liberty's and Primavera. Stewart also made ceramic tiles for the Edinburgh Tapestry Company, for whom he designed a wide range of items which included tablemats, greetings cards, wrapping papers and posters. Stewart was a highly original talent, with a wry wit and surreal sense of humour, which he used to the full in the important range of textiles he produced for Liberty's in the 1950s.

CERAMICS

Richard & Susan Parkinson
Richard
1927–1985

1949 Married Susan Sanderson

ca. 1949–50 Guildford School of Art, Surrey

1950 Worked for the summer at the Crowan Pottery, Cornwall, with Harry Davis

ca. 1950–51 Woolwich School of Art, London

1951–63 Set up and ran a pottery with his wife Susan at Braboume Lees, near Ashford, Kent

ca. 1960–71 Head of ceramics at Hornsey School of Art, London

1966–68 Ran a pottery in Cambridgeshire, decorating whitewares mainly for the National Trust, with designs by his third wife Dom Parkinson

1968 Moved the pottery to London

1971 Left teaching and moved the pottery to Wales, slip-casting and decorating mugs and lidded boxes

Susan
1925–

1945–49 Studied sculpture at the Royal College of Art, London, under Frank Dobson

Early 1950s Executed individual work, mainly sculpture in coiled stoneware, which was exhibited at Primavera under her maiden name, Sanderson

1951–63 Co-founded and ran the Braboume Lees Pottery with her husband Richard

Since the 1960s she has worked in portrait sculpture and been involved in teaching art to dyslexic children

Richard and Sue Parkinson successfully revived a strand of British ceramics whose origins go back to the eighteenth and nineteenth centuries, that of popular figure-making. The Parkinsons' work is modern and strong, full of wit and wry humour. Sue designed, modelled and decorated the wares, whilst Richard concentrated on the more technical side of production. He developed the high-temperature porcelain used for slip-casting and designed a special kiln in which to fire it. The Parkinsons were some of the very few in Britain to work with porcelain in the 1950s.

John & Walter Cole

John
1908–1988

Trained as a wood and metalwork teacher at the Shoreditch Training College, London

1931 One year's study of sculpture under John Skeaping at the Central School of Arts & Crafts, London

1936 Joined the staff of Beckenham School of Art, Kent, becoming Principal in 1945. Later Joint Principal with Keith Coleborn of the Ravensbourne College of Art formed from the amalgamation of Bromley, Beckenham and Sidcup Schools of Art

1947 Re-established with his brother the Rye Pottery, Sussex

1967 Retired from Ravensbourne

Walter
1913–

1930–31 Attended Woolwich Polytechnic School of Art, studying ceramics and drawing

1931–36 Studied ceramics and sculpture under John Skeaping at the Central School of Arts & Crafts, London

1936–39 Assistant to Eric Kennington RA

1939–45 Served with the Camouflage Unit Royal Engineers

1946–47 Assistant to James Gardner, designer of the 'Britain Can Make It' exhibition

1947–78 Re-established with his brother the Rye Pottery, Sussex, where he was responsible for the pottery's management and administration

The Cole brothers reopened the Rye Pottery in 1947 as a craft pottery working on a semi-industrial basis. Their chosen medium was traditional tin-glazed earthenware with painted decoration. In the later 1940s and early 1950s Rye Pottery played a vital rôle in the home market's demand for decorated ceramics. Until 1952 the sale of industrially produced, decorated wares was prohibited in Britain, all such ceramics being for export only. Studio pottery alone was exempt from this restriction and the Cole brothers made full use of this opportunity, hand-producing on a large scale tablewares, vases and decorative

objects. The pottery was decorated in a distinctive brightly coloured Contemporary manner which epitomizes the style now associated with the 'Festival of Britain'. The wares were extremely successful, selling around the world at prestigious shops such as Heal & Sons and Tiffany's.

Roy Midwinter
1923–1990

1941–46 Served with the RAF first in Bomber Command and then as a test pilot

1946–81 Joined the family firm of W R Midwinter Ltd, Director from 1948 and then Managing Director

1981–90 After retirement Roy Midwinter acted as a part-time design consultant for a number of companies, forming Roy Midwinter Design Associates in 1987

Roy Midwinter, through the family firm of W.R. Midwinter Ltd, developed and marketed the most successful industrially produced British tablewares of the 1950s. The wares were in a high Contemporary style. To complement these forms he commissioned decorative patterns from leading designers such as Sir Terence Conran and Sir Hugh Casson. Midwinter's in-house designer Jessie Tait also produced many original and successful patterns for the Stylecraft and Fashion ranges such as Primavera and Festival.

William John Clappison
NDD FSCD 1937–

1950–53 High School for Arts & Crafts, Hull

1953–57 Hull Regional College of Art & Crafts. Gained National Diploma in Design, Special Level Ceramics

1957–58 Royal College of Art, London. Faculty of Industrial Design, Certificate in Ceramics

1958–72 Chief Designer Hornsea Pottery Co. Ltd, Hornsea

1970 Elected to the Board of Directors

1972–76 Chief Designer Ravenhead Co. Ltd, St Helens

1976–84 Rejoined Hornsea Pottery Co. Ltd as house designer and Director of the Board

1984–86 Design Manager of the Alexon Group, designed ceramics for Marks & Spencer PLC

1987– Joined Royal Doulton as head of Shape (tableware) design

Whilst at Hornsea, between 1958 and 1962, Clappison was responsible for designing and commissioning designs for a remarkable series of ceramics which set Hornsea on the road to success as manufacturers of some of the most advanced and sophisticated industrial ceramics to be produced in Britain in the 1960s and 1970s.

GLASS

Irene Stevens
ARCA 1917–

1936–39 Following a private education, Irene Stevens attended Stourbridge School of Art

1939–1942 Studied at the Royal College of Art, at first in London and then at Ambleside in the Lake District where the RCA was evacuated. She obtained her degree in 1942

1942–45 Service in the WRAF

1946 A short period of further study at the RCA

1946–58 Principal designer for Thomas Webb & Corbett Ltd, Stourbridge

1958–77 Principal lecturer in glass and pottery, Stourbridge College of Art

1977 Retired

Irene Stevens's influence was one of the most, if not the most, important factors in the development of glass design and production in post-war Britain. Her work for Webb & Corbett, although made principally within the limitations of engraved, cut and polished glass, is remarkable for the originality and strength of her designs. From 1958 Stevens's teaching became a major force in the subsequent growth and development of British studio glass in the 1960s and 70s.

John Luxton
ARCA 1920–

Attended Hales Owen Grammar School, West Midlands

1936–39 Studied glass and general studies at Stourbridge School of Art

1939–40 Attended the Royal College of Art, then at Ambleside

1940–45 Served in the Field Artillery

1946–49 Royal College of Art studying glass and glass engraving under Professor Tristam

1949–70 Designer with Stuart & Sons, Stourbridge

1970–85 Head of design for Stuart & Sons

1985 Retired

John Luxton was a close contemporary of Irene Stevens at the Royal College of Art. Like her work for Webb & Corbett, Luxton's work for Stuarts was mainly carried out within the tradition of cut and polished glass. However, he brought great ingenuity to this, creating many outstanding Contemporary designs in cut glass. He recalls that on leaving the RCA his head was full of new ideas stemming from the Contemporary style then coming to the fore in design. It was from this fund of ideas, rooted in his experiences at the RCA, that he drew on for inspiration for his work with Stuarts in the Contemporary period.

David Hammond

DesRCA 1931–

1945 Attended a general art and design course at the Stourbridge School of Art & Design

1946 Joined Thomas Webb & Sons, Stourbridge

1951–53 National Service in the Royal Air Force

1953–56 Three-year course in industrial glass at the Royal College of Art, London

1956–88 Returned to Thomas Webb where he worked until his retirement

David Hammond was one of the group of RCA-trained designers who specialized in glass design and production in the 1950s. Like Irene Stevens and John Luxton, Hammond worked mainly within the British tradition of cut and engraved glass. However, in the late 1950s and early 1960s, working in conjunction with the technologist Stanley Eveson, he designed a series of cased coloured glass dishes and vases called the Flair range. These vessels were, in part, the result of trips to Scandinavia by Hammond and Eveson, who began at that time to experiment with techniques they had witnessed in the Scandinavian glass houses.

Geoffrey Baxter

NND DesRCA FCSD 1926–1995

Initially studied art at the Guildford School of Art

1950–54 Studied glass-working techniques at the Royal College of Art, London

1954–80 Designer, James Powell & Sons Ltd, the Whitefriars Glassworks, London

Following the completion of his course of studies at the RCA, Geoffrey Baxter was appointed resident designer at the Whitefriars Glassworks. He worked under William Wilson, formerly Chief Designer at Whitefriars and then Managing Director. Baxter developed several ranges of Contemporary glass during the 1950s and early 1960s. Whitefriars had a long tradition of using uncut coloured glass which, combined with Baxter's RCA training, led to the development in the 1950s of a Whitefriars style which showed a considerable awareness of Scandinavian design.

METALWORK

Robert Welch

OBE DesRCA RDI FSIA FRSA 1929–

1941–46 Hanley Castle Grammar School, Worcestershire

1946–47 1949–50 Malvern School of Art

1947–49 National Service in the Royal Air Force

1950–52 Birmingham College of Art

1952–55 Studied silversmithing at the Royal College of Art

Since 1955 Independent silversmith, metalwork and industrial designer with his own workshop in Chipping Camden, Gloucestershire

Robert Welch is one of the most influential British designers of metalwork this century. In particular, his work in stainless steel for the Bloxwich-based company, J & J Wiggin, Old Hall tableware, helped restore a high profile to British metalwork at an international level which it had not had since the early part of the century. Welch has also carried out many commissions for prestigious one-off pieces of silver, principally for academic, corporate and civic bodies. He has proved equally successful as an industrial designer, working in glass, ceramic and plastic, for such projects as light fittings, clocks, sanitary fittings, stoneware and table glass. He has been the recipient of numerous prizes, awards and medals throughout his career.

Gerald Benney

CBE DesRCA RDI 1930–

1948–50 Brighton College of Art, under Dunstan Purden

1951–53 Royal College of Art, London, under Professor Robert Goodden

Since 1953 Freelance silversmith and metal designer

1957–70 Design Consultant, Viners Ltd, Sheffield

1974–83 Professor of Silversmithing, the Royal College of Art

Gerald Benney is one of a number of RCA-trained silversmiths who gave British metalwork a much needed boost in the post-war period. Although Benney has always been foremost a practising silversmith, maintaining considerable workshops at his home, Beenham House, he is probably more widely known for his work in pewter and stainless steel for Viners. His first commission from this company involved the development of a series of modern designs for English pewter, a metal that had not received serious consideration since the early part of this century. Benney also introduced the use of texture, which he first developed for use on silver, as decoration for pewter and other work in stainless steel he designed for Viners in the late 1950s and early 1960s, particularly his well known "Studio" range of cutlery. Gerald Benney has been the recipient of numerous honours and awards throughout his career.

David Mellor

OBE DesRCA RDI FSIA 1930–

1946–48 Studied Sheffield College of Art

1948–49 National Service in the army

1950–54 Silversmithing, the Royal College of Art, London

Since 1954 Freelance silversmith, designer and consultant, establishing David Mellor Silversmithing/Industrial design workshop, Sheffield

1974 Established David Mellor Cutlery, Broom Hall, Sheffield

Following his training at the RCA, David Mellor has established himself as the leading British designer, and subsequently manufacturer of cutlery. He has been responsible for the design of many outstanding ranges throughout his career, from his classic Pride range for Walker & Hall of 1954, to commissions from central Government for cutlery, which included the Thrift range of 1966, and designs for his own manufacturing company such as the Chinese White & Black ranges of the late 1970s. Mellor's work has revolutionized the design and subsequently the manufacture of cutlery in Britain. He has been the recipient of many awards and examples of his work are in the collections of museums around the world.

Louis Osman

1914–1996

Studied architecture at the Bartlett School of Architecture, London

1931–35 Studied at the Slade School of Art, London

1935–39 In architectural practice, with some time spent in the late 1930s in Syria with British Museum archaeological expedition

1939–45 Served in the army's intelligence corps

1946–96 Practised as an architect and goldsmith

Osman designed a number of public buildings including the Principal's Lodge of Newnham College, Cambridge in 1951, and restored the Convent of Mercy, Cavendish Square in 1950, for which he commissioned Epstein's *Madonna & Child*. He turned to silver and goldsmithing during the 1950s, influenced by his friend Gerald Benney's success. Worked at Canons Ashby, Northamptonshire and later Byford Court, Hereford, alongside his wife the enamellist Dilys Osman. Continued collaborations with other artists including that with Geoffrey Clarke at Shere Church, Guildford, 1959, and with Graham Sutherland on the Ely Cathedral Cross, 1961. Osman won the prestigious De Beers Jewellery Prize in 1961 and went on to create the Crown for the Prince of Wales's investiture and the British Government's gift to the United States of America on their Bicentenary: a gold copy of the Magna Carta enclosed in an exquisite enamelled box.

INDUSTRIAL DESIGN

Martyn Rowlands

FSIA FPRI 1923–

1931–40 Educated Eltham College, London

1941–46 Served in the Royal Air Force.

1946–49 Central School of Arts & Crafts, London

1950–59 Designer with Bakelite, London. Then head of design, Ecko Plastics, Southend on Sea

1959 Founder and principal designer, Martyn Rowlands Design Consultants

1974–75 President of the Society of Industrial Artists and Designers

Martyn Rowlands is particularly noted for the design of plastic products and packaging. Among the many companies for whom he has received commissions are Boots the Chemist, the Thermos Company, Standard Telephones & Cables, British Rail and Betterwear. Rowlands's most well known design is probably that of the Delta Line telephone, better known as the Trim phone, developed by Standard Telephones & Cables as a luxury phone for the GPO.

David Slingsby Ogle
MBE DSC MSIA 1921–1962

Born Reigate, educated at Rugby School 1934–38

1939 One year wartime degree at Oxford

1940–45 Served in the Fleet Air Arm

1945–47 Central School of Art & Design, London

ca.1947 early 1950s Worked as a designer for Murphy Radio and afterwards as a freelance designer

1954 Set up David Ogle Associates, Stevenage, which moved to Letchworth in 1960

1959 Formed David Ogle Ltd for the design and development of specialist car bodies

1962 Died in a road accident

David Ogle was a pioneering industrial designer, his principal client in the 1950s being Bush, for whom he designed record players, televisions and radios, amongst which was the very successful Bush TR82. He also designed baths and cookers for Allied Iron Founders Ltd. David Ogle Ltd designs included the Ogle mini and limited editions of the Riley 1.5 and, his last piece of work, the Daimler SP250.

Richard Stevens
BSc RDI FCIBS FCSD 1924–1997

1935–40 Dorking County Grammar School, Surrey

1941–46 Took a degree in physics at the Regent Street Polytechnic, London

1942–53 Technician, Siemens Lamps & Supplies Ltd, London

1953–54 Designer, Metropolitan Vickers, London

1954–63 Chief Designer, Atlas Lighting, London

1963–69 Industrial design manager, Standard Telephones & Cables, London

1969–83 Design manager, Post Office Telecommunications (now British Telecom)

1972–73 President of the Society of Industrial Artists and Designers

Richard Stevens was a leading British industrial designer whose work was characterised by an intelligent and thoughtful approach to design problems that resulted in a refined and elegant style which emphasised the importance of quality in everything.

Albert Henry Woodfull
MSIA 1912–

ca.1926 Trained in silversmithing at the Vittoria School of Jewellery & Silversmithing, Birmingham, and subsequently took an experimental course in product design at the Birmingham College of Art & Craft

ca.1931 Became a product designer with the Streetly Manufacturing Company, part of British Industrial Plastics Ltd (BIP)

1952 Director of the advisory Product Design Unit of BIP

1970 Retired

A. H. Woodfull was one of the first professional British product designers. Having completed his training he was invited by Kenneth Chance, managing director of BIP, to become a designer with the company, Chance wanting at that time to bring "Art to an Artless Industry".

In 1952 Woodfull was invited to set up the Advisory Product Design Unit at BIP's headquarters, Albery, and to become design director. Here, with the assistance of a team of up to six people, he was responsible for the design and development, among much else, of many of the plastic tablewares and other plastic domestic products manufactured in Britain between 1945 and 1970. The designers John Vale, Ronald E Brookes and Barry Eccleston worked as principal assistants to Woodfull during this period.

Select Bibliography

Britain Can Make It, exhib. cat., London (HMSO) 1946

British Art in the Twentieth Century, London (The Royal Academy of Arts) 1987

Margot Coates, *Robert Welch, Designer/Craftsman. A Retrospective Exhibition 1955–1995*, Cheltenham 1995

The Daily Mail Ideal Home Book, London, 1951–1957

Design, London (Council of Industrial Design) 1949–63

Design in the Festival, An Illustrated Review of British Goods, London (HMSO) 1951

Designers in Britain, vols. 1–5, London (Society of Industrial Artists) 1947–1954

Festival of Britain, exhib. cat., London (HMSO) 1951

Gallery of British Art and Design 1900–1960, London (Victoria and Albert Museum) 1983

Phillippe Garner, *The Contemporary Decorative Arts from 1940 to the Present Day*, London (New Burlington Books) 1980

— *Twentieth-Century Furniture*, Oxford (Phaidon) 1980

Jennifer Harris, *Lucienne Day: A Career in Design*, Manchester (The Whitworth Art Gallery) 1993

Frances Hinchcliffe, *Fifties Furnishing Fabrics*, Exeter (Webb & Bower) 1989

House & Garden Magazine, London (Condé Nast Publications) 1949–63

Ideal Home, London (Odhams Press Ltd) 1947–54

Lesley Jackson, *The New Look – Design in the Fifties*, London (Thames & Hudson) 1991

Sylvia Katz, *Classic Plastics – From Bakelite to High Tech*, London (Thames & Hudson) 1984

Peter Lewis, *The 50s*, London (Heinemann) 1978

Fiona McCarthy and Patrick Nuttgens, *Eye for Industry: Royal Designers for Industry 1936–1986*, London (Lund Humphries) 1986

Valerie D. Mendes and Frances M. Hinchcliffe, *Ascher, Fabric, Art, Fashion*, London (The Victoria and Albert Museum) 1987

Ed. Ann Lee Morgan, *Contemporary Designers*, London (Macmillan) 1984

Alan Peat, *Midwinter, A Collectors Guide*, Moffat (Cameron & Hollis) 1992

— *David Whitehead Ltd, Artist Designed Textiles 1952–1969*, Oldham (Oldham Art Gallery) 1993

Mary Schoeser, *Fabrics and Wallpapers, Twentieth-Century Design*, New York (E.P. Dutton) 1986

Frances Spalding, *British Art Since 1920*, London (Thames & Hudson) 1986

Ed. Penny Sparke, *Did Britain Make It? British Design in Context 1946–1986*, London (The Design Council) 1986

The Studio Yearbook of Decorative Art, London and New York (The Studio Publications) 1943–64